LIGHT&
SHOOT

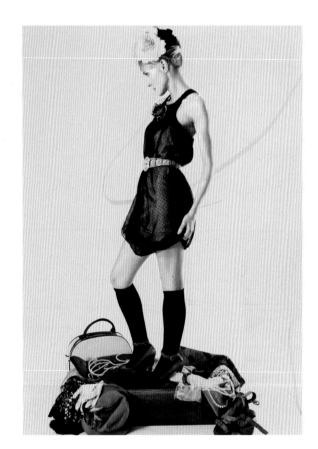

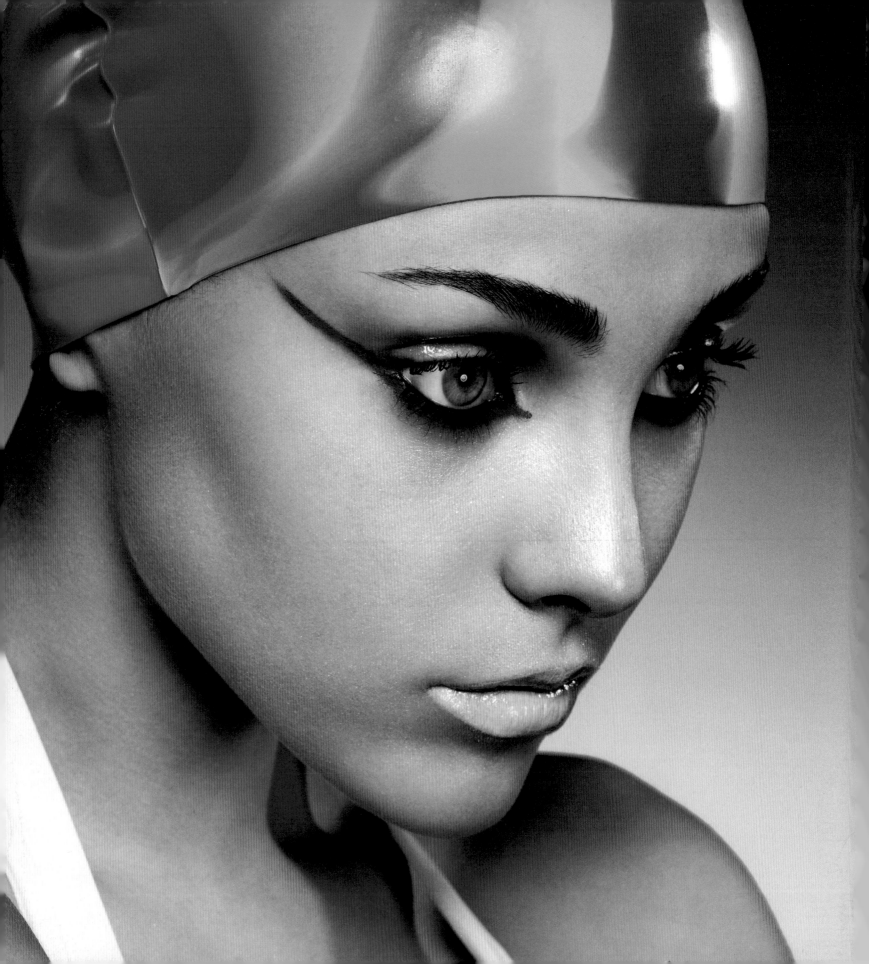

CHRIS GATCUM

LIGHT& SHOOT

50 FASHION PHOTOS

ILEX

First published in the UK in 2011 by

ILEX
210 High Street
Lewes
East Sussex
BN7 2NS
www.ilex-press.com

Copyright © 2011 The Ilex Press Limited

Publisher: Alastair Campbell
Creative Director: Peter Bridgewater
Associate Publisher: Adam Juniper
Managing Editor: Natalia Price-Cabrera
Editorial Assistant: Tara Gallagher
Art Director: James Hollywell
Design: JC Lanaway
3D Illustrations: Nicholas Rowland
Colour Origination: Ivy Press Reprographics

British Library Cataloguing-in-Publication Data
A catalogue record for this book is available from
the British Library.

ISBN: 978-1-907579-14-1

Printed and bound in China.

10 9 8 7 6 5 4 3 2

Contents

Introduction

Of all the genres of photography, fashion is arguably the most challenging, and certainly one of the most competitive. Yet despite this, if you go to any formal, general photography course, fashion will be, more often than not, the subject that most students want to specialize in. Whether this is based on dreams of fame and fortune from what can be an exceptionally lucrative career, or the associated glamour of photographing beautiful men and women dressed by celebrated designers, it seems that the majority of young photographers want to shoot fashion.

And who can blame them? Like fashion itself, the photography that surrounds it is fast-paced and exciting—constantly evolving and redefining itself, and inherently more open to experimentation and personal expression than many other genres. It's easy to think that fashion photography is simply about "photographing someone in clothes," similar to portraiture, but it is much more than that, and requires a truly multi-disciplinary approach to do it well. Outdoors on location, for example, you may well need the craft of a landscape photographer if you want to make the most of the location and the light, or the techniques and responses of a photojournalist if you're aiming to imbue your shots with a naturalistic, documentary style. At the same time, indoor location shoots can involve elements of interior photography and even architecture, while studio-based fashion can demand still-life and advertising photography skills, regardless of whether it's a relatively "straight" shot against a plain backdrop, or a scratch-built set in which you place your subject.

On top of all this, you need to borrow heavily from the portrait photographer's toolbox to fully appreciate how to light people, and to be truly successful, you need to be equally confident in all of these areas if you want your work to be as versatile—and as commercial—as possible. With so many skills required, it's perhaps unsurprising that for every aspiring photographer who transforms their passion into a career, many more who set out on a fashion-based path do not make it. This isn't to say you should give up before you begin (if "why bother" is your immediate reaction, then fashion photography isn't for you), but dreams and desires need to be tempered with reality: fashion photography takes commitment, determination, and no small amount of talent. It certainly isn't an "easy option."

What follows in this book is an inspirational and practical guide to shooting fashion in a wide range of styles and settings, with the emphasis on the use of lighting, rather than digital processing, to create a specific look or feel. Some of the images you will love, while others you may not be quite so keen on, but what they all have is a "spark"—a certain something that should serve to inspire you and your work, be it the pose, the approach to post-processing, or the lighting. With that in mind, you certainly shouldn't approach this book as a set of "blueprints" to creating definitive fashion shots, but instead treat it as a guide to techniques that can be borrowed, adapted, and repurposed for your own work. Make the shots your own and, from there, who knows where your fashion photography will take you.

Lighting Essentials

Without light there wouldn't be photography. Period. It doesn't matter whether you're shooting a landscape, a still life, or a portrait, all photographs need light in order to make an exposure. That clearly makes lighting a fundamental part of the photographic equation, and it's even more critical in fashion photography: not because there are conventions that need to be followed, or rules that need to be adhered to if you want to take a "good" shot, but the exact opposite. In fashion, there is no right or wrong.

Because there are no set guidelines, fashion photography is much more open to experimentation than most genres, and as you'll see when you look at the 50 stunning images in the following chapters, anything and everything goes when it comes to lighting a fashion shot. From shots taken outdoors with just the sun for company, through to elaborate multi-light setups, the only thing that ultimately counts in each of these shots is the result. Yet whether a picture is taken using flash, daylight, or something else altogether in the case of Marcelo Nunes's "black light" image on page 62, that core fact remains: without light there wouldn't be photography. So let's take a look at the options to get you started.

Flash

Without a doubt, flash is the most widely used type of artificial lighting for fashion shots, so much so that for many photographers it's impossible to comprehend shooting without it. There are many reasons for its popularity, including its cool running temperature and the brief burst of motion-freezing light, but the most important aspect from a creative perspective is the versatility and controllability that comes in part from the many and varied lighting modifiers that are available.

FLASHES, OR STROBES, come in a wide range of shapes, sizes, and even colors, and with the exception of the cheapest "unbranded" units they can be fitted with a bewildering array of accessories that shape and modify their output. From giant softboxes and umbrellas that create a soft, diffuse light, through to snoots and spot attachments that can limit the light to a diminutive, hard-edged pool with pinpoint accuracy, flash has it all. But with so much choice, it's not always easy to know where to start, especially when competing manufacturers all claim superiority in one area or another.

Broadly speaking, there are only two options you need to consider to start with: "pack and head" flash systems and integrated "monolights." As you'd expect, both have their advantages and disadvantages, but ultimately the choice is a personal one, with little to differentiate the two.

Pack-and-head systems

As the name suggests, a pack-and-head flash system comprises of two parts: a power pack and a flash head (or multiple heads) that will plug into it. The pack is the "brains" of this partnership, and it's the power of the pack that determines the power of the flash(es) attached to it—a 2400ws (watts per second) pack is more powerful than a 1200ws pack, for example. More importantly, the pack controls precisely how each flash that is plugged into it behaves—from the way in which the power is distributed between the flashes if you're using more than one, the amount of that power that each flash uses, through to simply turning the modeling light on or off.

RIGHT This Zeus pack-and-head system comes from Paul C. Buff, the creator of the popular AlienBees lighting range. Typical of this type of flash system, packs are available in several power configurations, with each pack allowing multiple lights to be plugged in and controlled.

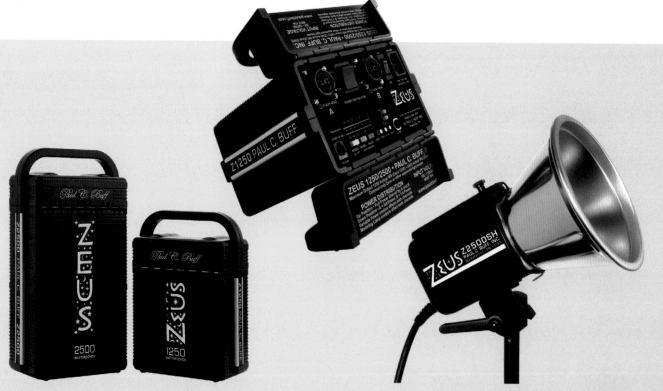

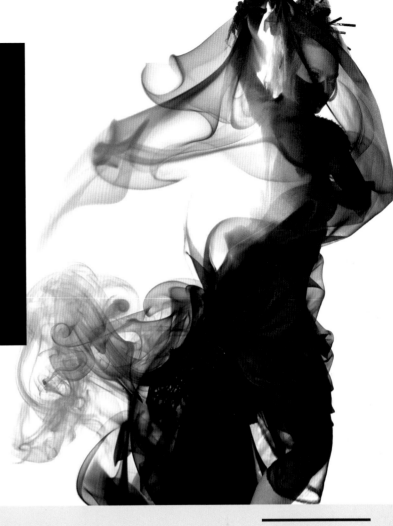

With so much of the flash technology placed in the pack, the flash heads you attach to it are relatively "dumb." Aside from an on/off switch there are often no other controls on the strobe itself, so apart from making sure the flash head is in the right position, everything else is determined by and from the pack. Having total control over your lights from a single "box" can be incredibly convenient because it means you don't have to run around your studio or location adjusting each and every light, and you only need a single wall socket for a pack that could power two, three, or even four strobes. However, this does have one quite significant drawback—if the pack breaks down then none of the flashes that are connected to it will work, potentially putting an end to an entire shoot.

⬦ FLASH POWER

- Whether it's a pack or a monolight, the general convention used for measuring the power of studio flashes is watts per second (ws), so you'll often see packs described as 1200ws or 2400ws and monolights boasting power ratings of 300ws, 600ws, or 1200ws. Unfortunately, what you see on the box isn't always what you get, especially with some of the cheap models from unestablished brands on the market.

- The reason for this is the watts-per-second rating is the *input* power to the pack or flash, and this doesn't necessarily match the output power. Because of the way in which a flash operates, there will always be a loss of power between input and output, but the efficiency and quality of the components used can have a profound effect on precisely how much of a loss there is. As a general rule, the more established the brand (and the more expensive), the more accurate the power ratings are likely to be.

ABOVE One flash technology, two very different looks. These photographs by Ethan T. Allen (see pages 24–25) and Alexey Ivanov (see pages 30–31) clearly demonstrate the versatility of pack-and-head flash systems when it comes to creating an individual look.

LEFT With your strobe (or strobes) attached to a power pack kept close to your camera, you can control a studio full of lights without having to run around the set.

Monolights

While a flash head attached to a pack is a relatively simple, "low-tech" device, a monolight is far more sophisticated, containing all of the necessary capacitors and flash controls in the strobe itself, much like a hotshoe-mounted flash. Like power-packs, monolights are measured by their watts-per-second input power—from low-powered 150ws flashes, through to powerful 1200ws strobes—and because these self-contained units just need a main power supply to function, it's very easy to "mix and match" different makes and models in a single setup: just plug them into the wall and you're ready to shoot.

Some photographers find it much easier to work with monolights because there's less confusion over how each flash is behaving. If you've got a power-pack with three strobes attached to it, it's not always easy to work out from the various knobs and dials exactly how each one is set, or indeed which light is plugged into which socket on the pack. But with a monolight you can simply look at the back of the head to see or adjust the power output, or make any other changes, and this makes the process more immediate and obvious.

Of course, having all of the flash technology in the head itself means that monolights are naturally going to cost more than a flash head that plugs into a pack. This isn't a major consideration, as you obviously don't have the additional expense of a power pack, but it is worth keeping in mind what will happen if a monolight "breaks." With all the technology squeezed into the head, repairs are likely to be more expensive (and should perhaps be more expected) than they would be on a simple pack-based flash.

LEFT Monolights are ideal for fashion work in the studio—for this quirky shot, Kristina Jelcic used two 500ws heads with umbrellas (see pages 42–43).

BELOW Designed to appeal to the style-conscious, the popular AlienBees' range of monolights not only comes with different power outputs, but is also available in a number of colors.

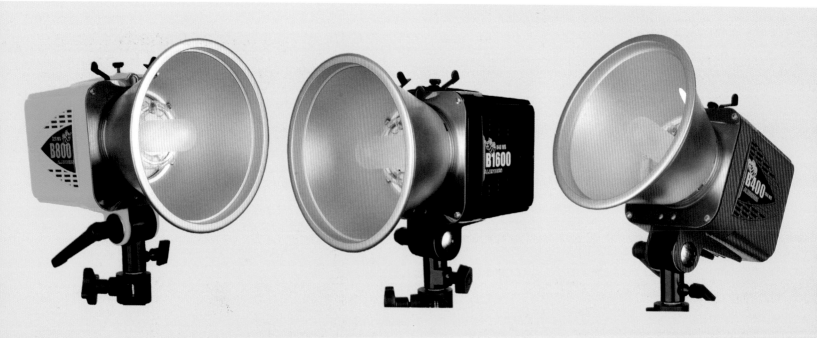

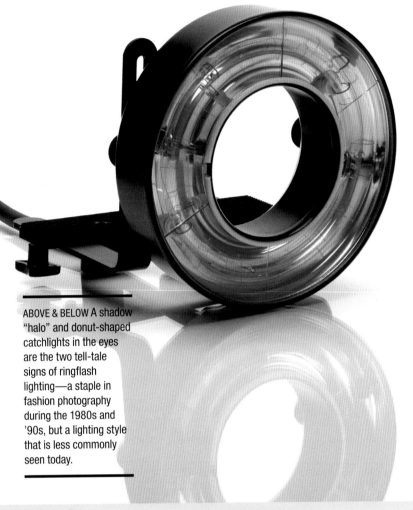

Ringflash

The existence of a ringflash in every major manufacturer's lighting catalog is a testimony to the importance of fashion photography within the photographic industry as a whole. This may sound like hyperbole, but it's worth reminding ourselves that ringflashes were originally designed for medical, dental, and forensic photography: they were a tool of science.

However, in the 1980s a number of cutting-edge fashion photographers saw the ringflash design's potential as a creative light source. With its circular shape (which sits around the camera lens), a ringflash delivers a near-shadowless light on the subject, hence its appropriateness for scientific records. But in the hands of the photographic "fashionista" it took on a whole new look, adding distinctive shadow "halos" around subjects and introducing distinctive donut-shaped catchlights to their eyes. Almost overnight, ringflash created a fresh fashion photography style, with countless magazines publishing numerous picture stories based on the exciting new look.

Of course, by its very nature, fashion photography is driven by the "new" and the "exciting," so it's hardly surprising that the popularity of ringflash has diminished: what was once a refreshing style became so commonplace that the effect is now perhaps something of a cliché. That said, fashion itself is cyclical, so there's little doubt that ringflash will, at some point, be in vogue once again.

ABOVE & BELOW A shadow "halo" and donut-shaped catchlights in the eyes are the two tell-tale signs of ringflash lighting—a staple in fashion photography during the 1980s and '90s, but a lighting style that is less commonly seen today.

⚎ FLASH RECYCLING TIMES

▢ While many photographers will make an initial decision on which flash to buy based on its nominal power rating, the recycling time is an equally important consideration. While pure power may help you shoot with a smaller aperture, this is wasted if the flash takes so long to recharge its capacitor (recycle) that you miss a shot. There is a way to reduce the recycling time, though, no matter what make or model of strobe you are using. Reducing the power of the flash will naturally mean that it doesn't take as long to recharge the capacitor, and this is where a high-power flash is particularly useful. A 1200ws flash set to 600ws is likely to recycle quicker than a 600ws flash set to full power, so while the output of both will be similar, the time it takes between flashes will not.

Continuous Lighting

There was a time when continuous lighting was the only answer for photographers looking to light their shots artificially, with high-power, heavy-duty incandescent lights migrating from the world of movie-making into the stills photographer's studio. Yet when flash arrived, with its cool running temperatures and photography-specific accessories, these so-called "hot lights" rapidly became a thing of the past and have now largely fallen out of favor with fashion photographers, and indeed photographers in general.

REGARDLESS OF THE SPECIFIC TECHNOLOGY used to create the light, all continuous light sources share a common drawback, namely that flash can deliver a much brighter light (albeit for a much shorter duration) than the majority of continuous lights, so shutter speeds can be brief. This means the photographer has more exposure options open to him with flash—not only split-second shutter speeds to freeze movement, but also using smaller apertures for increased depth of field and lower ISO settings for quality.

At the same time, though, continuous lighting has one major advantage: what you see is what you get. This arguably makes it much easier to light a shot with continuous lights than with flash. You don't have to worry about the power output of your individual lamps, or try and gauge where the light is falling: continuous lights show you the precise effect your lamps are having, making the entire process of setting up and working with them far more immediate.

Incandescent

Once the photographer's only option, incandescent lighting's biggest failing is the technology itself. To generate light, a tungsten filament needs to be heated, and this process can easily transform a small studio into an oppressive sweat-box for the photographer, model, and associated team to work in. In addition, tungsten lights burn at a warm color temperature—3,300K (degrees Kelvin) as opposed to the nominal 5,500K of daylight—so mixing the two light sources means using gels or filters over tungsten lights, not only reducing the effective output of the lamp, but also increasing the risk of light overheating and acetate gels melting, or even igniting. Yet despite these drawbacks, incandescent photographic lights are still available and their low purchase price (and low running/repair costs) has a definite appeal. However, tungsten lighting is no longer the only option available to photographers.

TOP RIGHT In a museum that wouldn't allow flash photography, an HMI lamp was used by Estúdio Nagô to create this evocative "film noir" style image (see pages 132–133).

RIGHT Most studio strobes use a tungsten modeling lamp, but this can also be used as a light source in its own right, as in this atmospheric shot from Alexandre Godinho (see pages 68–69).

OPPOSITE Incandescent, HMI, and fluorescent are the three continuous light source options for fashion photographers, although none can quite match the versatility of strobe lighting.

HMI

Although flash dominated all genres of photography when digital imaging started to emerge, many of the then high-resolution medium- and large-format camera backs designed for professional use relied on scanning technology, rather than the split-second exposures of film. This meant that flash was simply incompatible with high-end digital backs that needed a second or more to scan the image, and photographers looking to immerse themselves in electronic imaging once again had to turn to continuous lighting.

The answer lay in the world of television and movies—both wholly reliant on continuous lights—which had turned away from incandescent lamps in favor of HMI (Hydrargyrum Medium-Arc Iodide) lights. Unlike tungsten-based lamps, HMIs are cool running, so uncomfortably warm studios and sets are a thing of the past, and they also have a daylight color temperature, allowing them to mix with daylight with little or no filtration. For many digital pioneers this proved to be a near-perfect solution, although the high cost of HMI lighting meant renting, rather than buying the lights made the most sense from a financial standpoint.

Fluorescent

Although fluorescent lighting isn't a revolutionary light source in its own right, it has long been discounted for photography due to its wildly varying color temperatures. With film photography, it simply wasn't practical for color-accurate work, even when the fluorescent light and/or the camera was filtered, but with the white balance systems built into digital cameras, a number of manufacturers realized that it had potential as a photographic tool. As a result, there is now a growing range of fluorescent lighting designed specifically for photography, with daylight-balanced tubes and bulbs that run at a cool temperature and come at a much lower cost than HMIs. However, be wary of the ultra low-cost kits designed for enthusiasts—it's unlikely they will have many (if indeed any) lighting accessories beyond a stand and a basic reflector dish, and the "daylight" color temperature can often be significantly different to true daylight.

PROS / CONS

Incandescent

PROS	CONS
+ Low purchase price and running/repair costs	- Generate a lot of heat
+ Some models offer a variable beam pattern, from "flood" to "spot"	- Lamps can overheat and even explode
+ Specialist dimmer units available to control the power of multiple lights	- Need to be filtered to mix with daylight
	- Heat-resistant accessories more expensive than their flash counterparts
	- Fewer photographic accessories available compared to flash

Fluorescent

PROS	CONS
+ Cool running	- Low-cost "enthusiast" kits not always daylight balanced
+ Pro lighting is daylight balanced	- Very few lighting modifiers available
+ Unique striplight designs available	- Color temperature can gradually shift over the life of the lamp
+ Lights for the "enthusiast" market available at a very low cost	

HMI

PROS	CONS
+ Cool running	- Very expensive—renting often more cost effective than buying
+ High power lamps available	- Require a bulky ballast pack to operate
+ Daylight balanced	- Takes time to warm up to daylight color temperature
+ Flicker-free	- Color temperature liable to change over the life of the bulb
	- Minimal accessory range for stills photography

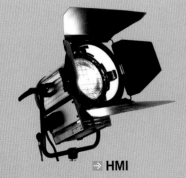

➡ HMI

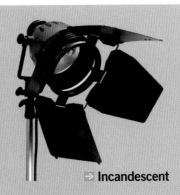

➡ Incandescent

➡ Fluorescent

Location Lighting

Shooting on location brings its own set of challenges, the foremost of which is powering your lights. If you're visiting a "powerless" location it's unlikely you will have electricity on tap. Lugging a generator along with you is one solution, however, battery power is a far more realistic way of getting your strobes working.

Battery power

Most flash manufacturers produce location lighting systems, with a battery-powered pack allowing you to plug your strobes in just as you would in the studio. Some will only operate as a portable solution, while others will allow you to plug them into a power outlet as well, so you can use mains electricity when and where it's available, and battery power when it's not. However, as versatile and useful as battery packs are, they can only supply a finite amount of power and once a battery has been drained (or falls below a certain charge level) your flashes will simply stop working. Even before this happens the recycling time of your strobe(s) is likely to become significantly longer as the charge is depleted, so always take at least two fully-charged batteries for every pack you intend to use. You may not need them, but it's better to have too many than find yourself stuck in the middle of nowhere explaining to your model and stylist—and perhaps even your client—why the shoot has to be abandoned.

Hotshoe flashes

Using battery-powered flashes on location doesn't just mean employing studio-style units attached to heavy (and often expensive) power packs: regular hotshoe flashes can also be used. The relatively high power of some of these portable flash units, combined with an increasing array of lighting accessories enables them to provide an array of lighting effects, from general illumination with a single flash, through to complex multi-light setups.

You don't need to use the latest fully automated flashes: a simple, yet powerful, manual flash with control over its power is perfect for lighting on location. The key to making the best use of your flash is to get it off camera, controlling it wirelessly (if the flash and your camera allow you to), connecting it with a sync cord, or using a radio-slave. This immediately gives you the freedom to position your small strobe where you want it, and with several flashes in your bag it's easy—and relatively cheap—to create a very portable and very versatile location lighting system.

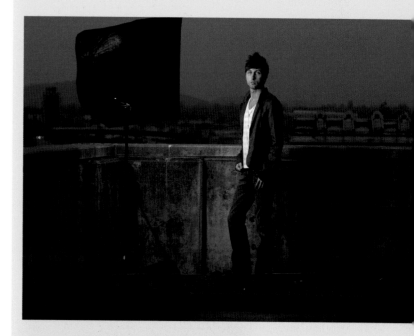

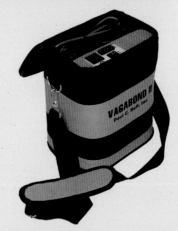

ABOVE A battery-powered pack will let you take your lights to locations that don't have a regular power supply. Most manufacturers produce dedicated pack-and-head style location lighting systems.

LEFT Taking studio-style strobes on location isn't the only answer—don't ignore hotshoe-mounted flashes as a possible solution. A single Nikon Speedlight used off camera helped Andrew Smith create this striking picture (see pages 96–97).

LEFT Battery packs for monolights aren't widely available, but the Vagabond from Paul C. Buff is one option.

RIGHT The setting sun and a reflector were the only lighting ingredients needed by Jens Ingvarsson (see pages 112–113).

BELOW Setting his strobes to dominate the daylight, Jaysen Turner effectively turned day into night to help create a narrative in this fashion shot (see pages 98–99).

Ambient light

Everything so far assumes that you want to light your shots artificially, but this isn't always the case and it certainly isn't necessary. The most obvious method of lighting an outdoor shot (and even some indoor ones) is to use the light that's already there—i.e. daylight. The main benefit is you don't have to remember to take it with you and you don't have to pay a penny for it. What's more, it's easy to see the precise effect the light is having before you make your exposure.

Ambient light isn't a perfect solution though. For a start, you don't have any control over it, so you can easily find yourself shooting under a heavy layer of cloud at the start of the day, only to have this replaced by strong, direct sunlight at noon. However, while you can't control the light, you can modify it. Portable diffusion screens can be used to soften the ambient light, and reflectors are a powerful accessory for location shots, useful for filling in shadows as well as acting as flags to selectively shade a certain area. Some photographers are so skilled in their use of reflectors that they can create a virtual outdoor studio, producing incredibly sophisticated lighting effects using nothing more than sunlight and carefully placed reflectors that act in a similar way to fill lights.

Mixing flash and daylight

Although you can use strobes on location, the biggest creative challenge is how you mix them with the ambient light. Indoors, the answer might be to simply use the location as you would a studio, with your flashes acting as the main light source, but when you move outside, the daylight will almost certainly need to be considered. During the day, it's likely that the ambient light levels will be quite bright so you need to decide whether you want the flash to dominate the scene, overpowering the daylight to create an image that is clearly lit artificially, or whether you want the flash to provide a more natural fill?

Regardless of the creative choice you make, the same rule applies: as long as the shutter speed is below your camera's maximum flash sync speed (around 1/200 sec on most DSLRs), your aperture setting will control the balance. For example, say you're using a single flash outdoors and the exposure reading for the ambient light is 1/30 sec at $f/8$. If you set your flash so it's also giving you a reading of $f/8$ on the subject, the flash will balance perfectly with the ambient light.

However, if you increase the power of the flash so it requires an aperture of $f/16$ (and you set this aperture on your camera), the exposure for the flash will be correct with a shutter speed of 1/30 sec, but you will be underexposing the ambient light by two stops. The result will be a perfectly exposed flash-lit subject against a dark background.

Conversely, if you decrease the flash power to give an aperture of $f/4$, a shutter speed of 1/30 sec would still give a well-exposed result for the flash, but the ambient light would now be overexposed by two stops. As a result, your model would now be set against a bleached out background.

Lighting Glossary

While you can use a continuous lamp or a strobe on its own, to control the light it is producing you need to employ lighting modifiers. From softboxes that diffuse the light, through to spot attachments that create a hard, well-defined light-pool there are numerous accessories available to help you achieve your vision and knowing what effect these modifiers have plays a vital part in creative lighting. Many photographers will spend a considerable amount of time experimenting with various combinations to produce their idiosyncratic images, so the following glossary provides a rundown of the most commonly used lighting accessories in fashion photography. The vast majority of these will feature in the following chapters, where the theory of photographic lighting is shown in practice.

Barndoors

More closely associated with continuous lighting than strobes, barndoors consist of four adjustable flaps ("doors") that can be used to regulate where the light falls. This allows you to restrict the light to a specific part of the subject or scene, or to prevent it spilling onto the camera's lens and causing flare.

Beauty dish

A beauty dish is a type of reflector dish specifically designed to create a soft light. The design of the reflector means that the light hits a flat, circular plate directly in front of the lamp, which bounces it back into the wide, shallow reflector bowl, and then out toward the subject. As the light is bounced twice before it reaches the subject (first from the reflective plate, and then from the reflector dish), it is diffused far more than using a standard reflector dish, creating a much softer light. Both white and silver beauty dishes are available, with a white reflector bowl creating a softer light.

Boom arm

If you want to have a lamp above your subject, without the light stand appearing in shot, then a boom arm is the answer. This simple pole attaches to the top of a sturdy stand, allowing the light to be positioned directly over a subject without encroaching into the shot.

Diffuser

A diffuser is a catch-all term used to describe any device that softens—or diffuses—the light. This could be a modifier attached to the lamp itself, such as a softbox or beauty dish, or it could be a semi-translucent sheet of fabric or a similar material that is positioned between the light source and the subject. The latter option is particularly useful if you're shooting outdoors on a sunny day as the diffusion material will soften the harsh, direct sunlight and lighten the otherwise dark shadows.

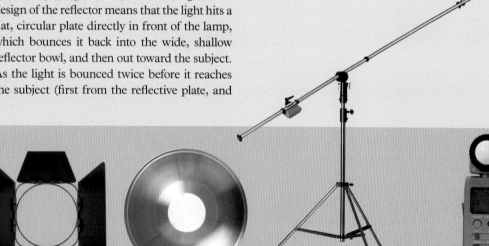

⇨ **Barndoors** ⇨ **Beauty dish** ⇨ **Boom arm** ⇨ **Flashmeter** ⇨ **Fresnel**

Fill light

A secondary light in a lighting setup, typically used in addition to the key light to fill in shadows.

Flag

While barndoors are often used with continuous light sources, flags are commonly used with strobes. A flag can be anything from a small piece of card through to a large board and its job is simple: it is positioned in front of a light to prevent it from falling on a certain part of the set. Flags are often used to shield the camera's lens from direct light that could cause flare, or to prevent a light aimed at the subject from spilling onto a background.

Flashmeter

A flashmeter is an essential tool for photographers using strobes, allowing you to take exposure readings from short-duration flashes. Look for a flashmeter that allows you to take incidental light readings, as well as reflected readings, so you can measure the light falling onto the subject for the most accurate measurement.

Fresnel/Spot

A fresnel or spot—whether it's a lamp in its own right, or a modifier that you attach to a light—produces a very small, controllable beam of light, making it ideal for picking out a detail or motif on an item of clothing or an accessory. Fresnels or spots often have a slot that allows them to be fitted with a gobo, allowing a sharply focused pattern to be projected onto the subject or background.

Gel

A gel (also sometimes known as an "acetate") is a colored, translucent material, usually made of plastic, that's positioned over the front of a lamp to change its color. This can be used for creative effect—to produce a red or green light, for example—or to change the color temperature of the light, converting a tungsten lamp to a daylight color temperature.

Gobo

Despite the apparent misspelling, gobo is an abbreviation of "go between." It most commonly refers to a sheet of card or board that has had a pattern cut out of it and is positioned between the light and the subject—hence "go between." Because of the cut-out pattern, the gobo creates distinct shadows, a classic example being the shadow of a window-frame cast onto a background to suggest light coming through a window that's out of shot (even if the studio is windowless). Metal gobos are also used in spotlights, where the light can be focused to create a hard edge to the shadows.

Grid

A grid is a disc made up of a honeycomb-like structure that fits onto the front of a reflector dish to channel the light and minimize its spread. The deeper or more densely packed the honeycomb, the greater the channeling effect, which helps concentrate the light on a specific part of the image.

Key light

The primary light in a lighting setup, the key light is typically brighter than the rest and provides the main illumination for the subject.

Light stand

Often overlooked, light stands come in a wide range of sizes and for greater flexibility it's good to have several different types. A floor stand that can support a light at ground level is ideal if you want to create a graduated effect on a plain backdrop in the studio—simply attach your light and aim it upward at the backdrop. Likewise, a heavyweight stand that will allow you to position a light over ten feet (3m) off the ground will also allow you to explore more creative options.

Octabox

A variation of the traditional softbox, an octabox—as its name suggests—has eight sides instead of four. Although this makes very little difference to the diffusion of the light, it has a very significant effect on the model. Instead of square or rectangular catchlights in the subject's eyes it creates a rounder, more natural-looking catchlight.

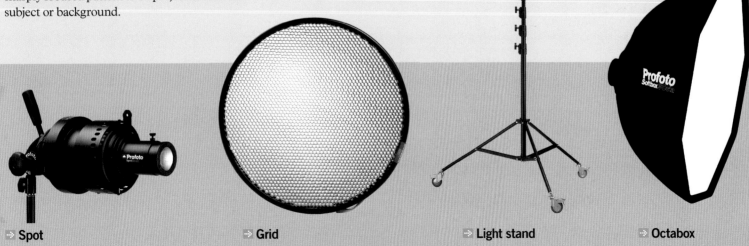

⇨ **Spot** ⇨ **Grid** ⇨ **Light stand** ⇨ **Octabox**

Radio slave

A radio slave is used to trigger a flash wirelessly, even if it isn't in direct view of the camera. A transmitter is fitted to the camera (usually in the hotshoe) and a receiver attached to the flash. When the camera fires, the transmitter sends a signal that triggers the flash. Multiple receivers can be used to fire multiple strobes at the same time, and an increasing number of studio strobes and packs now have radio slaves built in.

Reflector

A reflector is anything that is used to reflect light onto the subject, usually to lighten the shadows created by a direct light. The most common reflectors used are: white, which provides a soft light; silver, which creates a slightly harder reflection; and gold, which has a warming effect. However, any colored material will reflect light, while mirrors can also be used if you want the reflected light to be hard and crisp.

Reflector dish

Reflector dishes come in a wide range of sizes, and each has its own unique characteristics. At its most basic, a reflector dish operates as little more than a "spill-kill," preventing stray light from spilling out of the side of a lamp and potentially causing lens flare. Deeper and narrower dishes are designed to concentrate the light a little more (often in combination with a grid), while shallower and wider dishes allow the light to flood a scene.

Slave cell

A slave cell is an optical device used to trigger a flash without connecting it to a camera. The slave is plugged into a strobe and fires the flash the moment it detects another flash firing. In this way, multiple strobes can be fired at the same time, just so long as one is attached to the camera and the rest are fitted with slaves. Most studio strobes have built-in slave cells, with an increasing number now being equipped with radio slaves.

Snoot

This conical attachment restricts the spread of light from a strobe to create a distinctly narrow light-pool that's ideal for lighting a small area in a shot.

Softbox

A staple in studio photography, a softbox allows a light to be aimed directly at the subject (to maximize the output), while simultaneously spreading it over a wide area and through a diffuser to soften it. Softboxes are available in a wide range of sizes and the larger and deeper the softbox, the softer the light. In addition to the diffuser on the front of the softbox, removable internal diffusers ("baffles") provide another level of light softening, as does the choice between a white interior (softer) and a silver one (harder).

Striplight

A long, thin light that is available as a dedicated strobe, a fluorescent lamp similar to a domestic striplight, or as a softbox variant. The light can be used vertically to create a very narrow, but tall, light pattern, or horizontally above or below a model to create an equally narrow "wall" of light.

Umbrella

There are two types of umbrella: those that reflect light, and those that allow a light to be fired through them. Like a reflector, a reflective umbrella bounces light onto the subject, diffusing it as it does so. White umbrellas produce the softest light, silver umbrellas a harder, more powerful light, and gold umbrellas deliver subtle warmth to an image. Shoot-through umbrellas are used over a light that is aimed directly at the subject, with the semi-translucent material used in their construction diffusing the light in a similar fashion to a (crude) softbox.

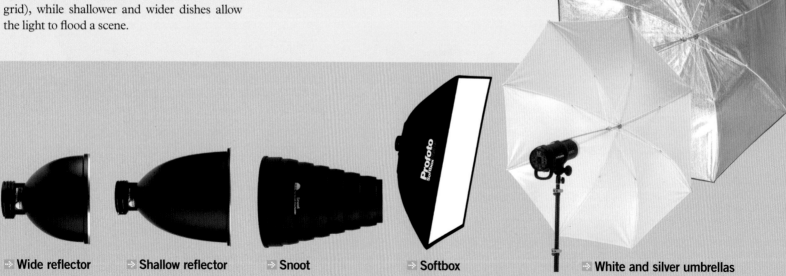

⟹ Wide reflector ⟹ Shallow reflector ⟹ Snoot ⟹ Softbox ⟹ White and silver umbrellas

How to use this book

In the following chapters of this book we're going to take a look at a collection of stunning fashion images, and get a behind-the-scenes insight into how and why they were created. To help you visualize how each shot was lit, they are all accompanied by a pair of 3D illustrations—both an overhead "plan" view and a perspective view—that give you an idea of the lighting used and its position. In addition, you'll find useful tips on creating a similar look for yourself, whether it's through the use of lighting, digital retouching, or simply a way of imbuing a photograph with a specific look or "feel."

It's worth noting that while the power, make, and even model of the lights used is often listed, this shouldn't be considered the only lighting that can be used. In most cases, a lower- or higher- powered lamp would create a very similar result, and a strobe could quite easily be replaced with a continuous light source, or vice versa. More importantly, these lighting setups should in no way be considered as a definitive collection of "blueprints" for successful fashion shots—such a thing just doesn't exist. Sure, you can try recreating a similar effect yourself, but also think about how you could take it a step further by adding your own creative twist.

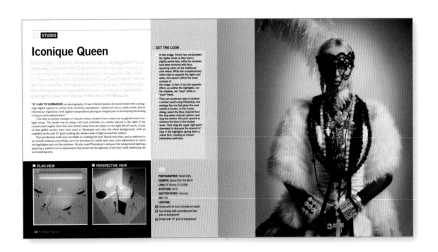

KEY TO 3D ILLUSTRATIONS

In the following chapters images are accompanied by 3D illustrations to support the lighting setups used. Below is a collection of visual icons that appear in the 3D illustrations for easy reference and understanding.

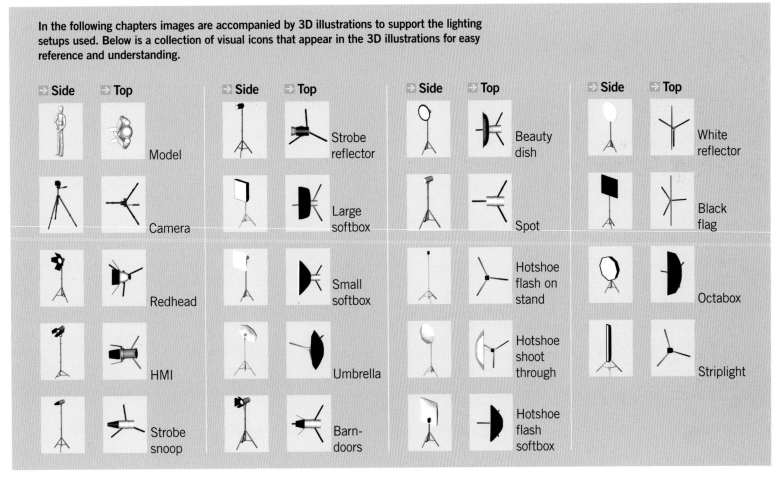

⇨ Side	⇨ Top		⇨ Side	⇨ Top		⇨ Side	⇨ Top		⇨ Side	⇨ Top	
		Model			Strobe reflector			Beauty dish			White reflector
		Camera			Large softbox			Spot			Black flag
		Redhead			Small softbox			Hotshoe flash on stand			Octabox
		HMI			Umbrella			Hotshoe shoot through			Striplight
		Strobe snoop			Barn-doors			Hotshoe flash softbox			

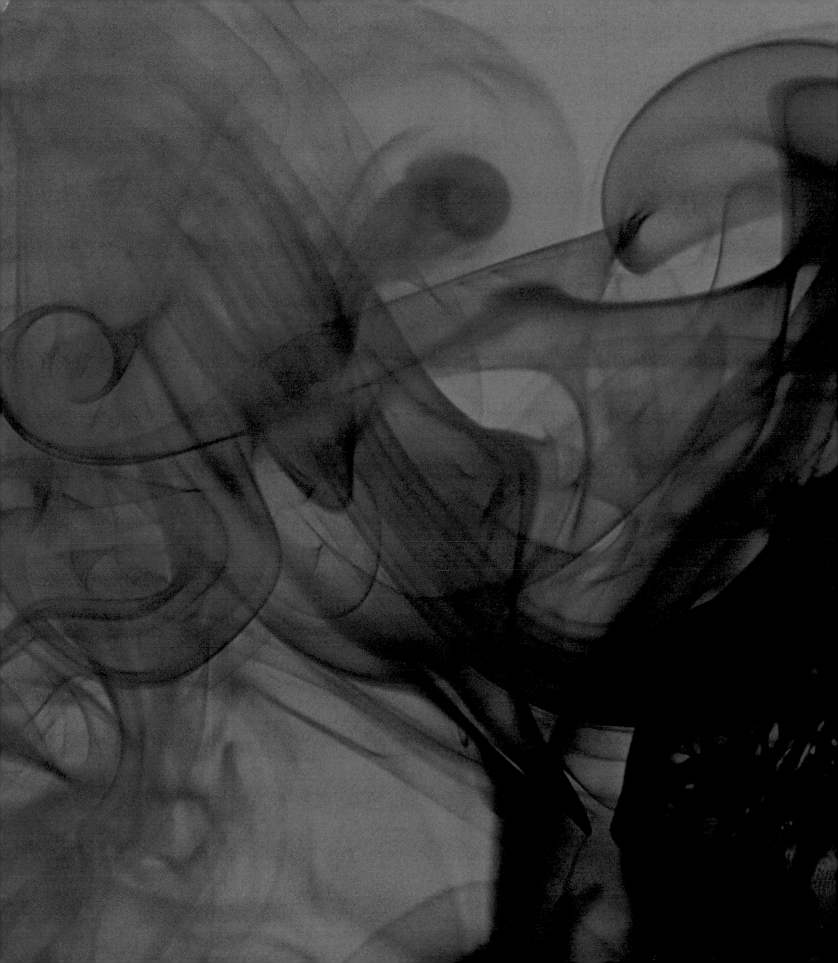

Studio

Take a look at any contemporary fashion magazine, or the images that follow in this chapter, and you will see clearly just how varied studio-based fashion photography is. With the possible exception of catalog shots, there is often less of a need—or desire—to present dry, static images that simply show little more than how an item looks, with far greater emphasis placed on creating a very specific look.

This is something that the studio is better equipped for than location-based shooting, as the starting point is a (literal) blank canvas. Within this space, anything is possible: it is the theater in which the shoot takes place and in which worlds can be created. You can choose to set your model against the stark minimalism of a pure white backdrop or an elaborately constructed set that's almost cinematic in scale, with infinite options in between.

Lighting techniques are equally unrestricted, with the once obligatory, all-revealing lighting now joined by setups that are unafraid to throw heavy, detail-concealing shadows across an outfit, or use colored light to alter its appearance and add tension to a shot. Only in the studio do you have absolute control over precisely what appears—and where—in the shot, and as you'll see in the following images, there is certainly nothing "ordinary" about shooting fashion in the studio.

Anime Umbrella Portrait

Not many photographers could label themselves as "fashion and astronomy" specialists, but Ethan T. Allen is exactly that, featuring in magazines such as French *Vogue*, *GQ*, and *Rolling Stone*, while simultaneously winning awards for his images of deep space. This is in addition to his role as creative director of Raspberry Media, the award-winning web design business he co-founded.

THE SHOT FEATURED HERE is the second from Ethan's *Smoke* series, an ongoing project that the photographer describes as "documenting myth and global cultural archetypes, while creating fashion from natural forms."

"This particular shot was a collaboration between myself and Stefan Daniel Bell, a fashion designer, which was inspired by popular Japanese cartoons—hence the title. The idea to integrate the smoke was there from the outset because we wanted to create an ethereal image that strongly referenced the anime genre. With the smoke images sourced before the shoot, the choice of materials and studio setup could both be tailored to give the most natural match. To help us achieve the right look, Stefan created the couture lace 'armor' from sheer fabrics, including a layered gown designed to merge with the smoke. Strong backlighting was chosen as the most suitable option in the studio and even the pose was predetermined to a certain extent. Once the studio session was over, I composited the model with the smoke images selected in pre-production, using Photoshop's layer masks to blend the smoke seamlessly with the couture."

⇨ GET THE LOOK

- Ethan's shot shows how meticulous pre-planning plays an important part in creating a naturalistic image from multiple photographs—in this case the combination of a staged studio shot and two pictures of smoke. By selecting the smoke before the shoot took place, Ethan could light and pose the model in a way that would help at the editing stage when everything was brought into Photoshop.

- To assemble the image, Ethan kept each of the three elements on its own layer so he could manipulate them all independently, but the key to the seamless blending lies in Photoshop's layer masks. Every layer you create in Photoshop has a layer mask attached to it, which allows you to selectively cover (or reveal, depending on what you are looking to achieve) parts of the image on the layer. This offers much greater flexibility than simply erasing sections of the layer as you can keep going back to the mask to fine-tune it, using brushes with low opacity settings and adding gradients to control transition areas.

■ PLAN VIEW

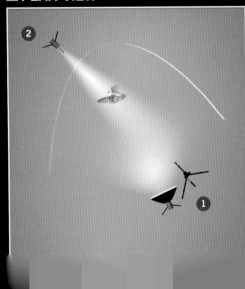

■ PERSPECTIVE VIEW

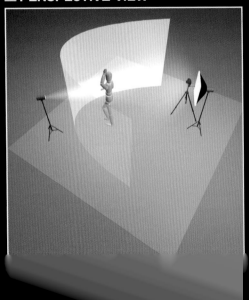

📷

PHOTOGRAPHER: Ethan T. Allen

CAMERA: Canon EOS 5D Mk II

LENS: EF 24–105mm *f*/4L IS USM @ 60mm focal length

APERTURE: *f*/5

SHUTTER SPEED: 1/64 sec

ISO: 200

LIGHTING:

1 Broncolor Mobil 1600W strobe with softbox

2 Broncolor Mobil 1600W strobe through cargo parachute

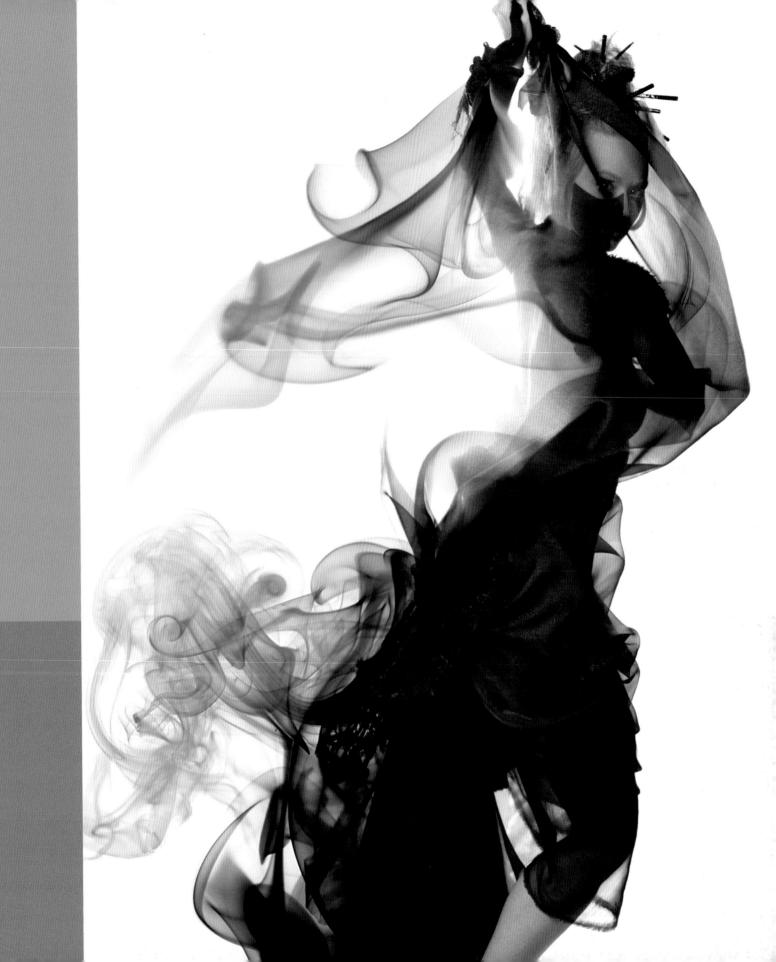

Julia and Marina

With his own model management agency, New York-based Jens Ingvarsson is in the fairly unique position of being "forced" to head to his studio on a fairly regular basis for TFP (Time For Portfolio) test shoots. In a TFP shoot, neither the model nor the photographer is paid for their time; instead, both work for free with the aim of getting shots for their mutual portfolios.

"THIS PHOTO WAS SHOT in my studio as a TFP test shoot that we did for fun more than anything, with my wife, Marina, and Julia modeling for me. The lighting setup was pretty simple—I used a beauty dish above and to the left of the model as a key light, and a medium-sized softbox on the same side, but a little further back, as a fill. This gave me the look I was after, with the soft shadows creating a bit of definition as they fell on the seamless white backdrop."

However, to get the poses he was after, Jens had to be creative when it came to shooting. Getting one of the girls in the right pose would be fairly straightforward (with enough shots), but getting both to strike the perfect pose simultaneously, while also shooting at that precise moment was unlikely to happen with all of the movement involved. To overcome this, Jens photographed the models individually, so he had a wide range of potential poses to choose from, and then combined the best two in Photoshop.

GET THE LOOK

The great thing about Jens's shot is the sense of "action." Although he photographed the models separately, their poses aren't static—the foot of the model kicking out and the hair of her "victim" both contain a small amount of motion blur that enhances the picture's spontaneous feel. Of course, this meant Jens had to get the models moving and trigger the shutter at the right moment, which isn't as easy as it sounds when you're using strobes: whether it's a studio pack or a hotshoe-mounted unit, all flashes need to recharge before they fire again and this recycling time can mean you miss a shot. To keep this time to a minimum, the answer is to decrease the flash's power—less power requires a smaller charge, which means a shorter recycling time. Obviously, this will affect your exposure, so be prepared to increase the ISO or use a wider aperture setting to compensate.

PLAN VIEW

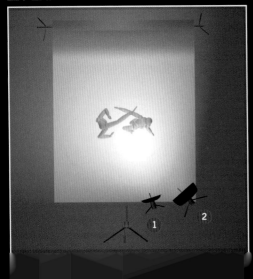

PERSPECTIVE VIEW

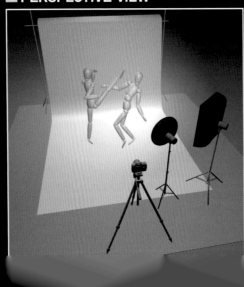

PHOTOGRAPHER: Jens Ingvarsson

CAMERA: Canon EOS 5D Mk II

LENS: Canon EF 24–70mm f/2.8L USM @ 70mm focal length

APERTURE: f/8

SHUTTER SPEED: 1/250 sec

ISO: 200

LIGHTING:

1 1600w strobe with beauty dish

2 1600w strobe with softbox

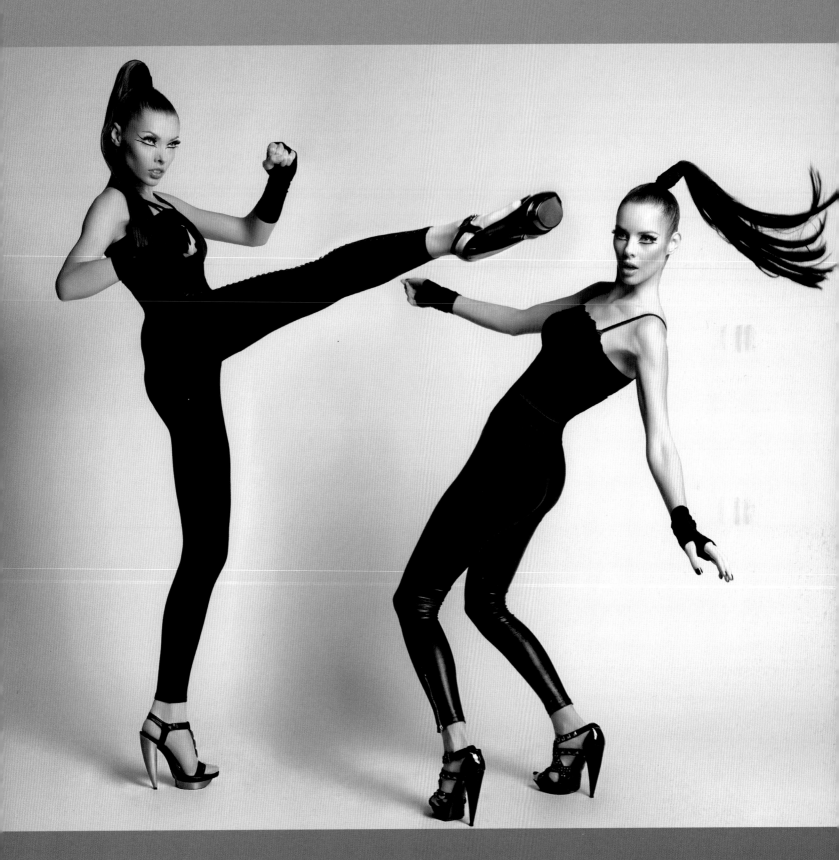

Contrast Dreams

Working under the company name of Bandits Graphiks, photographer and digital retoucher Marcelo Nunes has maintained a longstanding partnership with Brazilian fashion house, Madame Shanitz, shooting a wide range of their promotional material.

"I HAD BEEN COMMISSIONED to shoot a new catalog for a seasonal collection entitled *Contrast Dreams*. I knew immediately that contrast was going to play a very important part in the shoot, and for this particular shot the idea was to play with the contrast of the model's dark skin and the white fabric."

Rather than produce an overtly high-contrast result that would perhaps be more expected from the choice of a dark-skinned model in a pure white outfit, Marcelo has taken the shot in the opposite direction, using a subtlety of touch with the lighting and exposure to create a picture that doesn't immediately scream "high contrast."

Shooting in the studio gave him total control over all aspects of the shoot and the starting point was his choice of lighting—a single overhead strobe fitted with a softbox. This was augmented by a large white reflector positioned to the right of the camera and close to the front of the model. By positioning the reflector in such close proximity, and reflecting already-diffuse light, the reflector acts as an ultra-soft light source in its own right. Combined with an exposure that is deliberately darker than it could have been, the highlights in the outfit haven't blown out, and Marcelo has very successfully created an intriguing low-key look.

→ **GET THE LOOK**

■ Traditional low-key lighting relies on a single light source so that much of the image is shrouded in darkness, offset by brilliant-white highlights often created by a hard and direct backlight or sidelight. However, as Marcelo has shown here, low key doesn't necessarily mean you have to shoot a stark picture in the classic high-contrast, *film noir* style. The use of a softbox just above the model ensures that the light it produces falls off quickly, illuminating the face, but little else. Instead, it is left to the large white reflector to fill in the detail, again using it close to the model so the light falls off quickly. By choosing to use two very soft lighting tools, but in a way that ensures they produce as much contrast in the image as they can, the result is a contradictory blend of "soft" and "hard."

■ **PLAN VIEW**

■ **PERSPECTIVE VIEW**

📷

PHOTOGRAPHER: Marcelo Nunes
CAMERA: Sony DSC-R1
LENS: Carl Zeiss 24–120mm (equivalent) ƒ/2.4–4.8 T* @ 63mm focal length
APERTURE: ƒ/16
SHUTTER SPEED: 1/320 sec
ISO: 160
LIGHTING:
➊ Strobe with softbox
➋ White reflector

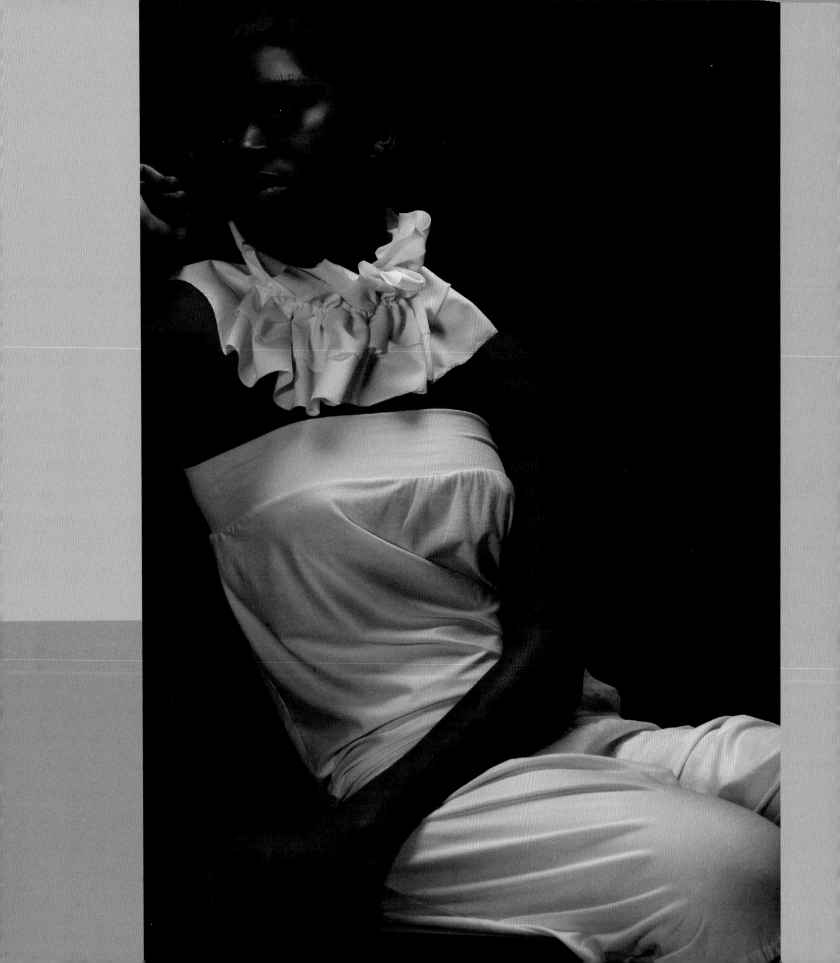

Stock

Stock photography might not immediately spring to mind as an obvious outlet for fashion photography, let alone truly creative fashion shots, but that's precisely where photographer and iStockphoto inspector, Alexey Ivanov, makes his living.

WITH ALMOST 20,000 DOWNLOADS from his image portfolio in the past three years, and individual images selling hundreds of times over, it's easy to see why this Russian pro likes to play the stock market. Many of Alexey's fashion shots exhibit a similar style to the picture shown here, typified by a dark background and seemingly hard-edged lighting. Although the lighting setups vary from shot to shot, many are based on the same fundamental technique: silver reflectors and bounced light.

"This studio setup comprises two light sources and a silver reflector. The first light is a silver beauty dish close to the left of the camera, aimed directly at the subject. Although the beauty dish provides a diffuse light, the silver reflector maximizes the strobe and putting it close to the model prevents it looking too soft, like it would with a softbox. The second light is a strobe with barndoors, positioned in front and to the right of the model. Using the barndoors, I can shield the camera and model from the light and aim it into a silver reflector, which then becomes the light source. The barndoors also give me control over the light at the bottom of the image so I can have softer shadows against the background and create a soft vignette."

⊡ GET THE LOOK

Using only two modestly-powered monolights to light his model, Alexey's lighting appears contradictory: it's hard-edged, yet it comes from diffused light sources. The reason for this is the proximity of the lights and the reflector to the model. As light travels from its source it is naturally scattered by the atmosphere that it passes through, and the greater the distance it has to travel, the softer it becomes. With only a short distance between the model and the beauty dish, and the reflector on the opposite side, the light isn't traveling very far, so it has little chance to scatter and soften. So, while Alexey's beauty dish and reflector create a naturally diffuse light, their silver color and close positioning prevent the light from becoming too diffuse, hence the striking paradox of "hard yet soft" light in the image.

⊡ PLAN VIEW

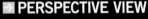

⊡ PERSPECTIVE VIEW

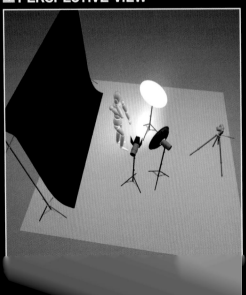

📷

PHOTOGRAPHER: Alexey Ivanov

CAMERA: Canon EOS 5D Mk II

LENS: Canon EF 70–200mm *f*/2.8L USM @ 180mm focal length

APERTURE: *f*/10

SHUTTER SPEED: 1/125 sec

ISO: 100

LIGHTING:

① Bowens Gemini 500ws monolight with silver beauty dish

② Bowens Gemini 500ws monolight with barndoors

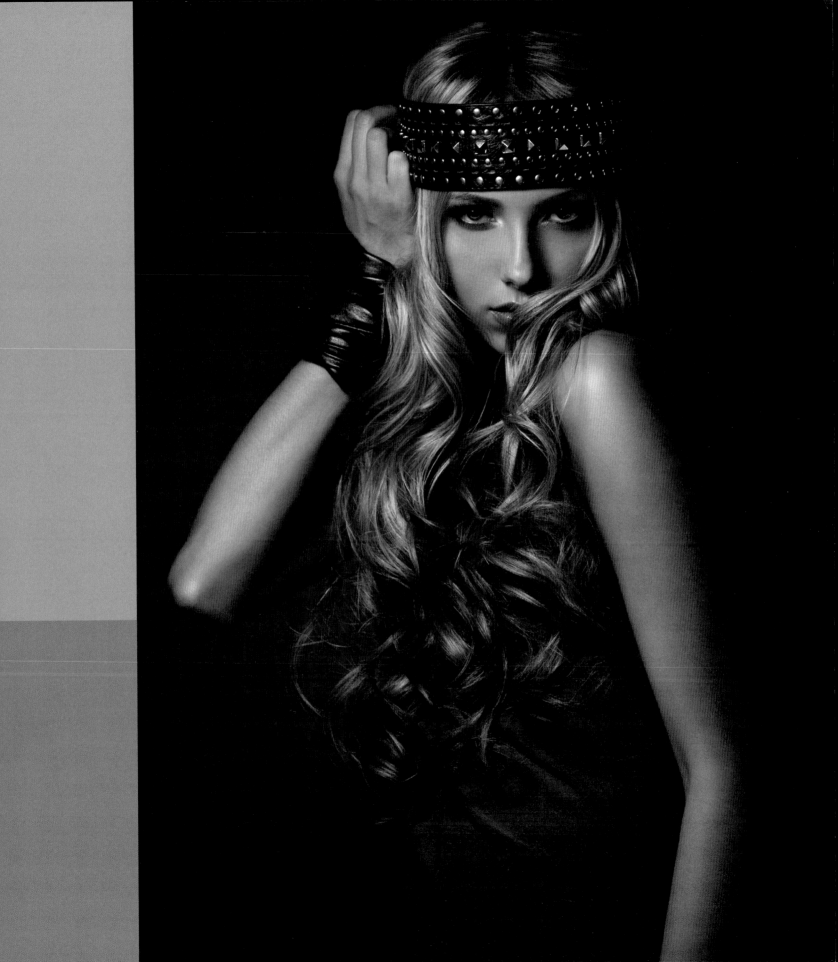

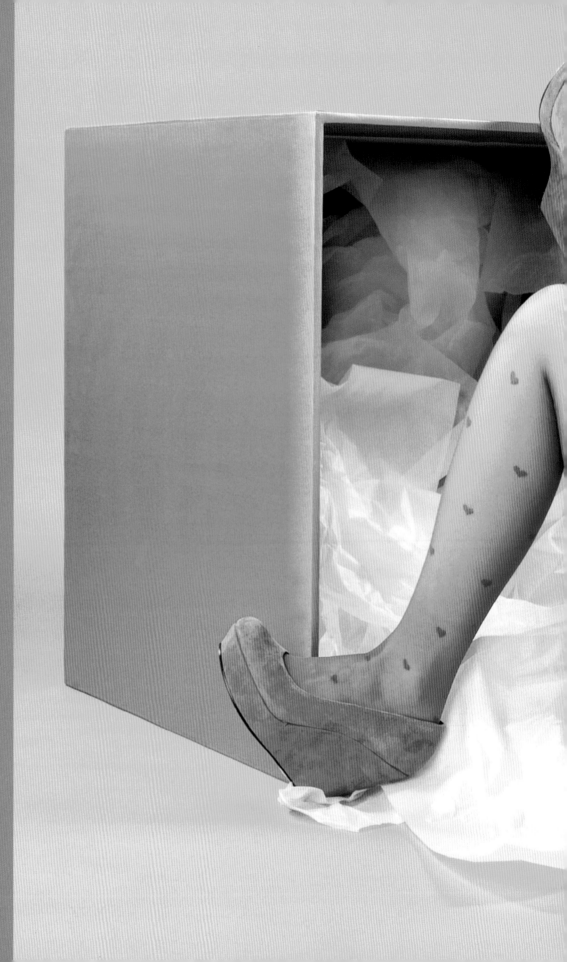

Clare
By Trish Ward (see overleaf)

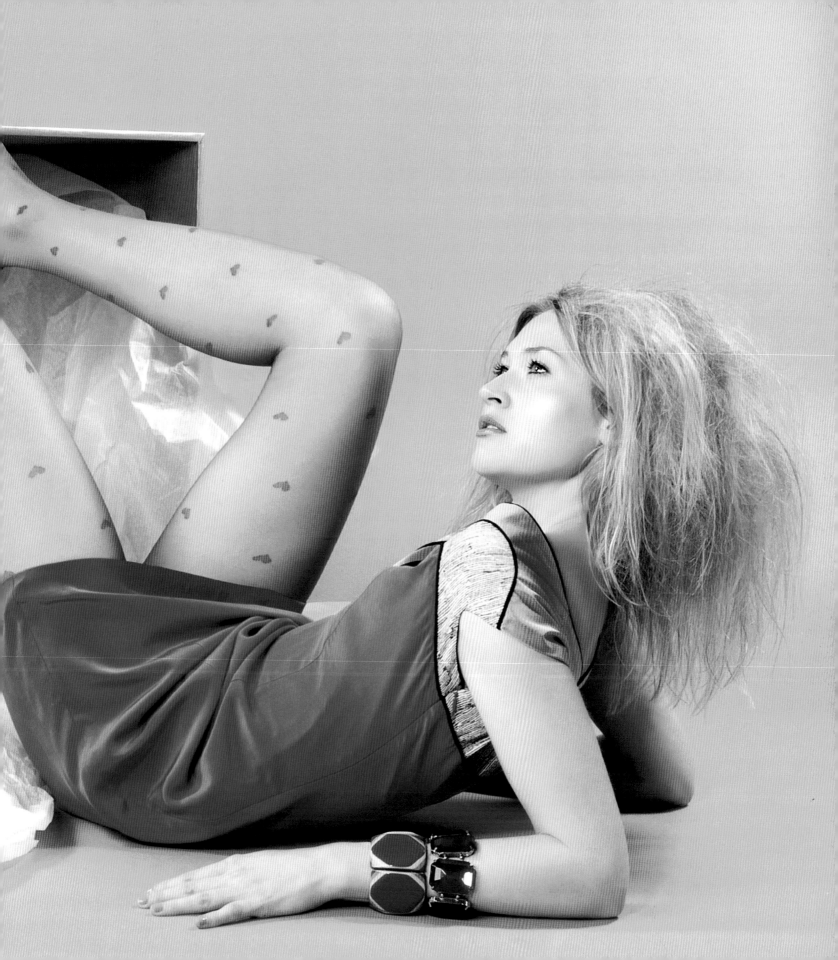

Clare

Young and up-and-coming photographer Trish Ward's portfolio is a striking blend of architecture and fashion images that often rely on a similarly minimal use of color and shape to give them their graphic, designed quality.

"THIS PICTURE WAS TAKEN at the end of a shoot I'd put together to showcase a range of fashion accessories in an imaginative and playful way. In addition to the various shoes and jewelry that we were photographing, the stylist, Esther Cain, had also brought along this amazing dress, so once we'd shot all the accessories, we decided to set up this picture, making it look as though the model had tumbled out of the box."

To light her quirky image, Trish set up four Elinchrom 500ws monolights: two with umbrellas to create the even lighting across the background, and two to light the subject. A softbox at ground level provided her with the overall illumination on the model, while a gridded strobe positioned above and to the left of the camera became the slightly stronger and more directional key light, adding a little more "bite" in terms of contrast.

"My retouching began with the Spot Healing and Patch tools to tidy up any small faults in the picture, and then I applied masks to carry out skin softening on the arms and face. Once these steps were complete, I duplicated the image onto a new layer and gave it a slightly cross-processed look to make the colors more vivid and the gold of the box stand out, reducing the opacity to make the effect more subtle."

■ PLAN VIEW

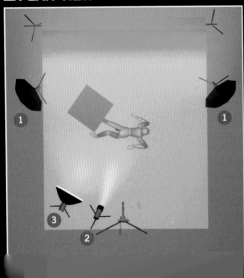

■ PERSPECTIVE VIEW

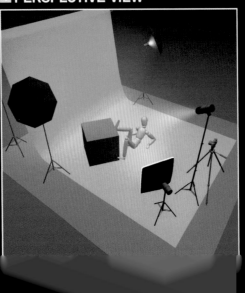

📷

PHOTOGRAPHER: Trish Ward

CAMERA: Canon EOS 40D

LENS: Canon EF 17–40mm *f*/4L USM @ 23mm focal length

APERTURE: *f*/11

SHUTTER SPEED: 1/125 sec

ISO: 100

LIGHTING:

❶ Two 500ws Elinchrom monolights and umbrellas

❷ 500ws Elinchrom monolight with grid

❸ 500ws Elinchrom monolight with softbox

Vivienne Westwood

Since graduating from London's University of Westminster in 1994, Perou's rapid ascent from studio assistant to international photographer has seen his portfolio and reputation grow equally.

AS WELL AS SHOOTING STILLS, Perou has moved into television and video work, appearing in front of the camera as a judge on the television series *Make Me A Supermodel* (US and UK), and behind the camera directing music videos for KT Tunstall and Marilyn Manson. It's counterculture icon, Marilyn Manson, who appears in this shot, one of a series taken as part of a campaign for legendary British fashion designer Vivienne Westwood.

Working in the studio, the idea was to create the impression that the model was floating, or levitating, which obviously required a certain amount of trickery. "Marilyn [Manson] was sitting on a stool, resting his foot on another, while the stylist sat on the floor behind him and supported his weight as he leaned backward. I lit the shot with three flash heads—one directly overhead that was firing through a large softbox to create the shadow on the floor, and two bare strobes with

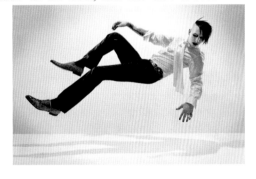

barndoors set at a 45-degree angle behind and to either side [of Manson]. The two sidelights were partially in shot, but that wasn't a problem as they were going to be retouched out afterward, along with the stools and the stylist. That said, the creative director actually considered using a part-edited shot with the stools and one of the lights still in frame. In fact, some shots of Dita Von Teese from the same campaign actually feature her on a stool pulling on a rope, with the lights in the background."

→ GET THE LOOK

- A "levitating" subject is definitely eye catching, and you don't need a huge budget to recreate the effect—all you need are two photographs and an image-editing program, and the process is fairly straightforward. Start by taking two shots: one with your subject posed on a stool, seat, or similar object that raises them off the ground, and a second image taken from the same position, using the same camera settings, but *without* the model and their support—a blank background shot.

- In your image-editing program, copy the shot with the model in it onto the blank background, and simply erase the support from around them. As long as the two images are perfectly aligned, you will reveal the "clean" background as you erase the support, and once it's gone, your subject will appear to be floating in mid-air.

■ PLAN VIEW

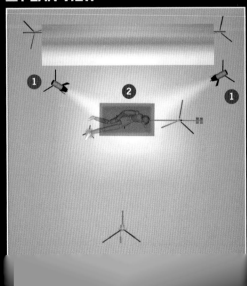

■ PERSPECTIVE VIEW

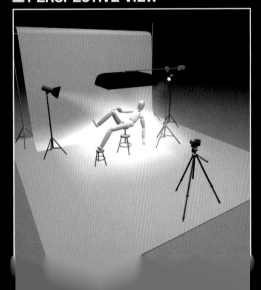

PHOTOGRAPHER: Perou
CAMERA: Mamiya RZ67 Pro
LENS: Mamiya 90mm *f*/3.5
APERTURE: *f*/16
SHUTTER SPEED: 1/400 sec
FILM: Kodak Portra 160VC
LIGHTING:

1 Two Elinchrom 3000 strobes with barndoors

2 One Elinchrom 3000 strobe with softbox

Vivienne Westwood Campaign
By Perou (see previous page)

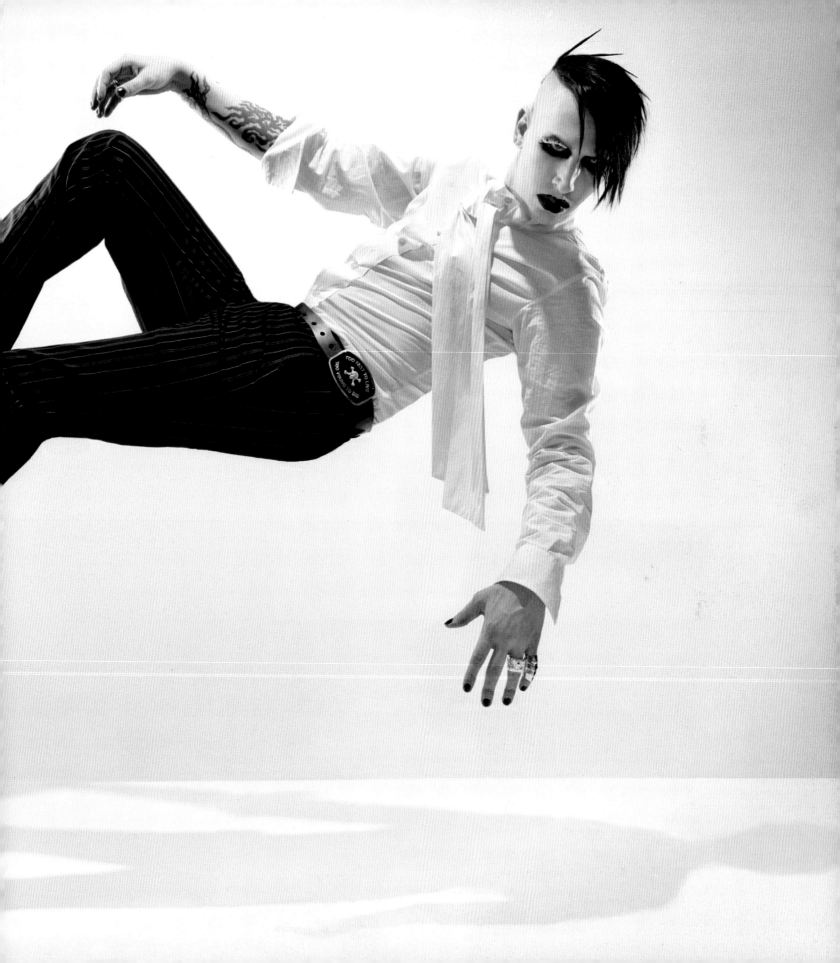

Paper Dress

As Kevin Mason knows only too well, it doesn't matter how much preparation you put in—sometimes things just don't go to plan. But when you're shooting a magazine cover on a tight deadline, you have to get the shot.

"I'D HAD THE DRESS AND SHOES made out of wallpaper, based on the idea of making the model look like a figurine on a cake. The intention was to build an entire room set out of the same bespoke paper, but at the last minute the designer was unable to get us the wallpaper we needed—and when I say last minute, it was an hour before the shoot! So we started pulling in different seamless paper backdrops, and as soon as I saw two together I got the idea to 'cut off' the model's head with different colors. Not only did this keep the original idea of an 'artificial' set, but it also suggests a ribbon around a cake (without laboring the point) and helps separate the model's body and dress.

"The main light was a softbox above the camera and I added a vertical strip softbox with a light orange gel to the left of the camera to light the model's leg. A beauty dish on the same side lifted the face and added definition to her chest, while a third light—this time with a grid and a warming gel—threw some light into the holes of the 'skirt' and warmed the paper a little. A similarly-gelled snoot behind the model acted as a hair light."

→ **GET THE LOOK**

While the footprints on the well-trodden seamless backdrop paper may seem at odds with the carefully-crafted wallpaper dress, Kevin was keen to keep this image as "honest" as possible and it's the conflict between the "pristine" and the "un(re)touched" that creates a certain conflict or tension within the shot. Instead of cropping to conceal the uneven background paper, it has been intentionally included, complete with all the creases and marks, while the staples and blank panels in the dress make it obvious that what we're looking at is hand-made, and not a Photoshopped fake. The post-production retouching has been kept to a minimum also, and while a great deal of attention was paid to the model's face when it came to her makeup for the shoot, her legs retain a natural, porcelain look that prevents the model being transformed into a "mannequin." This again enhances the idea that we're looking at something "real," and not something unattainable unless manipulated.

■ **PLAN VIEW**

■ **PERSPECTIVE VIEW**

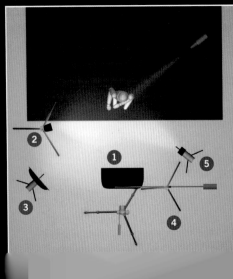

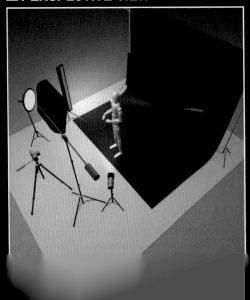

📷

PHOTOGRAPHER: Kevin Mason
CAMERA: Canon EOS 5D Mk II
LENS: Canon EF 24–70mm *f*/2.8L USM @ 35mm focal length
APERTURE: *f*/10
SHUTTER SPEED: 1/125 sec
ISO: 100
LIGHTING:

❶ Strobe with softbox
❷ Strobe with strip softbox and orange gel
❸ Strobe with beauty dish
❹ Strobe with grid and orange gel

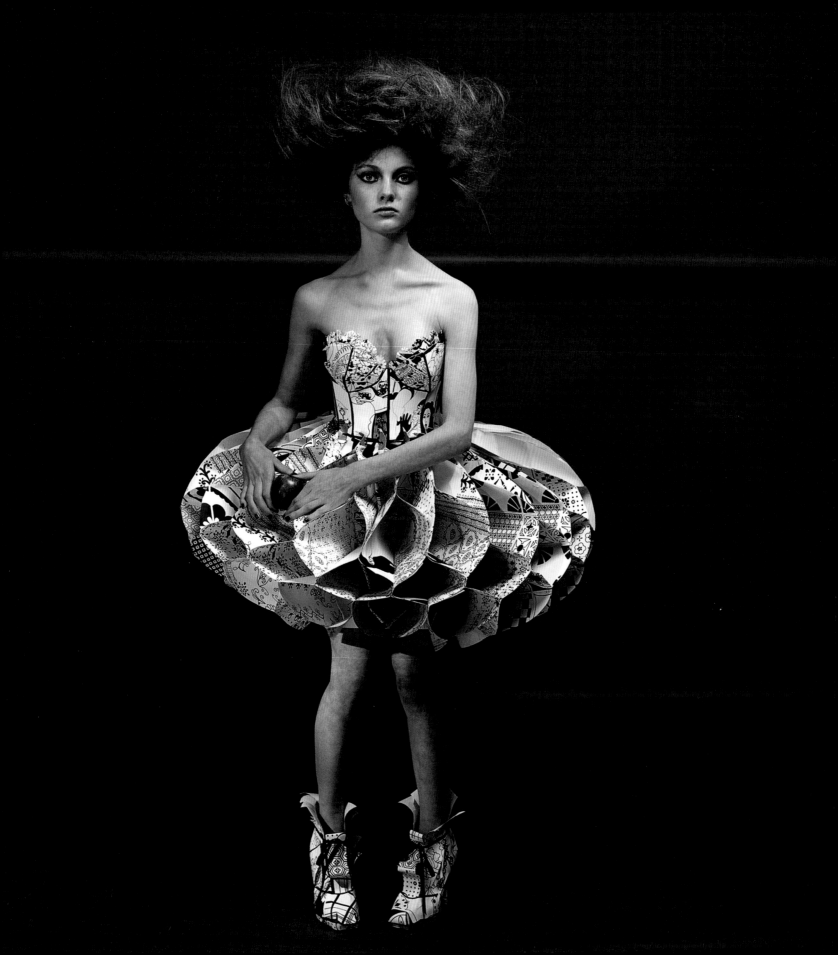

 STUDIO

Blank Magazine

Despite setting out to become an advertising photographer, Simon Pais realized that fashion was his true photographic vocation, leading him to quit his college course and set out on his own. Both magazine and advertising commissions followed, with his work now appearing in a wide range of Latin American publications.

"THIS PICTURE WAS AN ASSIGNMENT for Panamanian magazine *Blank*. They wanted a fashion series based around a sophisticated look, which used color to link the shots. I'm attracted to images that have a certain dark and mysterious element to them, so I looked to explore this through the lighting—combining the magazine's desire for color with my own, darker vision."

With this particular shot, Simon achieved his goal with a two-light setup. A 1000ws Hensel monolight with a standard reflector was used as the main light, positioned to the left of the camera and set to 7/10 power to give the photographer the exposure he was looking for. Mounting the strobe on a low-level stand and aiming it upward prevented any hard shadows appearing in the subject's face, and immediately gave a slightly theatrical look. Simon enhanced this with a second strobe positioned behind the model and to the right of the camera, setting it at a high angle to create a strong rim light. He added a yellow gel to introduce the color the magazine was looking for. The final touch was a smoke machine to create the literal "cloud" of mystery that Simon himself was keen to add.

→ **GET THE LOOK**

- If you read the vast majority of "how to" guides for portraiture, you'll repeatedly be told how important it is to establish eye contact with your subject and create catchlights in their eyes. In general, this is sound advice, as eye contact instantly creates a rapport between the viewer and the image, while catchlights add a "spark" of life.

- Here, however, Simon has deliberately ignored these traditionally quoted rules to create the opposite effect. Instead of a subject that's full of life, the eyes are dark and lifeless, and the gaze is directed away from the camera. This is a person who has no interest in the camera, the photograph, and therefore the viewer: he is distant and aloof. Through this careful choice of pose and lighting, Simon has transformed his subject from a fashion model into a "character," complete with personality traits and an implied narrative that can continue through subsequent shots in a series.

■ PLAN VIEW

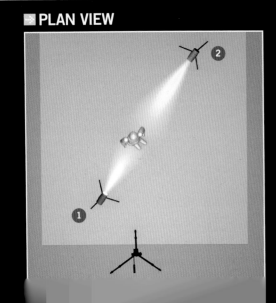

■ PERSPECTIVE VIEW

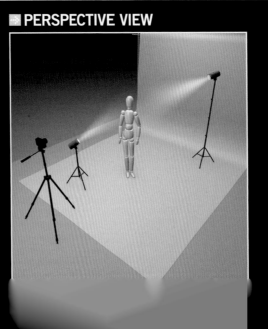

📷

PHOTOGRAPHER: Simon Pais
CAMERA: Canon EOS 40D
LENS: Canon EF 24–70mm *f*/2.8L USM @ 70mm focal length
APERTURE: *f*/11
SHUTTER SPEED: 1/200 sec
ISO: 100
LIGHTING:
1 Hensel 1000ws monolight
2 Hensel 500ws monolight with yellow gel

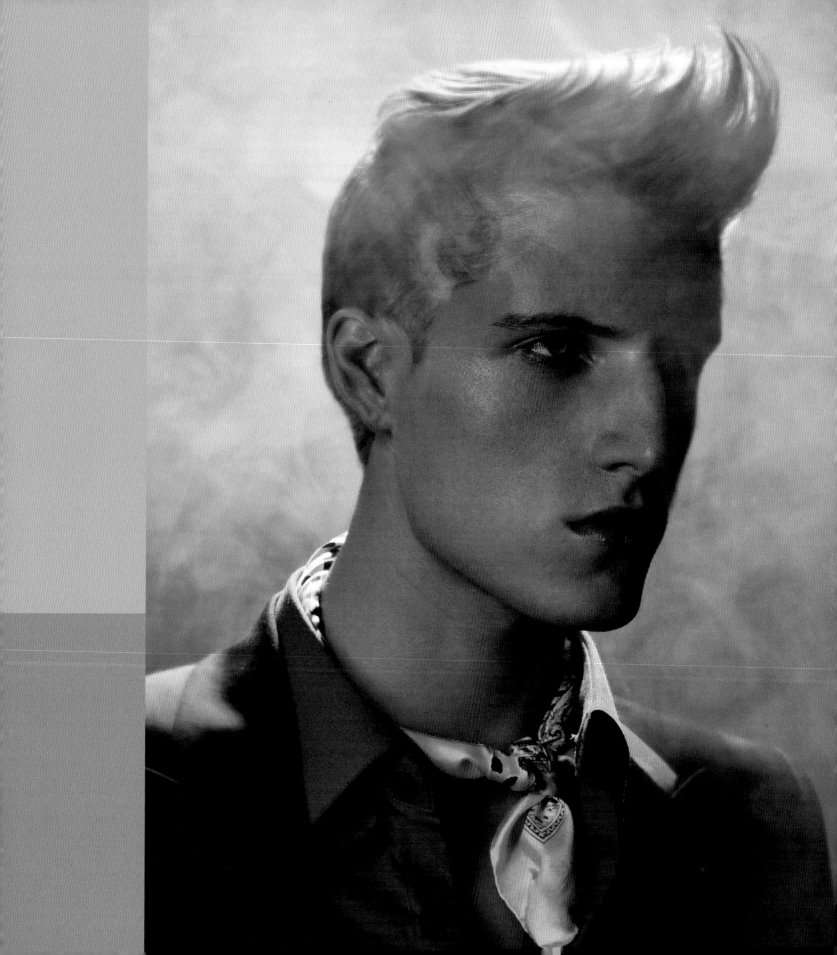

Cupcake Doll

With a clear idea of the look she wanted to create, London-based Kristina Jelcic took on the dual roles of stylist and photographer to realize an idiosyncratic fashion series that owes as much to Japanese pop-culture—especially the celebrated areas of anime and cosplay—as it does to photography.

"I WANTED TO CREATE a sweet, cute, very girly, and almost cartoonish fashion story. I shot it in my home studio, which normally has white walls, but that wasn't what I wanted style-wise. The easy answer was to buy some wallpaper and tape it to the wall—it's much quicker than papering the wall properly, plus I only needed to do a small area so it was cheap to buy! It also meant I could take the studio back to plain white walls just a few minutes after I was finished.

"The styling was very important in creating the 'hyper-cute' feel, so the makeup and hair were kept saccharine-sweet (and the hair a tad outlandish)—I even went out and bought a pair of socks with a cupcake pattern! Without those elements, the photo would definitely not work as well.

"To emphasize the two-dimensional feel, I needed almost shadowless lighting so I used a monolight at either side of the model, with one firing into a silver umbrella and the other into a shoot-through white umbrella. Afterward, the post-production work could begin, which mainly involved cleaning up the joins in the wallpaper, plus some basic retouching to the skin and hair, and a small amount of color correction."

→ GET THE LOOK

With this shot, Kristina has demonstrated that you don't need a complex, or even a particularly dramatic lighting setup to get a great shot. Her two-flash arrangement, with umbrellas to soften the light, would be more commonly used as a copy lighting setup to make mundane photographic reproductions of paintings, where even illumination is the only requirement. But here it serves a very precise, and very different purpose: it *enhances* the shot by becoming an integral part of the overall stylistic treatment. If there had been a difference in power between the lights, this would have introduced shadows that would have created a much greater three-dimensional sense. However, in this context the aim is to produce a cartoon-style image, which demands flat, two-dimensional lighting. While it may not be revolutionary or "exciting," a simple solution is sometimes the only one you need when you're looking to create a very specific look.

■ PLAN VIEW

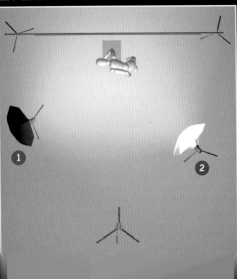

■ PERSPECTIVE VIEW

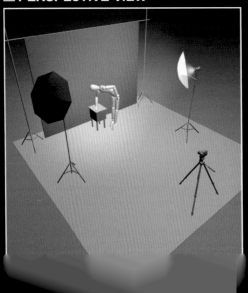

PHOTOGRAPHER: Kristina Jelcic

CAMERA: Nikon D70

LENS: Nikon 18–70mm *f*/3.5–4.5G ED-IF AF-S DX @ 35mm focal length

APERTURE: *f*/13

SHUTTER SPEED: 1/250 sec

ISO: 200

LIGHTING:

1 Elinchrom BX500 strobe with silver umbrella

2 Elinchrom BX500 strobe with shoot-through umbrella

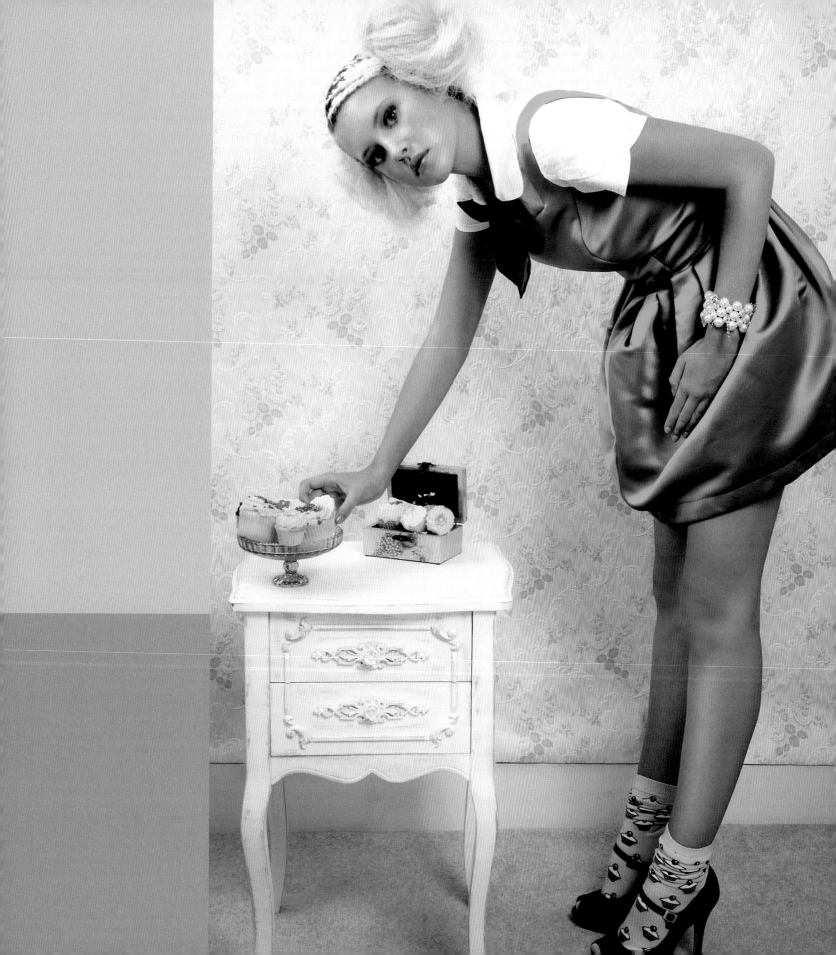

Iconique Queen

Modern. Real. Timeless. Those are the words photographer Yanick Déry uses to describe the 15-year career that has seen him shoot for an impressive client list that includes *Cosmopolitan, Elle, Time Out New York*, Redbull, and fashion designer Donna Karan. Yet not all of the Canadian photographer's work begins with a commission: this striking fashion image started out as a personal project before gracing the cover, and interior, of Montreal's *Kill* Magazine.

"IF I HAD TO SUMMARIZE my photography, I'd say it blends fashion-forward trends with cutting-edge digital capture to convey style, emotion, and passion. I always set out to create a new, almost ethereal air of glamour, with digital manipulation playing an integral part in developing the feeling of luxury and sophistication."

This shot is a prime example of Yanick's ethos, created from a relatively straightforward two-light setup. The model was lit using a 60-inch umbrella on a strobe placed to the right of the camera and roughly three feet (one meter) away from the subject so the light fell off nicely. A pair of blue-gelled strobes were then used to illuminate and color the white background, with an ungelled strobe and 10° grid creating the distinct halo of light around the subject.

Post-production work was inevitable in creating the look Yanick was after, and in addition to an overall contrast-controlling curve he introduced a subtle split-tone color adjustment to warm the highlights and cool the shadows. He also used Photoshop to enhance the background lighting, applying a masked curves adjustment that preserved the lightness of the halo while darkening the surrounding area.

⇨ GET THE LOOK

- In this image, Yanick has manipulated the lighter tones so they have a slightly yellow bias, while the shadows have been enriched with blue: opposing colors on the traditional color wheel. While the complementary colors help to separate the lights and darks, this doesn't affect the *tonal* contrast of the image. In fact, it has the opposite effect, as neither the highlights, nor the shadows, are "pure" white or "pure" black.

- There are numerous ways to achieve a similar result using Photoshop, but perhaps the one that gives the most control is Curves. In the Curves dialog, select the Blue channel from the drop-down channel options, and drag the bottom left point upward to enhance the blue in the shadow areas. Then drag the upper right point downward to decrease the amount of blue in the highlights (giving them a yellow tint), creating an instant yellow/blue split-tone.

■ PLAN VIEW

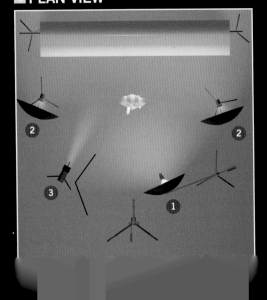

■ PERSPECTIVE VIEW

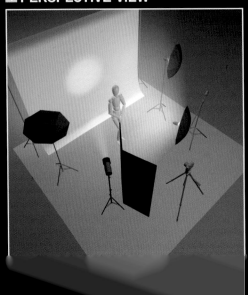

📷

PHOTOGRAPHER: Yanick Déry
CAMERA: Canon EOS 1Ds Mk III
LENS: EF 50mm *f*/1.4 USM
APERTURE: *f*/4.0
SHUTTER SPEED: 1/200 sec
ISO: 100
LIGHTING:

1 Strobe with 60-inch umbrella on model
2 Two strobes with umbrellas and blue gels on background
3 Strobe with 10° grid on background

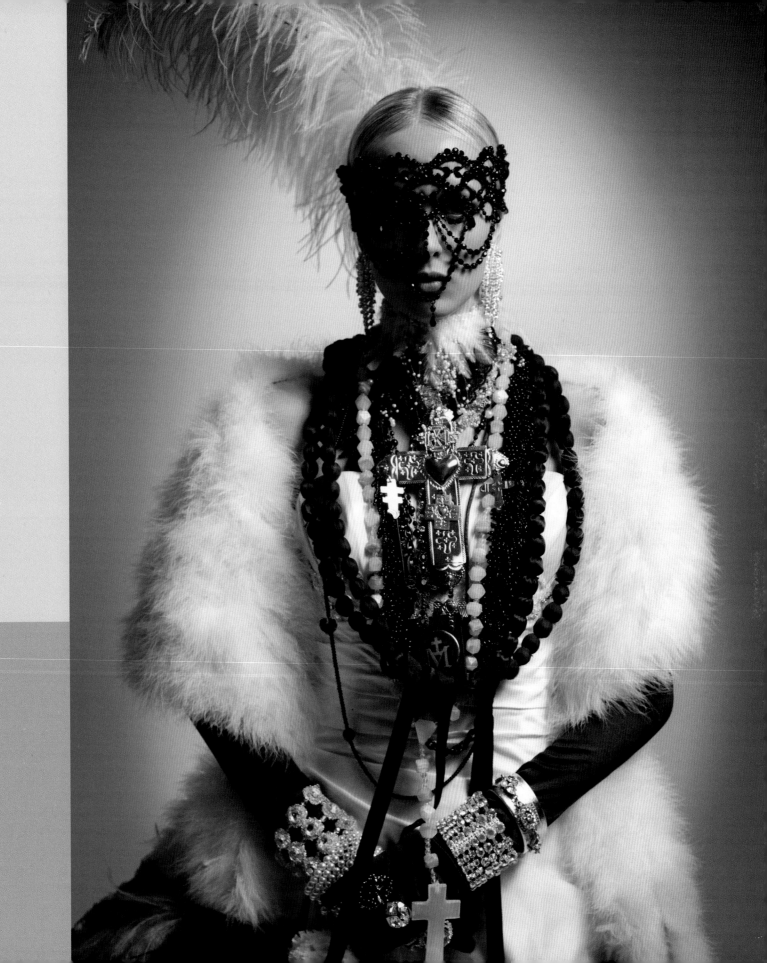

Tango
By Richard Warren (see overleaf)

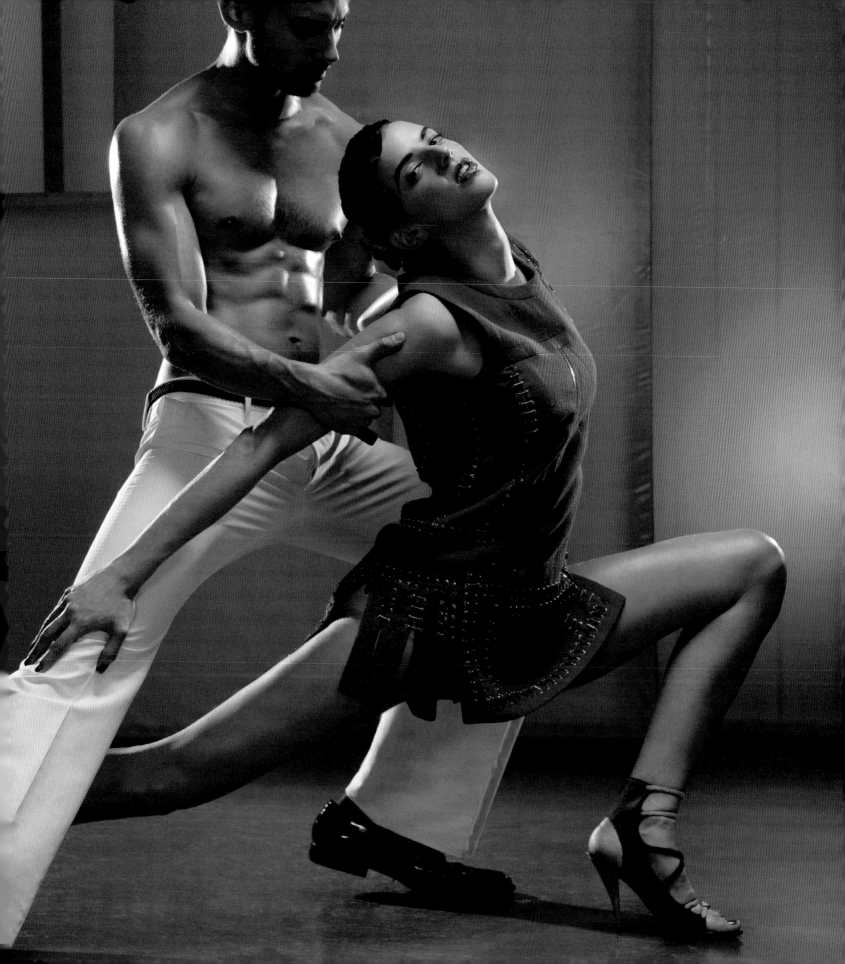

Tango

Richard Warren's photographic career began over three decades ago when he moved to New York and started working as an assistant for iconic photographers such as Helmut Newton and Robert Mapplethorpe. Richard's subsequent photographic career has taken him around the world, before returning to New York to set up his own studio. Still shooting for a global client base, this image comes from a fashion story shot for French magazine, *Style Monte Carlo.*

"THE THEME OF THE ISSUE was 'performance' and because the fashion that season had a heavy Spanish influence we decided to go for a Latin theme with a fashion story based around the tango. I wanted the set to maybe look like a club or a stage-set so I made the background myself, using some 2" x 4" wood and a sheet of plastic from a hardware store, and lit it using a number of gelled lights.

Red was important because it's the color of passion (tango being a passionate dance), so that's the predominant color, while the rest of the gels enhance the theatrical feel. However, the lighting isn't what makes a shot. My favorite Italian chef says that the sauce for pasta should only be a complement, and the pasta itself should be delicious on its own. The same is true with lighting for fashion. The model, the hair, and the makeup all have to be beautiful before you even start thinking about light: it's very rare that *lighting* creates a fashion shot."

⇢ GET THE LOOK

- Using gels is a great way of injecting drama into your shots, but as Richard notes, it's important that it complements the shot rather than being used in a deliberate attempt to *create* the image. Gels are often used because they *can* be, and not because they *should* be: If they don't enhance the overall concept or mood then you need to ask "why" the light is colored?

- That said, there's one color-combination that will work well together even without an overriding context: orange and blue. The human visual system is familiar with the juxtaposition of "warm" domestic incandescent lighting and "cool" daylight, so we more naturally accept this combination than, say, red and green lights. So, if you really want to use colored light, consider using orange and blue color-correction gels to create the impression of cool daylight coming into a tungsten-lit interior, or vice versa, rather than strong primaries.

◆ PLAN VIEW

◆ PERSPECTIVE VIEW

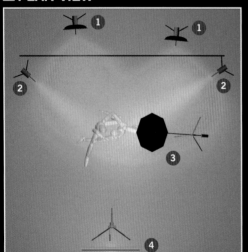

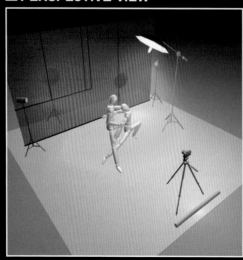

📷

PHOTOGRAPHER: Richard Warren

CAMERA: Hasselblad H2 & CF39 digital back

LENS: Hasselblad HC 50mm *f*/3.5

APERTURE: *f*/8

SHUTTER SPEED: 1/125 sec

ISO: 100

LIGHTING:

1 Two strobes with beauty dishes and red gel

2 Two strobes with reflector dish and green/yellow gel

3 Strobe with 1 meter Balcar umbrella

4 6-inch x 30-inch striplight with blue gel

Silvia Alfonzo

By the age of 25, Colombian-born Raul Higuera was named as one of the top 100 advertising photographers in the world. Today, less than five years later, commissions for global brands such as Coca-Cola, Marlboro, Renault, and Chevrolet have all passed through his studio doors, while his fashion images regularly appear in *Vogue*, *Elle*, *Marie Claire*, and *Harper's Bazaar*, to name just a few of his distinguished magazine clients.

SPLITTING HIS TIME BETWEEN studios in New York, Paris, and Bogotá, it was in his New York studio that Raul created this image for Colombian fashion designer, Silvia Alfonzo. Unlike some of his studio work, which relies on big-budget sets constructed on an almost cinematic scale, the materials used here are decidedly modest: nothing more than a selection of polystyrene blocks of differing sizes. However, these simple white blocks have been transformed through Raul's creativity with the lighting.

The model is lit in a relatively conventional fashion using two Profoto studio strobes fitted with standard reflector dishes, but these are clearly secondary to Raul's main light source: a video projector positioned close to the camera. This is what truly "makes" the shot, projecting an abstract spiral staircase image onto the set. This leads the viewer's gaze up and along the model, while the abstract green shapes created using a laser add an extra layer of detail and interest.

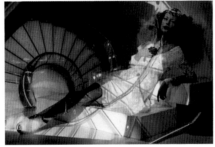

→ GET THE LOOK

▪ Projecting an image is a great way of adding interest to an otherwise "straight" studio shot, but it's vital that the projection complements the set, rather than fighting with it. In this shot, Raul has kept the color in his set to a minimum: a white background, white polystyrene blocks, a neutral-colored floor, and a model dressed in white. It is the projected image that adds the color, and even then it is a unified palette of cyans, blues, and purples, rather than a kaleidoscope of colors.

▪ There are numerous ways you can project an image, and a spotlight strobe that allows a gobo to be replaced with a color transparency is a great solution if you want to use a relatively short exposure time. However, it does mean you need a suitable transparency to project, whereas a digital video projector will enable you to use a digital file instead, offering much greater flexibility in your choice of source material.

▪ PLAN VIEW

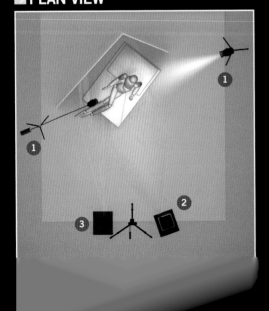

▪ PERSPECTIVE VIEW

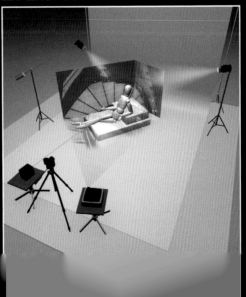

📷

PHOTOGRAPHER: Raul Higuera
CAMERA: Canon EOS 5D Mk II
LENS: Canon EF 24–70mm *f*/2.8L USM @ 59mm focal length
APERTURE: *f*/14
SHUTTER SPEED: 1/2 sec
ISO: 250
LIGHTING:
① Two Profoto strobes with reflector dishes
② Video projector
③ Green laser

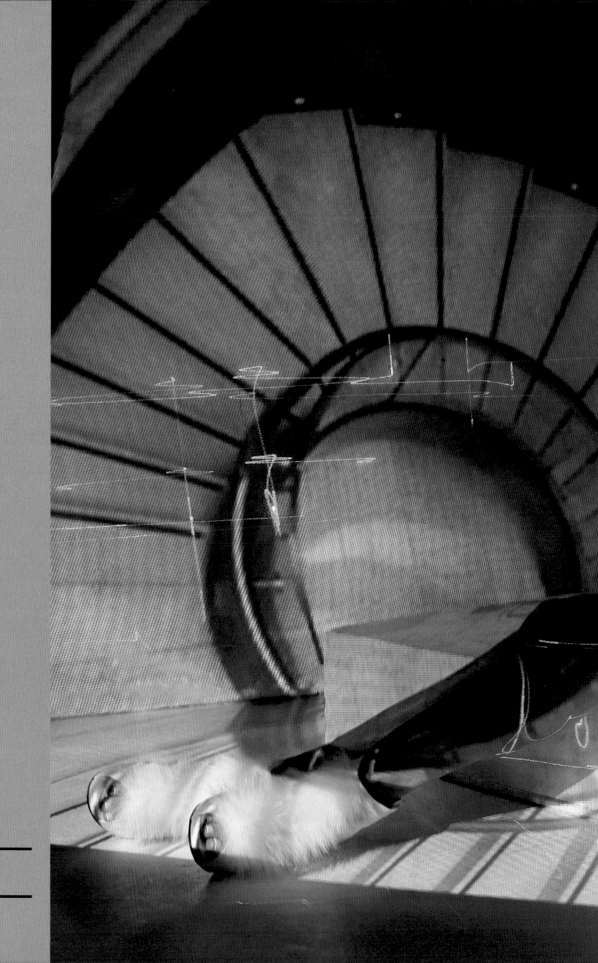

Silvia Alfonzo
By Raul Higuera (see previous page)

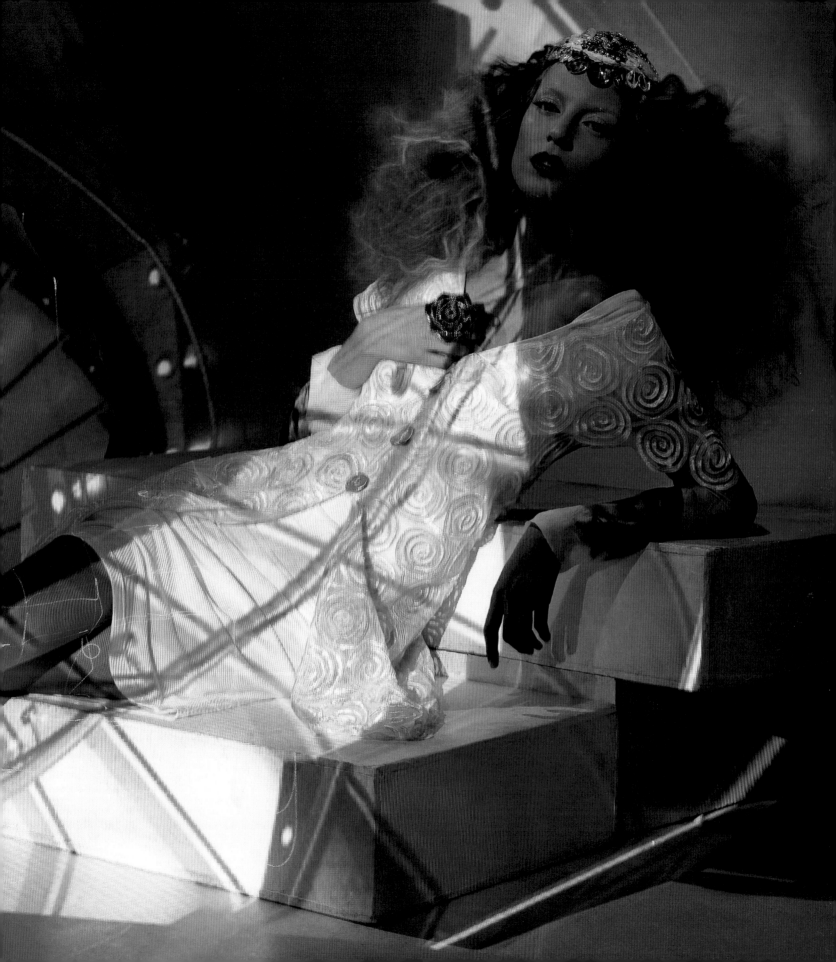

Dior

Joining forces in early 2007, Ollie Porter and Mario Capaldi became Ollie & Capaldi, a dynamic duo of fashion photographers whose collaborative approach has resulted in a distinctive visual style that is applied across its fashion, beauty, and portrait photography.

"THIS WAS ORIGINALLY a test shot taken in the studio for our portfolio, with the model wearing a cap by Dior. Like a lot of our images it incorporates blue-colored light and the idea of perfection—of beauty made almost *too* perfect—which are both fundamental elements of our style. We don't like to rely on post-production to 'make' our shots, so we do as much as possible in camera, limiting the digital work to cleaning the skin up—'cosmetic retouching' we'd call it.

"In this shot, we used a beauty dish with a grid on it to light the model's face, with another beauty dish used as a fill, two stops under the key and fitted with a blue gel. We added two pink 'clip' lights that are just hitting the side of the swimming cap and shoulders to add some color contrast, with a further blue-gelled light on the background: Where it hits the hot spot on the wall it's white, but bleeds off to blue.

"We always strive to be unique with our work, and this means we look less at contemporary photographers and more to photographers from the past and American comic book art; comics and graphic novels going back to the 1960s and artists, such as Jack Kirby, are a huge influence for both of us."

⇨ GET THE LOOK

- The decision to develop a "signature" lighting style is purely a personal one, with some photographers feeling that lighting each shoot they do on an individual basis offers them greater flexibility in their approach, while others take the viewpoint that a cross-portfolio style creates a much stronger sense of personal identity, or a "brand."

- Ollie & Capaldi falls firmly into the latter category, and the five-light setup used here is typical of the lighting style that underpins the partnership. The key to the particular signature is the color blue, although turquoise was initially the pair's color of choice. As they say, "we like color in general, but find that blue gives us nicer skintones and, instead of having dark, muddy shadows, it fills them with a nice blue hue." Exploring or developing a color lighting style is relatively straightforward—you simply have to find a color that works for you and employ it consistently throughout your images—but it can also be extremely effective.

⬡ PLAN VIEW

⬡ PERSPECTIVE VIEW

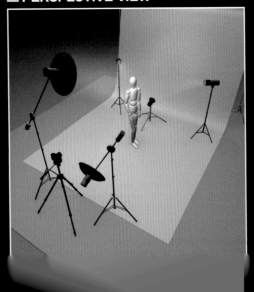

📷

PHOTOGRAPHER: Ollie & Capaldi

CAMERA: Hasselblad H2 with Phase One P30 digital back

LENS: Hasselblad HC Macro 120mm *f*/4

APERTURE: *f*/16

SHUTTER SPEED: 1/500 sec

ISO: 100

LIGHTING:

1. Strobe with beauty dish
2. Strobe with beauty dish and blue gel
3. Two strobes with reflectors and pink gels
4. Strobe with reflector and blue gel

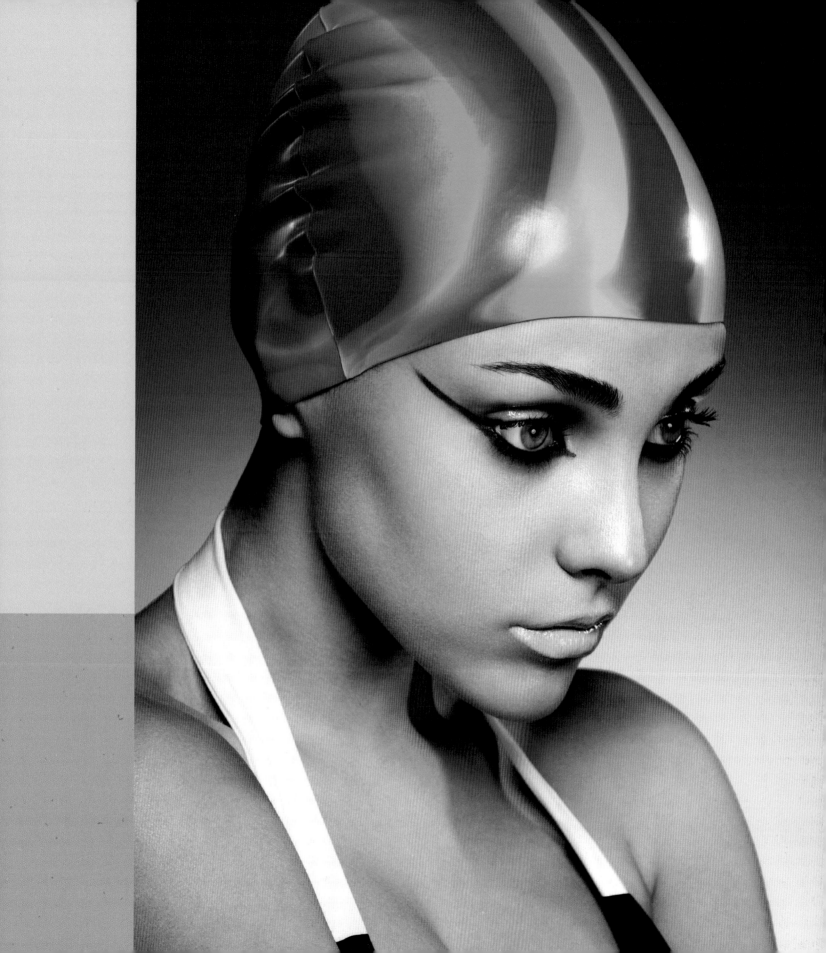

Flaunt Magazine

Having worked alongside some of the biggest names in fashion photography as he made his way up the photographic ladder, it's hardly surprising that South African-born photographer Mark Cant has gone on to shoot for such iconic names as L'Oreal, *Elle*, and superstar-turned-fashion designer, Victoria Beckham.

"THIS IMAGE WAS SHOT for the New York magazine *Flaunt*, and while the idea involved clowns, we were going for a monochrome 'Marcel Marceau' look. I keep a huge stockpile of reference images and amongst them was an old Patrick Demarchelier shoot from *Italian Vogue*. It was originally in black and white, but it had a bit of movement and quirkiness about it, and that was what I wanted.

"Unlike some photographers, I don't have a signature style, but I do tend to use the same lighting equipment. For this shot, the model was lit by a strobe firing into a white umbrella, set on a boom to the left of camera. The flash was quite tight to her, because I find the closer the umbrella, the quicker the light falls off and this enables a white background to go gray very, very quickly. Additionally, I had a cross beam set up pretty much above her, with another flash head fitted with a grid to give the spotlight effect on the background. I was very pleased with the result as shot, so there wasn't much post-production involved—just a little light retouching on the skin."

⇢ GET THE LOOK

With so much black, white, and gray in this shot, Mark has effectively produced a monochrome image, but in color—only the muted skintones and very lightly tinted blonde hair tell us it isn't a true black-and-white picture. To achieve this convincingly, precise control over the color is essential, and that means setting the white balance as accurately as possible. With digital cameras containing a wide range of preset white balance settings, this would seem fairly straightforward, and setting a "flash" white balance when you're using strobes is a good starting point. However, all lights vary in color temperature to a greater or lesser degree, so the only true way of ensuring your grays are neutral is to shoot a gray card and set the white balance manually. Your camera manual will give you the precise details of how to go about this, but once it's set you are guaranteed absolute neutrality.

▣ PLAN VIEW

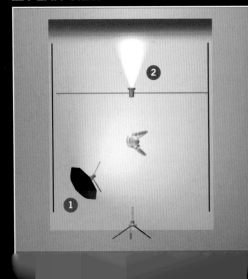

▣ PERSPECTIVE VIEW

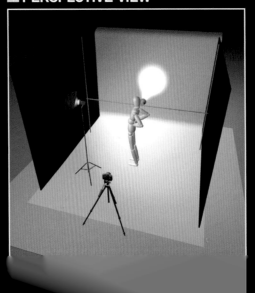

📷

PHOTOGRAPHER: Mark Cant
CAMERA: Canon EOS 1Ds Mk II
LENS: Canon EF 28–70mm *f*/2.8L USM @ 62mm
APERTURE: *f*/22
SHUTTER SPEED: 1/200 sec
ISO: 160
LIGHTING:
1 Strobe with umbrella on model
2 Strobe with grid on background

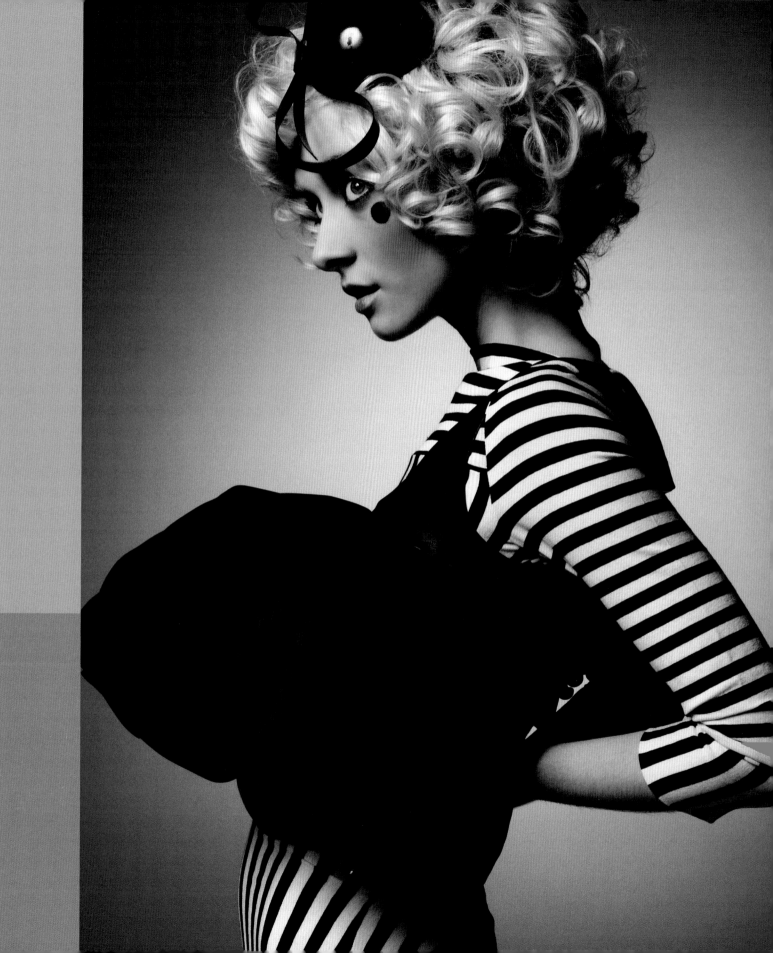

Cyber-torero

Splitting his time between Los Angeles and his motherland, Russian-born fashion, portrait, and advertising photographer Mikhail "Misha" Mikhaylov's obsession with photography means that even his downtime can be turned into a productive photoshoot.

"THIS PICTURE WAS TAKEN during a fun night at my buddy's studio in Moscow, Russia. He had some friends over who were fashion designers and they'd brought some of the coolest, high-tech looking outfits that I've ever seen. After a few cognacs, coffees, and ear-busting Rammstein tunes I was inspired by the idea of creating a shot of a cyber *torero*—a bullfighter from hell! We quickly dressed Vitaly—the photographer whose studio we were in—in these crazy-looking outfits and shot a series of images, including this one. The hardest part was to catch the fabric so it worked as the main part of the composition: I think it took around 20 shots to get it right.

"The setup for the shot was fairly simple and it was all done in front of a black, seamless background about 6-feet (2 meters) behind the model. The main light was a strobe with a medium-sized octabox, with the baffles removed so it produced a harder light. This was positioned in front of the model, and slightly forward, so it was at an angle that would light up the fabric from the front. A second light with a standard reflector dish and a red gel was aimed at his back to enhance the 'hellish' look and after 15 minutes of minor color-correction work in Photoshop the shot was done!"

GET THE LOOK

- Misha's intense cyber-torero image is inextricably linked to the events surrounding its production, with the charged evening of alcohol, caffeine, and industrial metal music clearly apparent in the energetic and powerful image. It's a photograph that, like the romanticized depictions of Spanish matadors, is filled with passion.

- However, we don't need to know the back-story to the image to see this because all the emotion is contained within the picture itself. The futuristic (and slightly fetishistic) outfit and frenzied facial expression immediately give the model character, but the use of light and color play an equally important part. Red is a color that is naturally associated with fire, energy, passion, and danger, while black is equally emotive in its darkness. Hard-edged, high-contrast lighting also exudes an entirely different energy to soft, diffuse light: the former creating tension, drama, and a distinctly masculine feel, while the latter has much more of a calming and feminine appeal.

PLAN VIEW

PERSPECTIVE VIEW

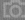

PHOTOGRAPHER: Mikhail "Misha" Mikhaylov

CAMERA: Canon EOS 5D

LENS: Canon EF 85mm *f*/1.8 USM

APERTURE: *f*/9

SHUTTER SPEED: 1/200 sec

ISO: 50

LIGHTING:

1 Hensel Integra monolight with octabox

2 Hensel Integra monolight with standard reflector dish and red gel

Vessel

Having worked as a creative director for a leading advertising agency in North America, Trevor Brady moved behind the camera to provide creative solutions to a global client list that includes Adidas and *Elle* magazine. With bases in New York, Los Angeles, and Toronto, the eclectic locations of his clients mean that Trevor is constantly jetting around the world, leading an almost nomadic existence as a full-time fashion and advertising photographer.

"THIS SHOOT WAS FOR *FUXYZ* magazine in Barcelona, Spain. They had asked me to shoot a story around the theme of 'naked,' but I didn't want to shoot the obvious 'naked=nude' because I knew there would be a lot of nude images in the issue. Instead, I decided to explore the concept of 'naked' in terms of exposed, disguised, and camouflaged, forming a series of images where the subject emerges from a 'vessel.'

"To accomplish the look, I worked with fashion stylist Deanna Palkowski, using clothing that blended in color and had a cocoon or 'wrapped-up' feel to it. To create the image itself, I knew I'd have to shoot two images—one static shot, and a second that recorded the movement of the model entering/exiting her vessel. I shot in a daylight studio, using a strobe fired through a softbox for the static shot, with the windowlight acting as a fill. Then I switched off the strobe and made a series of longer exposures for the motion shot, using just the ambient light. It was then simply a question of using Photoshop to combine two of the shots that worked best together."

⇒ GET THE LOOK

- Layering two images as Trevor has done here is definitely easier to do when you can take full control over the process in Photoshop, allowing you to pick and choose from a range of shots and use the two that best suit the result you are after. However, it's not the only way of combining a static shot with movement: you can also use the classic "flash and blur" technique.

- If you're working in a daylight studio, choose a slow shutter speed—something in the region of a second or more works well—and take an ambient light reading that gives you the appropriate aperture setting for the ambient light. Set up your strobes to light your shot, making sure that the exposure they need matches the aperture needed for the daylight. When you shoot, the flash will "freeze" your model, while the slow shutter speed will continue to record any subsequent movement.

▣ PLAN VIEW

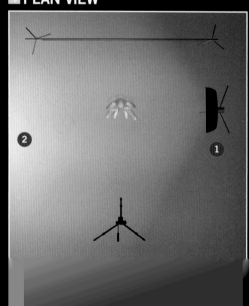

▣ PERSPECTIVE VIEW

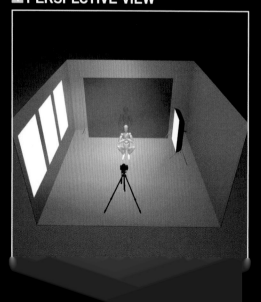

📷

PHOTOGRAPHER: Trevor Brady
CAMERA: Canon EOS 5D Mk II
LENS: Canon EF 24–70mm *f*/2.8L USM @ 50mm focal length

Shot 1 (with strobe) / Shot 2 (daylight only)
APERTURE: *f*/8 / *f*/5.6
SHUTTER SPEED: 1/125 sec / 5 seconds
ISO: 100 / 100
LIGHTING:
❶ Strobe with softbox
❷ Ambient window light

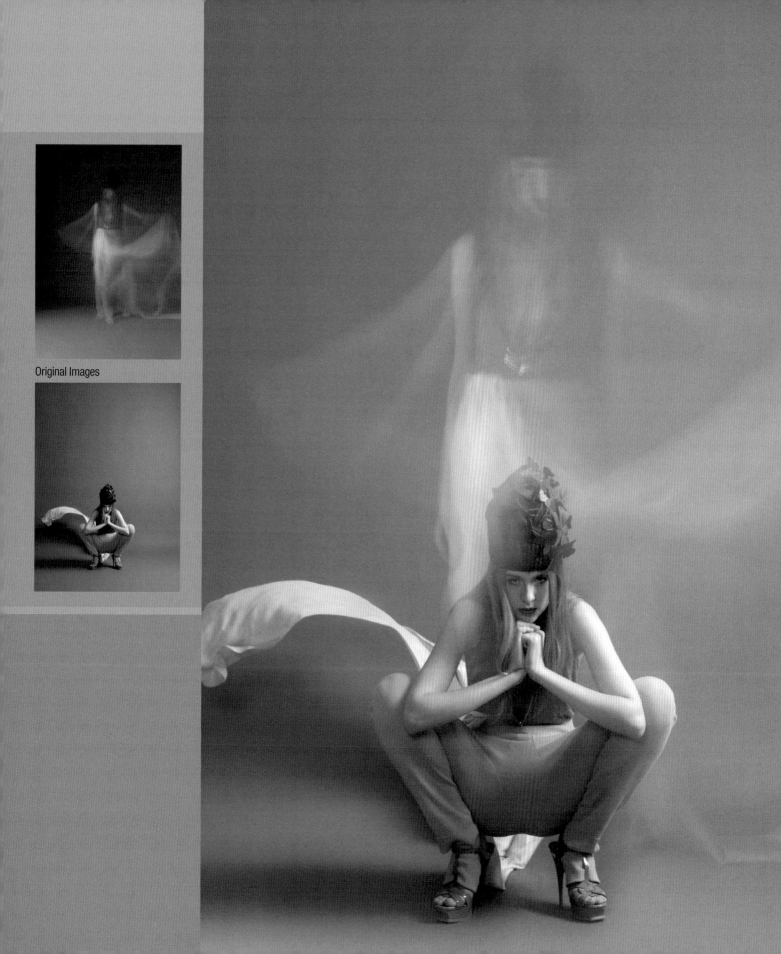

Original Images

Bogusia

Inspired by Sandro Botticelli's famous painting, *The Birth of Venus*, Anna Olszewska was looking for a statuesque pose in her contemporary, fashion-based photographic reworking of the picture. Her starting point was a (literal) blank canvas: a small studio with a roll of white seamless paper, into which came the overflowing suitcase (a distinct nod to the seashell from which Botticelli's Venus emerges) and the modern-day "goddess."

"TO EMPHASIZE THE MODEL'S SHAPE and help her to stand out against the background I set up a key light with a long softbox behind the model to the right of the camera, at a one o'clock position. I balanced this with a second light from the opposite direction, coming from the front left to fill in the detail. I fitted a large softbox to this fill light as well and reduced the power so it was giving me one and a half stops less than my key light. To brighten the background I used a third softbox, this time placed slightly behind the model so it wouldn't spill onto her and create any unwanted shadows. Again, I set this one and a half stops down from the key light—enough to lighten the background, but not so much that I lost the separation between the model and the white seamless paper.

"Apart from the overall pink tint, most of what you see was achieved in camera, with the post-production work restricted to basic retouching, slight skin smoothing, and a minor curves adjustment for contrast."

GET THE LOOK

- Although Anna's shot was largely created in-camera, the pink tone that colors the background was added post-capture when she was working on the image in Photoshop. There are numerous ways that you can create a colored background from white, and Anna chose to use an adjustment layer and a layer mask.

- The first step is to create a Fill adjustment layer above your image and select the color you want to use from Photoshop's color picker. As well as coloring the background, this will also color the subject, so you need to selectively mask the adjustment layer. Every adjustment layer you create automatically has a layer mask attached to it, which you can activate by clicking on the mask icon in the layers palette. With the mask selected you can use the Brush tool to modify it and selectively "remove" the layer effect—in this case to remove the pink color from the model.

PLAN VIEW

PERSPECTIVE VIEW

PHOTOGRAPHER: Anna Olszewska

CAMERA: Canon EOS 40D

LENS: Canon EF 17–40mm *f*/4L USM @ 28mm focal length

APERTURE: *f*/11

SHUTTER SPEED: 1/125 sec

ISO: 100

LIGHTING:

1 Three strobes with softboxes

Luz Negra

Like most professional fashion photographers, Marcelo Nunes is constantly looking for new ways to create eye-catching images, both for his portfolio and to use in his commercial work. As demonstrated with this image, this doesn't necessarily just mean experimenting with new lighting configurations, but also exploring unusual lighting sources.

"THIS PHOTO WAS MADE for a fashion student for his graduation project. Using the technique of *moulage*, he was wrapping the white cloths around his models by hand, effectively creating the outfits 'live.' This meant they had to be recorded photographically to give them any great permanence. Because of the brightness of the white fabric I thought it would be great to use 'black light' for the shots; I just felt the luminescence and the soft blue hues this type of light provides would add something extra to his work. So I got an ultraviolet bulb that I could use in a domestic light fitting and used this just above the model as my main light source, with large white reflectors either side of the camera bouncing it back onto the subject.

"I took the shots using my old Hasselblad 500 C/M as film responds to UV lighting a lot better than most digital cameras will, but because of the low light levels I had to push my ISO 400 film by three stops. Even with the film rated at ISO 3200, I still needed to shoot with my aperture wide open to get the exposure time down to one second!"

➔ GET THE LOOK

- Ultraviolet light—or "black light" as it's commonly referred to—exists outside the visible spectrum (at around 350–370nm for photographic purposes), which means it's harder to work with than regular light sources. UV lighting is frequently used in nightclubs and stage lighting, and many electronics and gadget-style stores offer ready-made UV lamps, so getting hold of fluorescent-style tubes or bulbs is the easy part of the process.

- However, because of the UV (and infrared) blocking filters that are often used in front of a DSLR's sensor to maximize image quality from the visible light spectrum, film is a much better option when it comes to shooting. You'll also need to consider using a Kodak Wratten 18a (or similar) filter over the lens to transmit the ultraviolet light while blocking any visible light, although as you won't be able to see through it you will need to compose and focus your shot first.

◼ PLAN VIEW

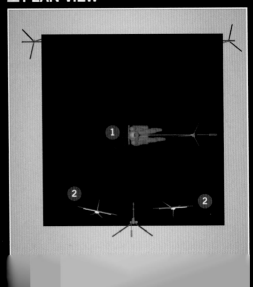

◼ PERSPECTIVE VIEW

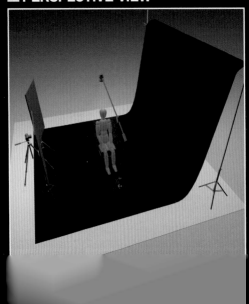

PHOTOGRAPHER: Marcelo Nunes
CAMERA: Hasselblad 500 C/M
LENS: Hasselblad CFE 80mm *f*/2.8
APERTURE: *f*/2.8
SHUTTER SPEED: 1 second
FILM: ISO 400, pushed to ISO 3200
LIGHTING:
1 Continuous ultraviolet (UV) lamp
2 Two white reflectors

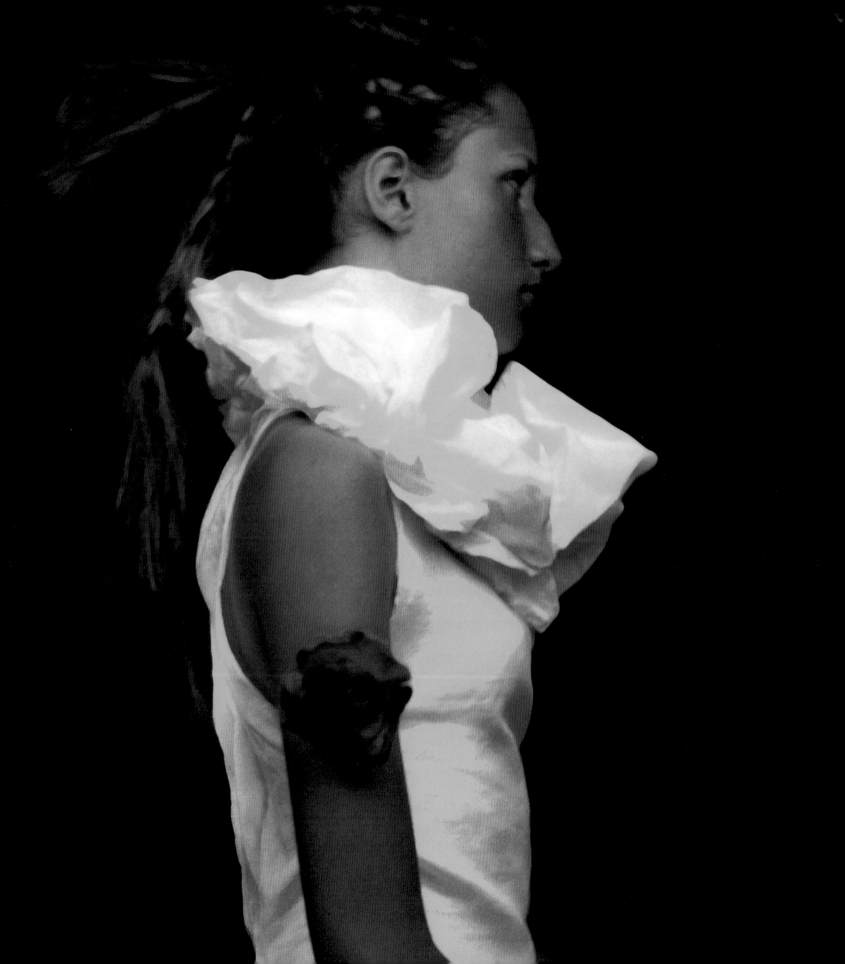

Mirror Wall

Equally at home on location or in the studio, this shot comes from the burgeoning portfolio that Kerry Burrow will be taking with him as he relocates from Wichita, Kansas, to New York city—a move set to build up his career as a photographer in the city's thriving fashion scene.

"I STRONGLY BELIEVE there's a time and a place for elaborate multi-light setups and I have the utmost respect for people who shoot that way all the time. Equally, though, I think there's more than one right way to do almost everything in this world and sometimes you don't need a lot of lights to get the shot you're looking for. For this picture I used a single strobe with a 40-inch umbrella placed almost directly above the model's head, pointing downward at a very slight angle. Because I shot her in a room where she was surrounded on three sides by huge mirrors, it wasn't the strobe that was providing the majority of the lighting, it was the actual walls of the studio!

"I shot with the aperture wide open on my 50mm *f*/1.4 lens to conceal the distracting texture of the wrinkled cloth background, while retaining the color, and most of what you see was achieved in-camera. The computer work was limited to a slight color correction to cool the image a little and slight sharpening—other than that there was nothing else. There wasn't even any cosmetic retouching done to the model."

GET THE LOOK

Mirrors are wonderfully versatile in studio photography, regardless of whether you're shooting fashion, portraits, or still life. By their very nature they reflect a huge amount of light—certainly much more than a standard silver reflector—and in many ways they can be considered more as a low-powered light source than a "reflector." Positioned close to a model, a mirror can easily overpower your main light and because they're available in such a wide range of shapes and sizes there are numerous creative options, be it narrow, full-length mirrors used to add a crisp highlight to the whole height of the figure, or a smaller mirror employed to selectively lighten the face in a similar way to a strobe with a snoot or a spotlight. Alternatively, you can encircle your model with mirrors as Kerry has done here, producing an even, enveloping light scheme with a single strobe.

PLAN VIEW

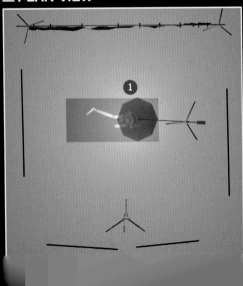

PERSPECTIVE VIEW

PHOTOGRAPHER: Kerry Burrow
CAMERA: Canon EOS 5D Mk II
LENS: EF 50mm *f*1.4 USM
APERTURE: *f*/1.4
SHUTTER SPEED: 1/160 sec
ISO: 100
LIGHTING:
1 600w strobe with silver umbrella

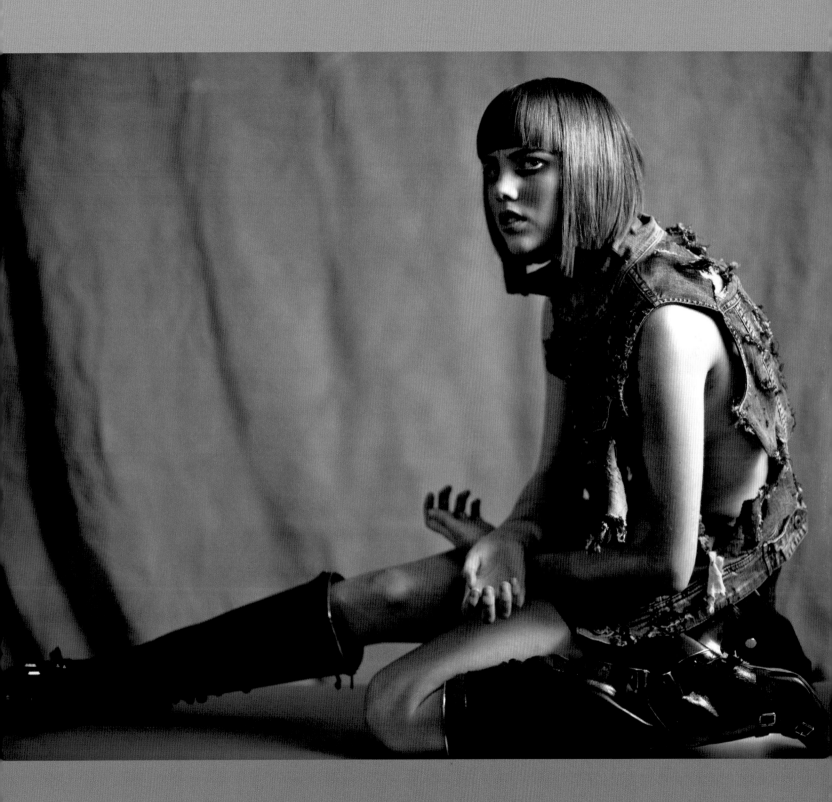

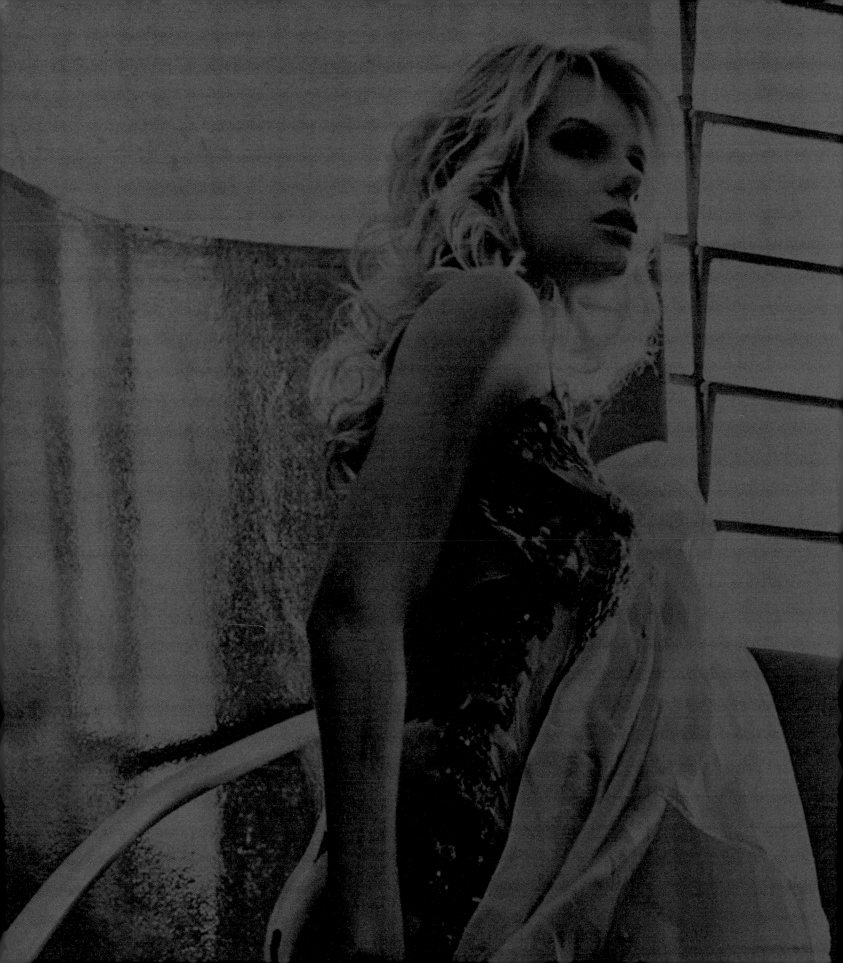

Location

Shooting in a studio may give you absolute control over what appears in front of the camera, but almost anywhere can become the setting for a successful fashion shoot. The images featured in this chapter, for example, cover a wide range of locations, indoors and out: from the luxurious surroundings of a five-star Parisian hotel and a mansion house, all the way through to less exotic backdrops such as a parking lot or the restroom of a bar. Yet as disparate as these settings are, they all have one fundamental thing in common and that is their ability to return fantastic photographs.

Although shooting on location provides you with a ready-made setting for your photographs, it requires a slightly different skill-set to studio-based photography if you want to get things right. We've already seen how lighting on location doesn't necessarily just mean rolling up and plugging in your lights, and there are also many other issues to consider and problems to overcome. If you're shooting outdoors, for example, there's the weather to consider, which can help or hinder your lighting efforts, and if you suddenly realize you need a certain piece of kit that you left behind, you'll have to think on your feet to come up with a solution. These are just two immediately obvious challenges you'll face (a full list would be endless), but with a bit of pre-planning and, at times, a certain amount of luck, there's no doubt that stunning location shots are totally within your reach, as we'll see in this chapter.

Marine Hein

Based in Porto Alegre, Brazil, professional photographer Alexandre Godinho has spent many years shooting for a wide range of clients. This includes a two-year stint as the sole photographer for Elder Depizzol Casting, a model agency based in the Brazilian city of Curitiba, which saw Alexandre traveling to the city every month to meet and photograph both new and established models in a wide range of styles.

"THIS PARTICULAR SHOT was taken in a hotel bar in Curitiba and the model, Marine Hein, was one of the last models I was photographing that day. Although the room had large windows, it was getting late and it was quite dark inside, with the only light coming from the overhead lights in the bar. I didn't want to lose the warm atmosphere the domestic bulbs were creating, so instead of using flash I fitted my studio strobe with a more powerful, 100-watt modeling bulb. This isn't really recommended because it can apparently damage the capacitors in the flash head, but it was my only option at the time and it still seems to work ok.

"I had my assistant hold the light above and slightly in front of the model, using the strobe's modeling lamp like a large torch to fill in any shadows around the eyes. I also shot handheld, setting a high ISO and a custom white balance to get the look I was after, and the only retouching I needed to do was to smooth the model's skin slightly and fine-tune the color."

⇨ GET THE LOOK

If you want to make sure that all your light sources match in terms of their color, you have two choices—you either make sure all the lights you're using have the same color temperature to start with, or you use colored gels to convert the color of one or more of them until they all match. So, for example, you'd use an orange color correction gel over a flash if you wanted to balance it with tungsten lighting, or a blue color correction gel over an incandescent lamp if you wanted to give it a daylight color balance. However, for this shot Alexandre only had a studio strobe with him, and he didn't have any gels. There was a fairly straightforward answer, though: Instead of using the cool blue flash, which would have totally destroyed the warm atmosphere, he used the flash head's incandescent modeling lamp, effectively turning his strobe into a low-powered tungsten light.

▣ PLAN VIEW

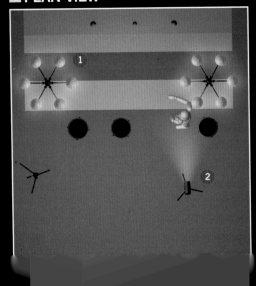

▣ PERSPECTIVE VIEW

📷

PHOTOGRAPHER: Alexandre Godinho

CAMERA: Canon EOS 5D

LENS: Canon EF 70–200mm *f*/2.8L IS USM @ 115mm focal length

APERTURE: *f*/2.8

SHUTTER SPEED: 1/60 sec

ISO: 800

LIGHTING:

❶ Ambient light

❷ 100 watt modeling bulb

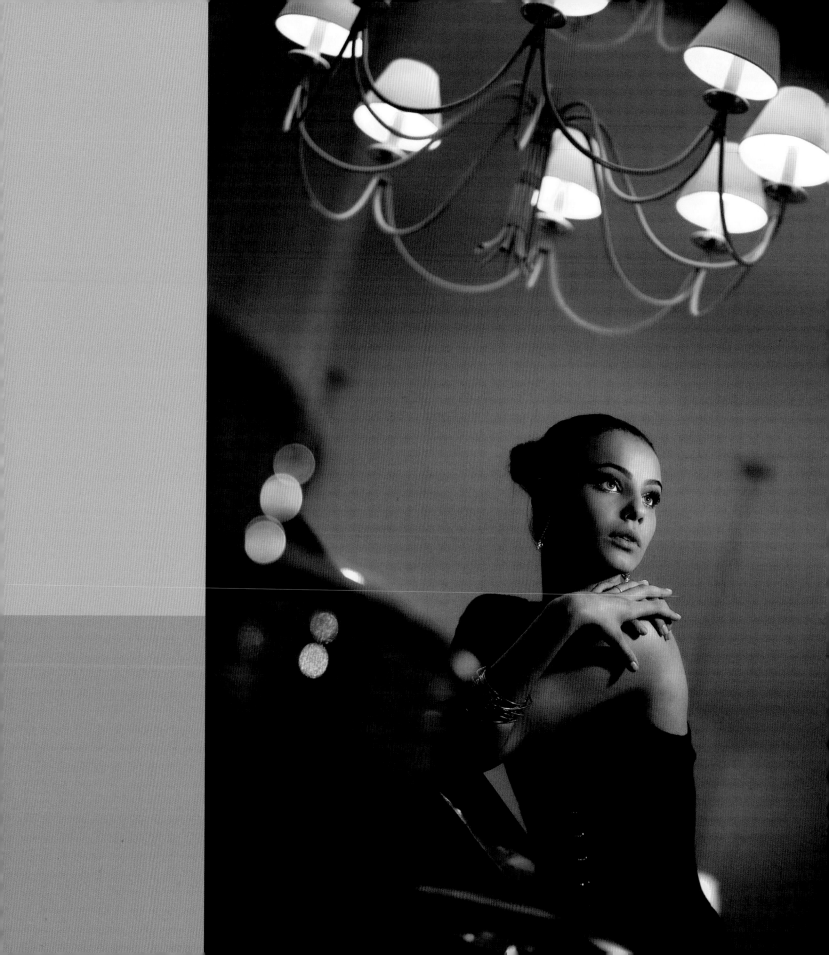

Vogue Italia

Initially setting out as an illustrator, Miles Aldridge is something of an "accidental photographer," falling into the role when a collection of photographs he'd taken for his girlfriend, an aspiring model, led to a meeting at British *Vogue*. Since then his iconic images have been published around the world in prestigious titles such as *The New Yorker, The New York Times, Numéro,* and, of course, throughout the *Vogue* empire, with advertising commissions seeing him work for YSL, Coca-Cola, L'Oreal, as well as shooting the prestigious Lavazza calendar for 2010.

THIS IMAGE COMES from *Gleaming Evenings*, one of Miles's many fashion stories for *Vogue Italia*, and was shot on location in the presidential suite of the five-star Meurice Hotel in Paris. Like the other pictures in the series, it uses an exceptionally limited color palette, contrasting cool cyan-blues and warm tungsten hues. However, this isn't the result of digital manipulation; it's purely down to the lighting.

To provide the base color and exposure Miles used two strobes with spill-kill reflectors, firing them through ½ CTB (Color Temperature Blue) color-correction gels and bouncing the lights off the room's walls. A dedicated 1200ws spotlight with a ½ CTB gel became his key light, aimed from ground level up toward his model, while a fourth strobe—this time fitted with a fresnel attachment and mounted on a boom—acts as a high-angle clip light, adding highlights to the model's hair and shoulders. The final touch was the inclusion of the bedside lamps, creating a warm glow from their tungsten bulbs.

▶ GET THE LOOK

- The recipe for this shot is all to do with the color, or, more specifically, manipulating the color to emphasize the contrast between the warm and cool hues. In Miles's case, the ingredients needed to make this happen were daylight-balanced film, daylight-balanced (flash) lights gelled to make them appear cooler on film, and incandescent lamps that would naturally appear warm.

- If you're shooting digitally, a similar result can be achieved through the white balance setting. Daylight and flash have a color temperature of around 5500K (Kelvin), while tungsten has a temperature close to 3200K. Instead of setting your camera's white balance to one of these specific presets, manually set it to a color temperature between the two: 4000–4500K, for example. This will mean any daylight- or flash-lit areas will appear cooler (more blue), while incandescent light sources will appear warmer (more orange).

■ PLAN VIEW

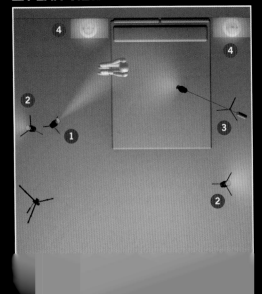

■ PERSPECTIVE VIEW

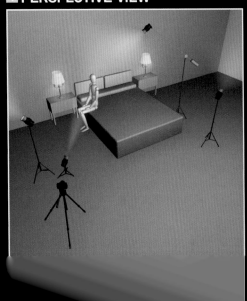

PHOTOGRAPHER: Miles Aldridge (Courtesy of Miles Aldridge/trunkarchive.com)

CAMERA: Rollei 6001

LENS: 80mm

APERTURE: *f*/16

SHUTTER SPEED: 1/4 sec

FILM: Fuji Provia 400 at ISO 400

LIGHTING:

1 Profoto strobe with spot attachment and ½ CTB (Color Temperature Blue) gel

2 Two Profoto strobes with reflector dish and ½ CTB (Color Temperature Blue) gel

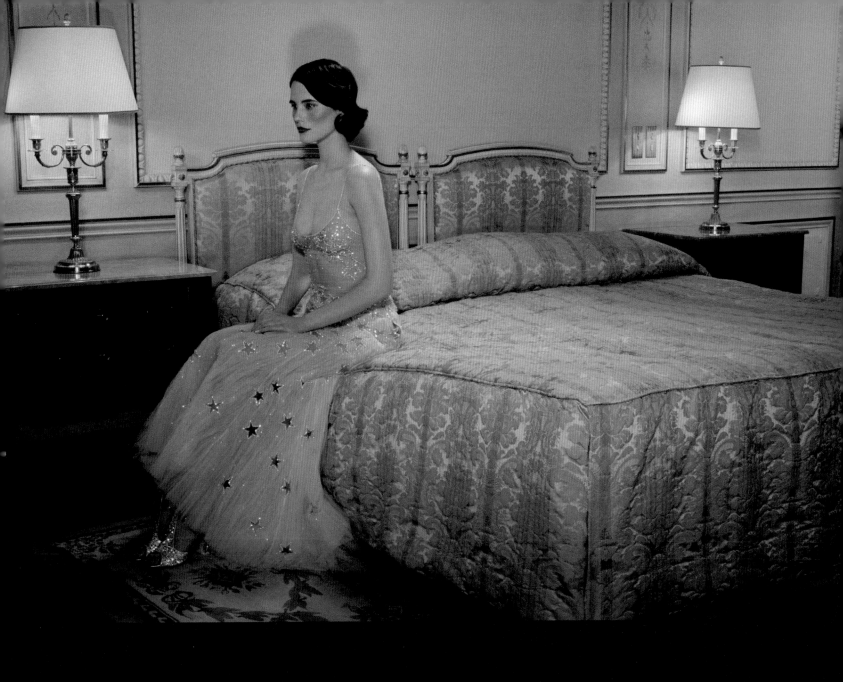

Sheridan @ The Brewery

Although he's usually found working full time as a doctor, Danny Tucker's main interest is shooting lifestyle and fashion-inspired portraits, seeking out locations in and around his hometown in Queensland, Australia.

"THIS PHOTOGRAPH WAS TAKEN as a portfolio-builder for the model and the setting is a public bar. I'd arranged permission to shoot there with the manager on a previous scouting visit, but even so, we only had about 45 minutes between the bar opening and the lunchtime rush, so we had to work extremely quickly.

"Shooting using just the ambient light helped speed things up, although there was a real mix of lighting sources going on: there was indirect sunlight coming from a large window, with warm incandescent lights in the background and a fluorescent striplight over the pool table. Because of the wild variation of color temperatures, a custom white balance wasn't necessarily going to help, so as I was shooting Raw I decided to take a chance and leave it to the camera. I knew I'd be doing some color toning in the post-processing stage anyway, so a perfect white balance wasn't vital, although the camera did a great job considering the variety of temperatures in the mix.

"Despite all the lightsources, it was still quite dark inside the bar, so I selected a fast ISO, knowing from previous tests that the 5D Mk II and Lightroom's noise reduction could produce a good result. I did consider setting up a couple of strobes, but there wasn't that much time and, in any case, we weren't allowed to introduce extra clutter in the public bar."

⤑ **GET THE LOOK**

▪ Although Danny's camera did a great job at managing the different color temperatures of the lightsources in the bar, manipulating the color was planned from the start. Once he had imported the Raw file into Lightroom it underwent cropping and straightening, with a medium contrast tone curve added before both color and luminance noise reduction were used to counter the high ISO. Toning was also performed in Lightroom, although not with the usual range of tools. "The magenta tone was introduced using changes in Lightroom's Camera Calibration panel—shifting the hue and increasing the saturation of the reds and adjusting the green/blue channels a small amount until it just looked right. Although the camera calibration tab isn't intended to be used like this, I find it sometimes produces a better color result than is achievable using HSL (Hue/Saturation/Luminance)."

▰ PLAN VIEW

▰ PERSPECTIVE VIEW

📷

PHOTOGRAPHER: Danny Tucker
CAMERA: Canon EOS 5D Mk II
LENS: Canon EF 85mm *f*/1.8 USM
APERTURE: *f*/4.5
SHUTTER SPEED: 1/200 sec
ISO: 4000
LIGHTING:
① Indirect sunlight through window
② Overhead fluorescent strip

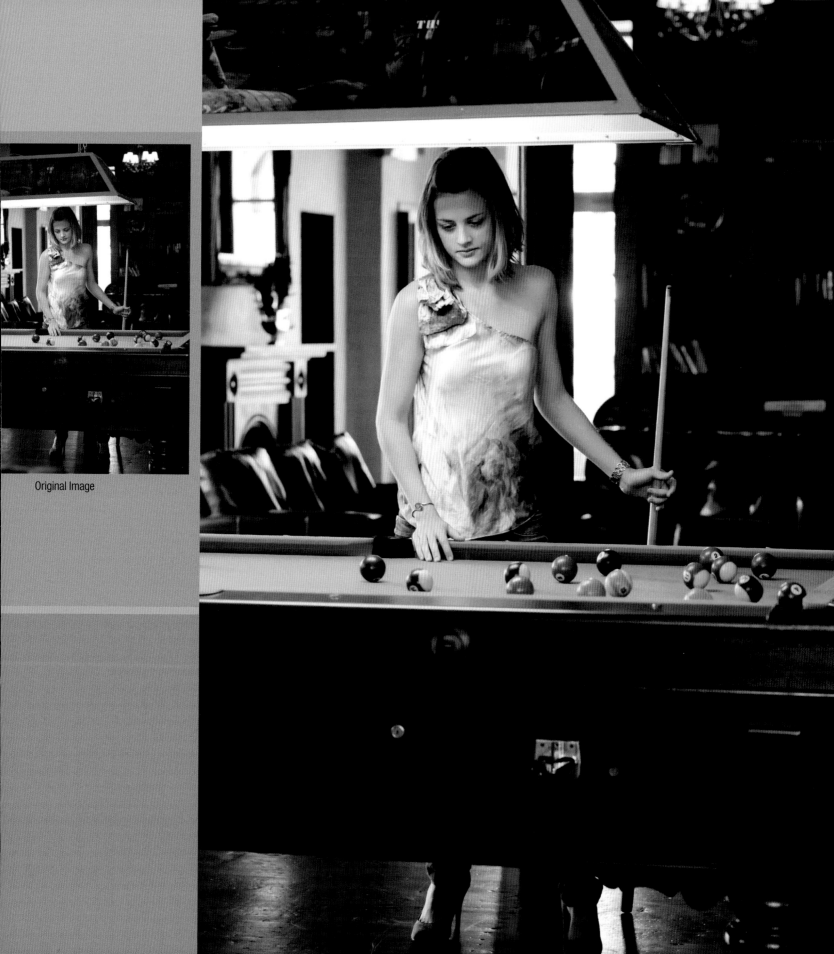

Original Image

Original Image

Coquette
By Amy Dunn (see overleaf)

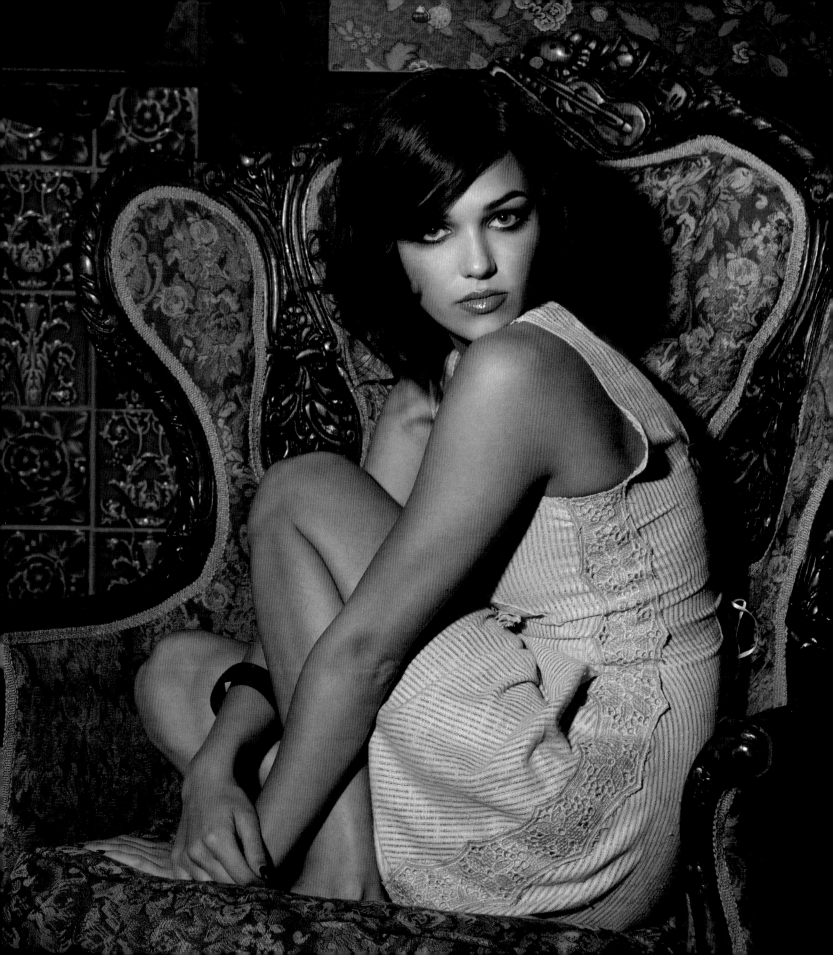

Coquette

Having graced the pages of magazines such as *Vogue, Marie Claire, Harper's Bazaar,* and *Cosmopolitan,* it's hardly surprising that former model Amy Dunn's move from in front of the lens to behind the camera has seen her concentrate on fashion photography.

"I LOVE CREATING pretty, quirky, and fun images that are loaded with personality," says Amy, "so I'm all about interesting locations. For this shot, the model's mother secured a historical house in Galveston, Texas. I loved all of the wonderful textures in the house and fell in love with this stately chair that was positioned against the ornately-tiled fireplace. The furniture had an aristocratic feel, so it was important the wardrobe wouldn't compete with the setting. The simplicity of fashion designer Clare Renee's handmade linen dress worked perfectly with the warm tones of the room."

To light her ornate location, Amy kept things simple, using a single strobe fitted with a 30° grid and barndoors, set to the left of the camera and angled down on the model to emphasize her face. An exposure that favored the flash over the ambient light, created a distinct, concentrated pool of light

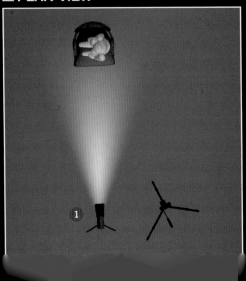

on her subject that falls off into a natural, dark vignette toward the left of the shot, preventing the viewer's eye from wandering out of the shot. "We achieved the results in minutes, with minimal retouching. All that was needed on the model herself was a little dodging and burning to add definition, and a change of nail color from light to dark."

⤏ **GET THE LOOK**

▪ When you're photographing your model against a plain backdrop in a studio environment, the full focus of the image is naturally going to be on them and their clothes, with nothing else to distract the viewer. But, when you switch to location shooting, the setting adds a further level to the "story" you're trying to tell, which makes choosing the right location critical; the wrong location can detract from the subject, just as easily as the right one can enhance the shot.

▪ Not only is it the setting that's important, but also the smaller elements and details within it, which all need to be working in harmony. In this shot, for example, the patch of wall at the top right of the photograph was originally a stark, off-white color that distracted from the model (see small image on page 74). Adding the red, patterned wallpaper in post-production not only helps concentrate the focus on the subject, but the careful choice of color and pattern complements and enhances the grandeur of the setting.

▪ PLAN VIEW

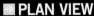

▪ PERSPECTIVE VIEW

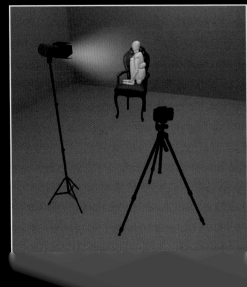

📷

PHOTOGRAPHER: Amy Dunn
CAMERA: Canon EOS 5D Mk II
LENS: Canon EF 24–70mm *f*/2.8L USM @ 70mm focal length
APERTURE: *f*/8
SHUTTER SPEED: 1/125 sec
ISO: 160
LIGHTING:
❶ AlienBees AB1600 monolight with 30° grid and barndoors

Edwin

After pursuing a degree in Visual Arts in her hometown of Bogotá, Colombia, Diana Sandoval headed to the acclaimed TAI college in Madrid, Spain, earning a masters degree in digital fashion photography. Now she is running her own photography studio, shooting a wide range of fashion and advertising projects for a variety of clients.

THIS SHOT COMES FROM a series that was commissioned by the model, Edwin, for his portfolio. With a free hand over what she could do—and where—Diana scouted Bogotá for potential locations before settling on an unlikely, but striking setting—the unisex restroom in a popular city bar.

"I loved the contrast of the turquoise blue wall and the red curtains, and also the small, white, symmetrical lights, and I knew I wanted to have Edwin lying on the washstand at some point. There wasn't much space to work in the restroom, but because I'd checked it out before I arrived I had an idea about how I'd be lighting my shots. In the end it was actually lit more simply than I'd anticipated—a single flash with a white umbrella to the left of the camera, just above the model. It was a great shoot, and it's still in Edwin's portfolio. We get on really well now, and I love to photograph him—I even went to LA to do a second photo book with him."

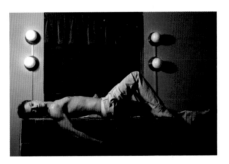

GET THE LOOK

- Unless you're shooting specifically for a black-and-white result, color has a significant effect on your photographs. This is perhaps most important with fashion photography, as any garments you shoot will naturally be colored (even if it's shades of gray) making the overall color "theme" an important consideration. Here, for example, Diana's color palette is incredibly limited. In addition to the model's skin there are only five colors or tones: the turquoise of the walls, the red of the curtains and light surrounds, and black, white, and gray.

- What makes the shot so successful is the color contrast between the red and turquoise (which sit on opposite sides of the color wheel and are therefore naturally complementary), and the tonal contrast of the light-skinned model in pale gray pants lying on, and in front of, areas that are effectively black. Everything is working in harmony, resulting in a shot where the model clearly stands out.

■ PLAN VIEW

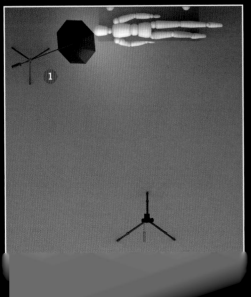

■ PERSPECTIVE VIEW

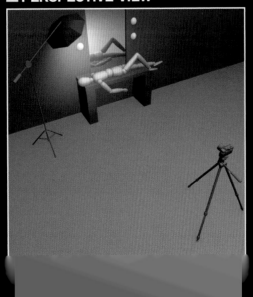

PHOTOGRAPHER: Diana Sandoval
CAMERA: Canon EOS 20D
LENS: Sigma 18–250mm f/3.5–6.3 DC OS
APERTURE: f/10
SHUTTER SPEED: 1/125 sec
ISO: 100
LIGHTING:
1 600w monolight with white umbrella

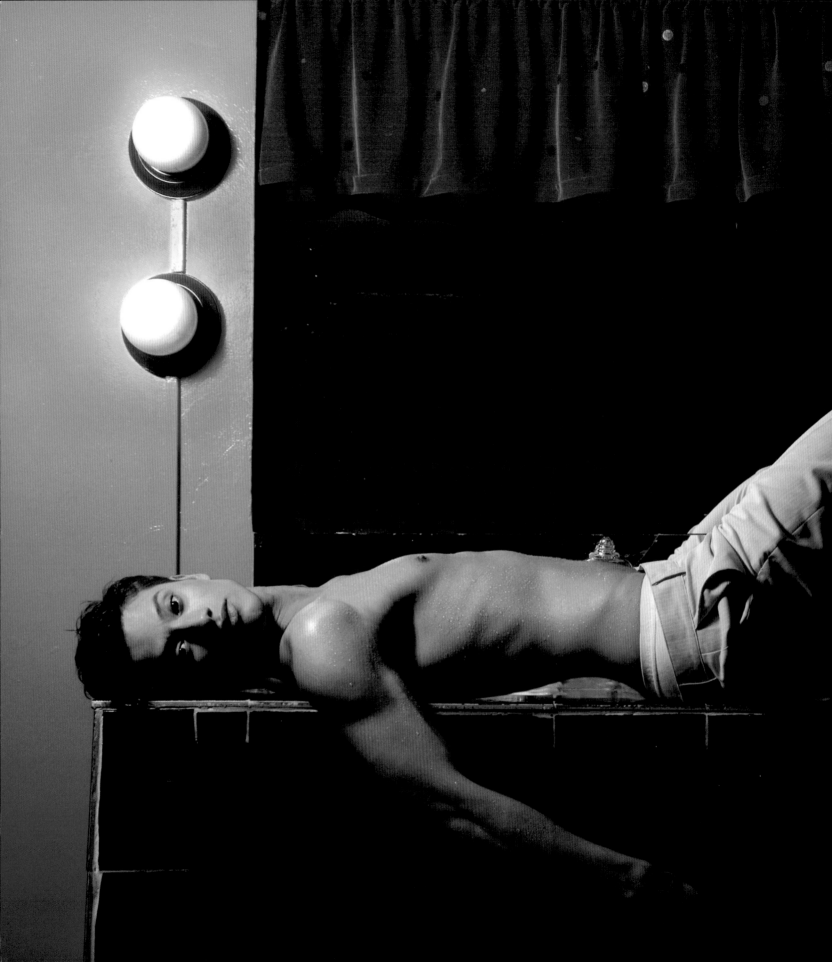

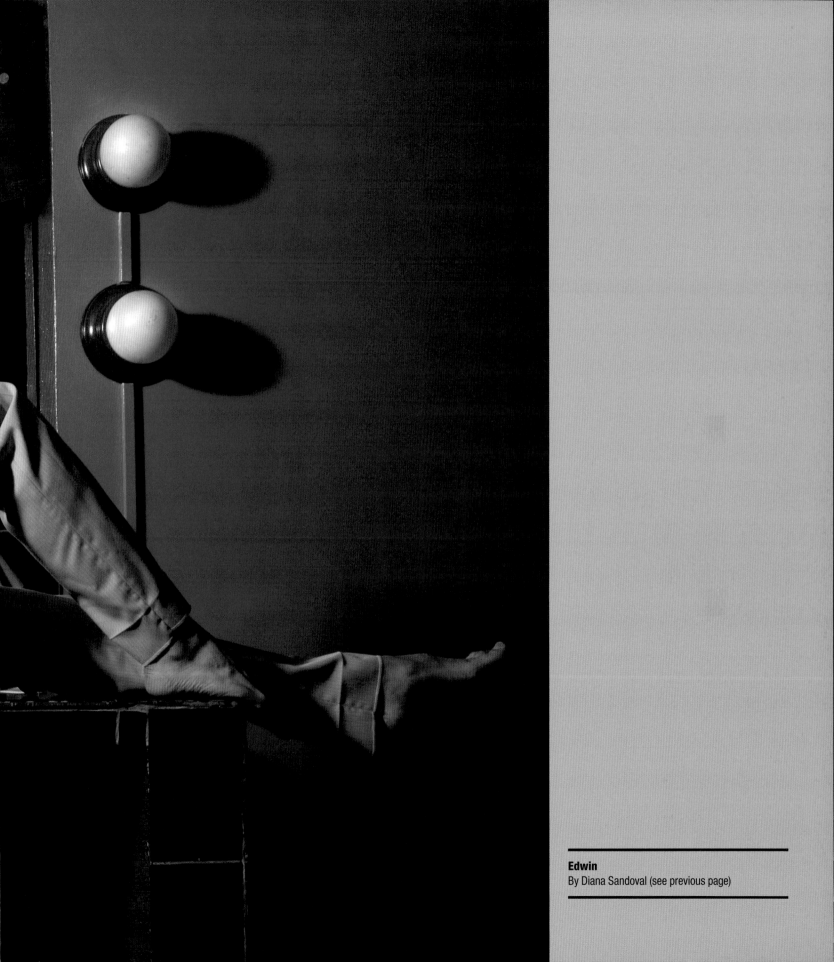

Edwin
By Diana Sandoval (see previous page)

Yvonne

Although he trained as a graphic designer, Mauricio González has always preferred photography, and after a three-year period spent assisting two of Colombia's most renowned photographers (Mauricio Vélez and Raul Higuera) he decided to turn his passion into a full-time career. Five years later, having spent time in New York, he is back in his native Colombia producing work for a number of the country's leading advertising agencies and fashion designers.

THE SHOT SEEN HERE is the result of an informal photography session with a model and old friend that Mauricio hadn't seen for a long time. "She is so beautiful—she has gorgeous curly hair, a lovely tan complexion, and is great to work with. We decided to meet up and do the shoot at an empty house that belongs to a friend of mine. It wasn't for any real reason, we just wanted to take some pictures and have a good time. When we got to the house I picked a room that had light flooding through the window and positioned the model in the 'sun spot.' I wanted to get the effect of light streaming through shutters, but because the window didn't have any I had to improvise. I got a roll of one-inch wide masking tape and tore off about 20 or 30 pieces—enough to cover the window and create the 'shutter' effect. We did a range of poses, sitting and standing, but really it was just about enjoying ourselves, and other than adjusting the contrast and adding a warm tone, everything you see was achieved in-camera."

⇢ GET THE LOOK

■ Although Mauricio's lighting setup is incredibly simple—nothing more than sunlight pouring through a window—the addition of the window-shutter effect breaks up the light and adds another dimension to the shot. Recreating this is obviously straightforward when you're in the right location with the sun in the right position, requiring nothing more exotic than a roll of tape. But even in a windowless studio you can create a similar effect, using a focusing spotlight and a "gobo"—a piece of metal or card with the shutter-like slats cut out of it. Shining the light through the gobo will throw the shadows onto your subject, while you can use the spot's focus to control how hard- or soft-edged those shadows are.

■ PLAN VIEW

■ PERSPECTIVE VIEW

📷

PHOTOGRAPHER: Mauricio González
CAMERA: Canon EOS 5D Mk II
LENS: Canon EF 28–135mm ƒ/3.5–5.6 IS @ 47mm focal length
APERTURE: ƒ/4.5
SHUTTER SPEED: 1/250 sec
ISO: 160
LIGHTING:
① Ambient window-light

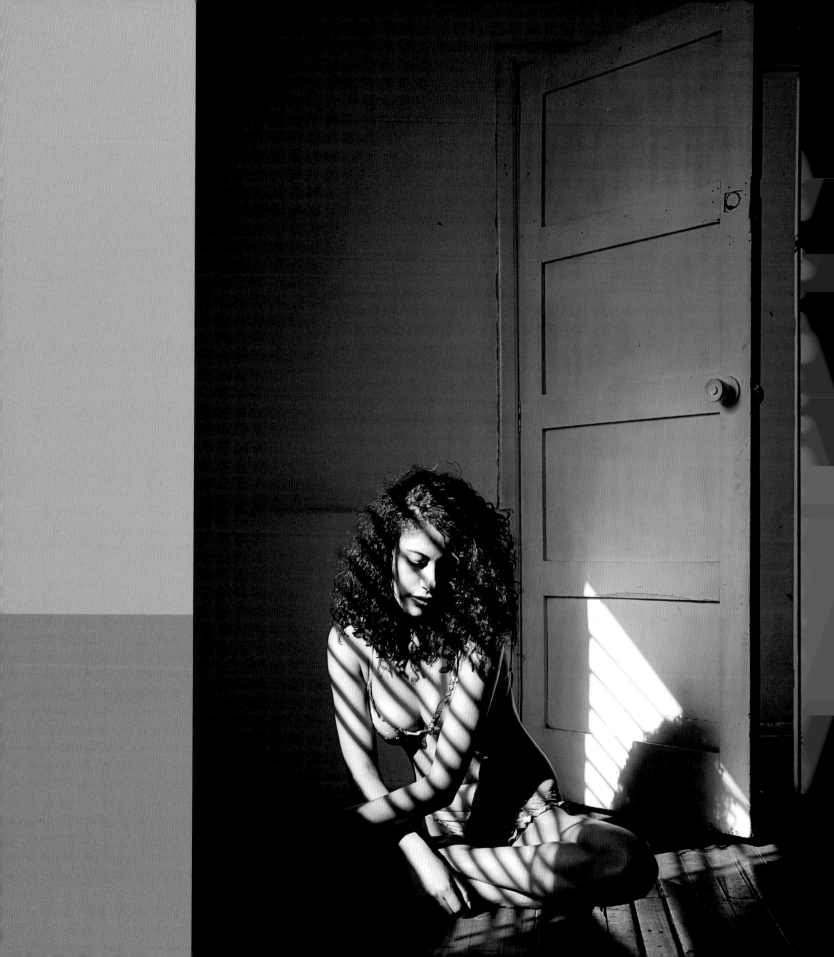

Meltdown

As well as teaching fashion photography and lighting at his studio in Brighton, England, Kevin Mason shoots for a wide range of editorial and commercial clients, and is equally at home in the warmth of the studio as he is battling the elements on location.

"THIS SHOOT WAS FOR a magazine cover, with a loose brief that just had to involve summer/Brighton/the seaside and needed to work as a square crop. It was a collaboration between myself and Emma Sandham-King, based on a 'melting' idea: a hot, summery image with a slight global-warming theme.

These beach huts are naturally vibrant and, after we'd checked out the most colorful, we settled on orange and pink as our backdrop. We sourced as many similarly colored items as we could, and used cheap polystyrene tiles to create a feel of the 'pixelated' beach hut colors falling onto the floor. We went with an equally stylized look for the model, with a lot of bold colors in the makeup and hair (which was wired to make it look as if she was really running).

The lighting was relatively simple—two Bowens 500 watt monolights, a Nikon Speedlight, and a reflector—but battling the heavy wind meant we had an umbrella turn inside out, and we weren't helped when a passer-by crashed his bicycle into our lights! Despite this we managed to get the shot done in the two-hour window we had for it, and after a quick tidy-up of the seafront we had it ready to print a couple of hours later."

GET THE LOOK

- As many photographers who work (or have worked) with transparency film will already know, slightly underexposing your shots is a great way of increasing the saturation. You don't need to underexpose by much—1/3 of a stop is enough to boost the color without the shot simply looking too dark—but it's an effective way of making already saturated colors really "pop."

- To a certain extent, the same is true of digital capture, with slight underexposure helping to intensify already-bold colors. In this shot, for example, Kevin had an exposure reading of *f*/16 on the model, but with the same ISO and shutter speed, the ambient light was reading *f*/13—1/2 a stop less. Rather than reduce the power of his flashes to balance the daylight, he set the camera at *f*/16 and allowed the ambient light to be underexposed slightly "to get added punch to the clouds and sky."

PLAN VIEW

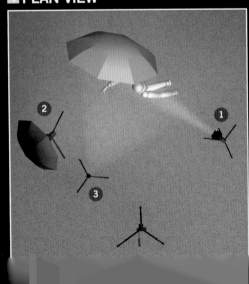

PERSPECTIVE VIEW

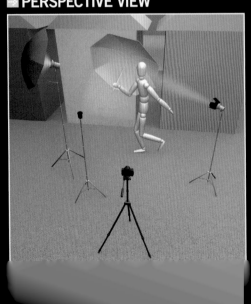

PHOTOGRAPHER: Kevin Mason

CAMERA: Canon EOS 40D

LENS: Canon EF-S 10–22mm *f*/3.5–4.5 USM @ 13mm focal length

APERTURE: *f*/16

SHUTTER SPEED: 1/125 sec

ISO: 160

LIGHTING:

1. 500ws Bowens monolight with barndoors and light straw gel
2. 500ws Bowens monolight with silver umbrella and light straw gel

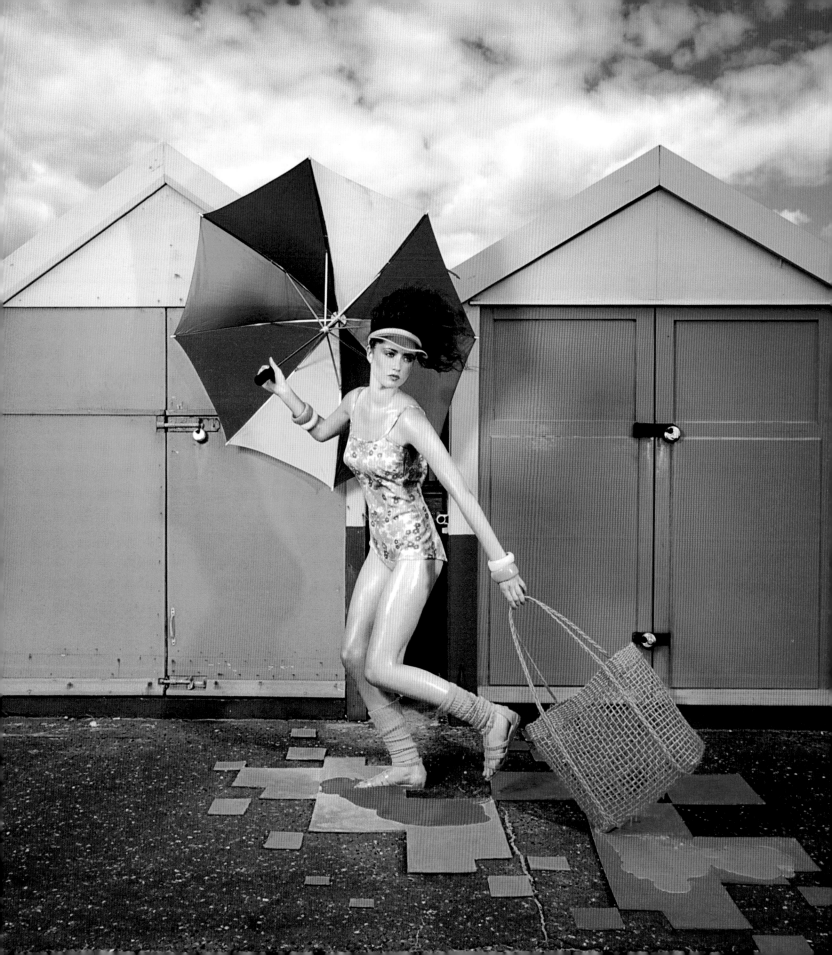

I Love Fashion

As a visual artist, Rossina Bossio works across a range of media that includes painting, drawing, and video, as well as photography. This also makes her approach fashion photography in a slightly different way to many commercial photographers—her images are not so much about idealized beauty and seduction, but more about realism.

"THIS WAS THE FIRST TIME I had photographed Bella, so we hadn't done any test shots or anything like that before I arrived at her apartment in Paris with my camera and tripod. When it comes to working with models, I generally work with whatever I have to hand because I think this makes everything more experimental and spontaneous. For this shot, Bella had already taken lots of great clothes out of her closet and we chose some outfits together for the shoot.

"After we'd finished styling her, we went to the living room and it occurred to me that it would look cool if we messed up the place a little bit. So we threw stuff on the floor and I asked her to crash on the sofa, as if she'd just arrived home drunk from a party. Then she just let go and started doing her thing! I like things to be about 'the moment'—I have a character in mind, but I like to give the model the freedom to improvise if they want to, so Bella did a lot of poses until she slipped and fell onto the floor. That was the moment when the shot happened."

→ GET THE LOOK

▢ With the image downloaded to her computer, Rossina did all of her post-production in Photoshop, introducing the muted color palette, enhancing the cold atmosphere, and darkening areas around the model to focus the attention of the shot. The key to her shot's muted, low-contrast look lies in adjusting the output levels so the highlights are toned, rather than pure white. This can be done with either Levels or Curves in Photoshop and both let you control the highlights and shadows independently. To lower the brightness of the highlights in Levels, simply use the Output Levels slider at the bottom of the dialog window. Sliding the white (highlight) slider to the left will lower the value of the highlights from 255 (pure white), darkening them down and reducing the overall contrast. Alternatively, if you prefer to work with curves, lowering the top right end of an RGB curve vertically downward has the same effect.

◼ PLAN VIEW

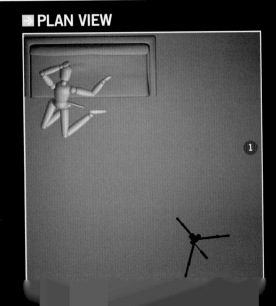

◼ PERSPECTIVE VIEW

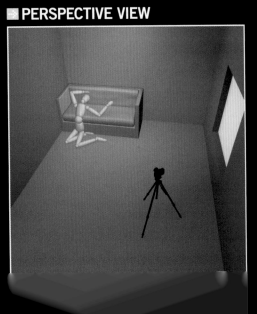

PHOTOGRAPHER: Rossina Bossio

CAMERA: Canon Rebel XT (EOS 350D)

LENS: Canon EF 28–105mm *f*/3.5–4.5 II USM @ 28mm focal length

APERTURE: *f*/3.5

SHUTTER SPEED: 1/40 sec

ISO: 100

LIGHTING:

❶ Ambient daylight

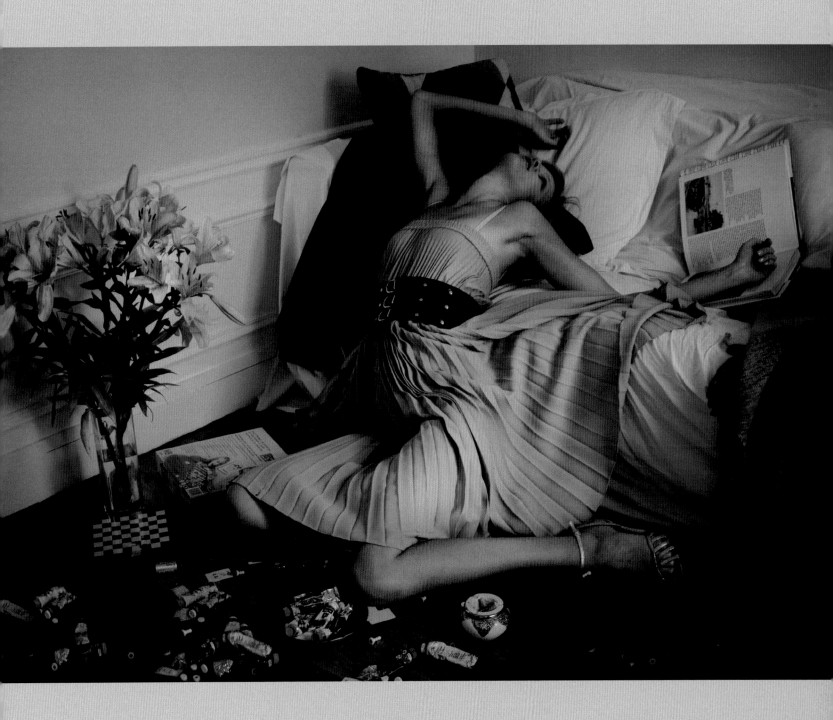

Cape Town Carousel

South African photographer Sean Knott is as confident shooting fashion as he is advertising, portraiture, documentary, and still life, so it's hardly surprising that his commissions see him traveling widely and working closely with advertising agencies and designers the world over.

"THIS IMAGE WAS PART of a lingerie campaign, taken on location in Cape Town, South Africa. It was going to be used for window graphics and in-store point-of-sale advertising, but I wanted to avoid the typical soft and romantic look that characterizes lingerie photography and produce a series of shots with an edgier feel.

"Most of my fashion work is done on location and I like to mix flash with daylight. At the time of this shot, strong sunlight was falling onto the carousel behind the girl and that's partly why I used ringflash—it's an even light that prevents harsh shadows, but it still lets you create a great 'flash-lit' feel. This was also important because we had a lot of shots to get through each day and I didn't have the time to constantly change the setup. In these situations I'll always try and keep the lighting simple, and a camera handheld with a ringflash lets me do just that, but still achieve great results.

"I let the flash dominate the shot, to darken the bright background, which was helped by the natural 'fall-off.' The contrast was increased in post-production to enhance the mood and create the vivid, saturated look I was after."

↪ **GET THE LOOK**

■ Although a lot of people see using a ringflash as a relatively "easy" way of lighting an image, this has its advantages. For a start, as Sean has pointed out, it's a great way of producing a distinctly flash-lit shot that can be repeated across a series of pictures in a short space of time, providing consistency in a series of fashion photographs.

■ However, you still need to think about how you're going to use the flash, as it can produce very different results depending on its distance from the subject. Used fairly close, as Sean has done here, the light from the flash will fall-off quickly, meaning the model will be considerably brighter than the background, enhancing the apparent contrast between the two elements and helping the model "pop." Conversely, if you use a ringflash with a longer focal length (from a greater distance), the light will fall off more gradually, effectively lowering the contrast between the subject and their background.

■ PLAN VIEW

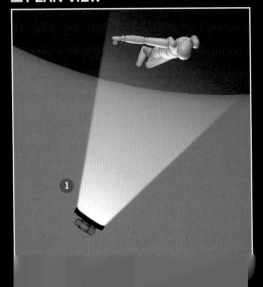

■ PERSPECTIVE VIEW

📷

PHOTOGRAPHER: Sean Knott

CAMERA: Canon EOS-1DS Mk III

LENS: EF 24–70mm *f*/2.8L USM @ 59mm focal length

APERTURE: *f*/6.3

SHUTTER SPEED: 1/125 sec

ISO: 100

LIGHTING:

❶ Profoto ringflash and daylight

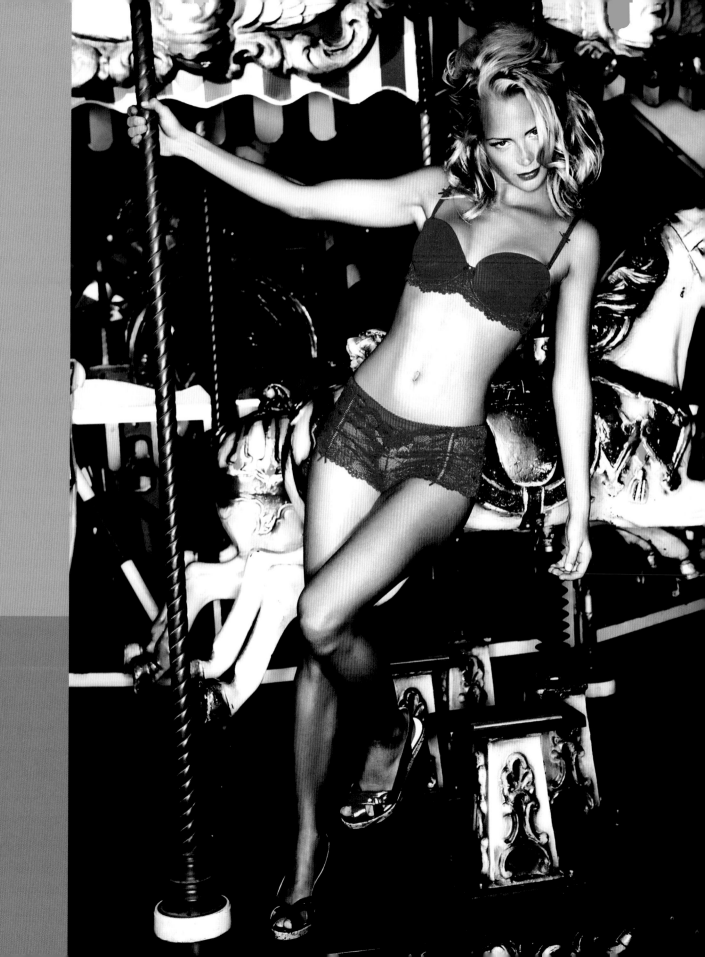

Original Image

Urban Fashion
By Danny Tucker (see overleaf)

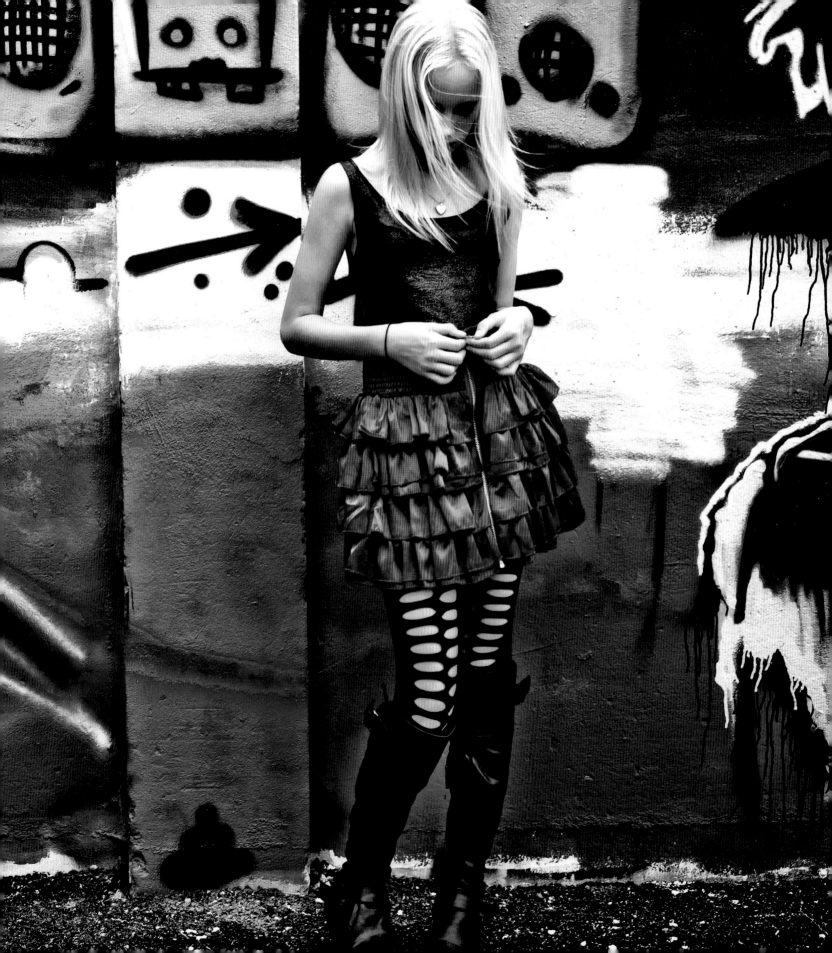

Urban Fashion

Inspired by photographers such as Nick Onken, Zack Arias, and Chase Jarvis, self-taught photographer Danny Tucker enjoys putting what he learns into practice in his fashion shots, but that doesn't always mean multiple strobes or complex lighting setups—equally striking results can be produced with much less kit.

"THIS IS MY DAUGHTER, Katy, who loves to dress up for photoshoots and is taking a strong interest in fashion. We weren't looking to shoot anywhere specific on the day, but when we came across this wall I knew I wanted to use it—the graffiti-style artwork made a great backdrop and complemented the colors of Katy's outfit. The wall was at the back of the car park of a local art gallery, so we dropped by the gallery and they gave me permission to shoot. I do a lot of location work, and most places I call on are happy to let me photograph once I've explained what I want to do. Katy tried a number of different poses while we were there, but I like this one best, without direct eye contact."

There was nothing exotic about Danny's lighting for this shot—he didn't have strobes with him,

so it was a case of using the ambient light. With the sun setting behind clouds, this meant a diffuse light was being thrown down, so the contrast was low, and shadows weak. But although the lighting at the time wasn't strong, Danny knew that could be easily remedied in post-production.

⋙ GET THE LOOK

- With the sun behind the clouds and no in-camera processing of his Raw files, the contrast and saturation were both lacking, so software intervention was vital if Danny wanted to make the colors "pop." Danny carried out the work in Adobe Lightroom, starting out by pushing the Exposure and Fill Light options in the Basic editing panel to the max. This gave a bright image overall, so the blacks were adjusted, deliberately clipping the histogram to get the blocked-in look to the shadow areas. This was reinforced with a contrast-boosting S-curve, giving it an additional push at the highlight end to add extra brightness to the highlights.

- With the contrast sorted, the blue saturation was increased in the HSL (hue/saturation/luminance) panel, with its luminance reduced to saturate the wall. The saturation of the purples and greens was also increased to emphasize the skirt and green paint (see small image on page 88), with the vibrance and saturation sliders fine-tuned so the effect wasn't over the top.

▪ PLAN VIEW

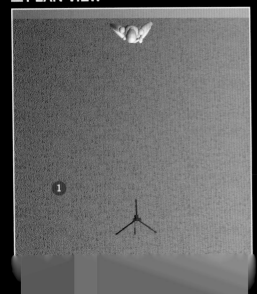

▪ PERSPECTIVE VIEW

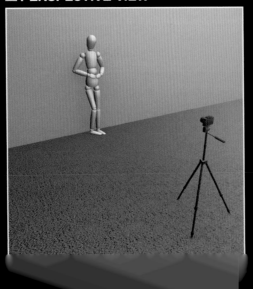

📷

PHOTOGRAPHER: Danny Tucker
CAMERA: Canon EOS 5D Mk II
LENS: Canon EF 50mm ƒ/1.4
APERTURE: ƒ/8
SHUTTER SPEED: 1/50 sec
ISO: 320
LIGHTING:
1 Daylight

LOCATION

ED Magazine

Raised in a predominantly female environment, it's perhaps not that surprising that Simon Pais' early artistic interest centered on drawing female portraits. However, at the age of 17, drawing gave way to photography, and despite starting a course in advertising photography, it wasn't long before Simon returned to his initial inspiration, abandoning his studies to pursue a career in the female-orientated world of fashion photography.

"I WAS COMMISSIONED to shoot a selection of wedding dresses for *ED Magazine* in Chile, including this dress by couture designer Ruben Campos, the 'architect of Chilean fashion' and one of the premiere designers in South America. I shot on location at Museo de la Solidaridad Salvador Allende in Santiago, Chile, and the idea was to show a glamorous bride emerging from an export crate, looking more like a doll than a real person. This meant directing the model in a way that created a deliberate doll-like pose: stiff, but at the same time flowing and feminine.

"To enhance the artificial look I used a lighting setup that added drama and volume to the figure, with strong diagonal lighting and shadows providing the obvious theatricality. To achieve this, I set both of my lights to the left of the camera and aimed them directly at the model: a 1000ws monolight as my key, and a 500ws monolight from a tighter angle as a fill, so the shadows weren't heavy and black."

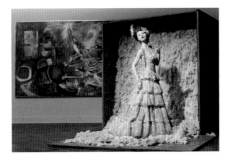

PLAN VIEW

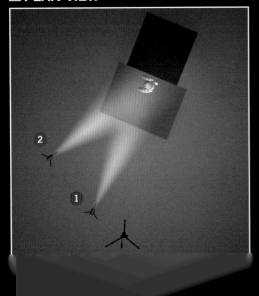

PERSPECTIVE VIEW

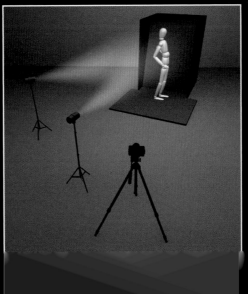

PHOTOGRAPHER: Simon Pais
CAMERA: Canon EOS 40D
LENS: Canon EF 24–70mm *f*/2.8L USM @ 32mm focal length
APERTURE: *f*/8
SHUTTER SPEED: 1/100 sec
ISO: 100
LIGHTING:
1 Hensel 1000ws monolight
2 Hensel 500ws monolight

ED Magazine
By Simon Pais (see previous page)

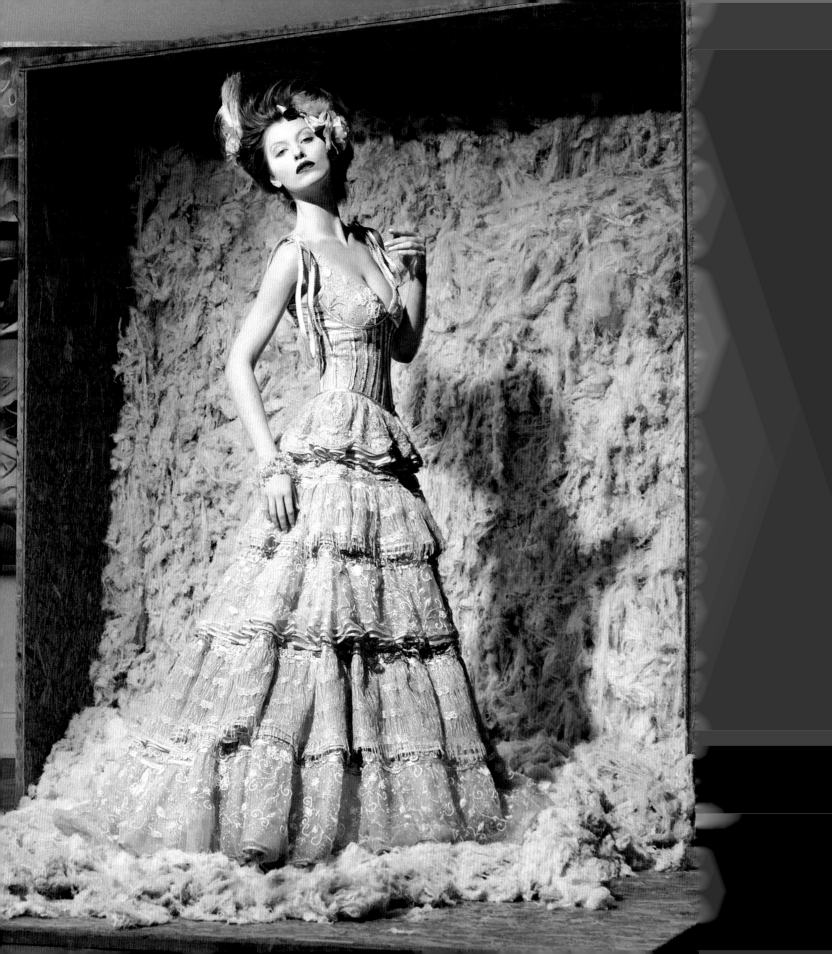

Swimming Pool

Efrén Hernández Luis is a relative newcomer to fashion photography, but since getting his first SLR he has worked hard to hone his skills, enrolling on photographic courses and experimenting whenever he has the opportunity.

"WHEN I STARTED taking pictures I'd go out and look for images I already had in my mind, especially landscapes. As I learnt more, my interest in portraits increased and fashion seemed like a natural progression. What I like most is the lack of rules—you can be as imaginative as you like—and the whole thing is more about teamwork, with designers, makeup artists, stylists, and of course models all bringing something to a shoot.

"This shot was taken at a fashion workshop at Casa Rahn (the Old Convent of Santo Domingo) located in Puerto de la Cruz, Tenerife and it's actually a very simple shot. It was taken at midday in an empty swimming pool and, although the sun was directly overhead, it was a cloudy day so there were no problems with shadows—I didn't even need to use a reflector, just the natural soft light."

But while the shoot was straightforward, Efrén worked hard on the post-processing, using Adobe's Camera Raw convertor to regulate the tonal range before adding two gradients to the image; one to lower the exposure of the sky and bring out the cloud detail, and a second to lighten the bottom half of the image and "lift" the model. Taking the image into Photoshop, Efrén went on to use the program's HDR tools, applying subtle tonemapping to create the slightly "hyper-real" look.

⇢ GET THE LOOK

A fairly recent photographic development, HDR (High Dynamic Range) photography is primarily used as a way of overcoming extreme contrast in a scene. By shooting a series of exposures that cover the full range of tones and then combining, or *tonemapping* them, it's possible to produce an image with detail in every area, from the brightest highlight to the deepest shadow, even when this would normally exceed the dynamic range of your camera. However, while it has a technical purpose, there's no reason why the tools associated with HDR imagery can't be used in less conventional ways as Efrén has done here. By tonemapping a single image—either in Photoshop or a dedicated HDR program such as Photomatix Pro—the contrast levels can be manipulated to give a distinctive appearance. While this will never look entirely natural, it's definitely eye-catching, and certainly a way of adding an extra level of visual excitement to a fashion shot.

▦ PLAN VIEW

▦ PERSPECTIVE VIEW

📷

PHOTOGRAPHER: Efrén Hernández Luis

CAMERA: Canon EOS 1000D

LENS: Canon EF-S 18–55mm *f*/3.5–5.6 IS @ 34mm focal length

APERTURE: *f*/8

SHUTTER SPEED: 1/320 sec

ISO: 100

LIGHTING:

1 Ambient daylight

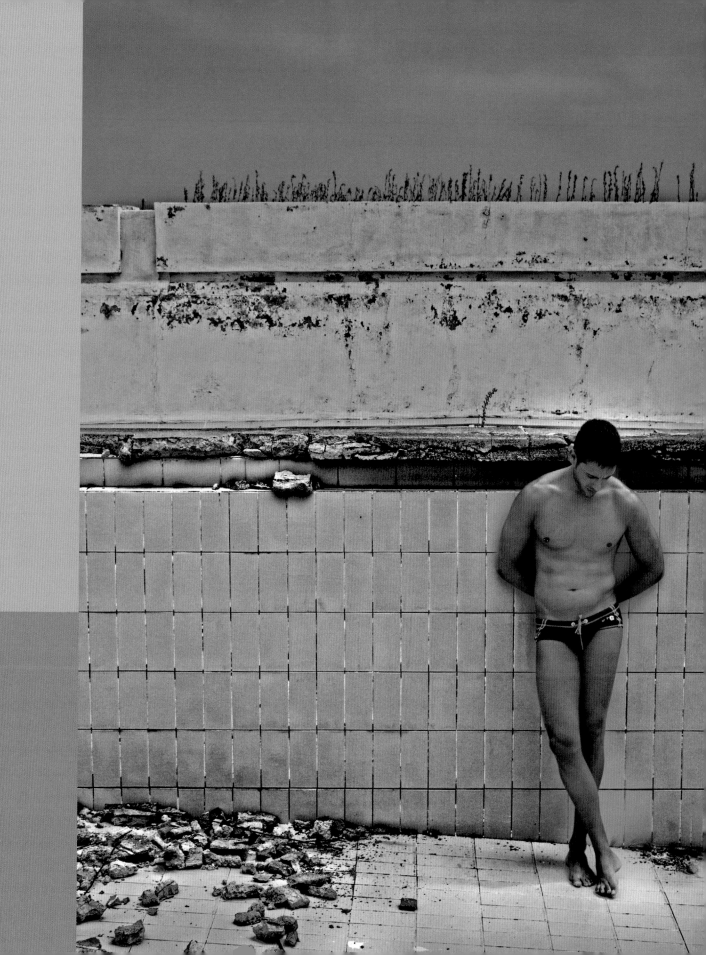

Jump

When he isn't selling his own, and other photographers' work through the online Cuba Gallery, New Zealand-based creative director and commercial photographer, Andrew Smith, is constantly experimenting behind the camera.

"I WAS LOOKING TO SHOOT a series of fashion images based on New Balance shoes and because of the product I wanted to create a strong urban/street feel. I had the idea of the model jumping in a kind of 'free-running' pose, so I chose a gritty location where the model could leap from a higher level so he would appear to be 'flying' across the scene. We used the narrow ledge at the bottom of the metal shutter behind him, and although it took a lot of attempts to get it right, the additional height makes the shot stronger. The leap looks almost bionic!"

Although the pose required a lot of work, the lighting setup was very basic—a remotely-triggered Nikon SB-800 Speedlight bounced into an umbrella was all that Andrew needed to produce the streetlamp-style light for the nocturnal shoot. While this produced an already striking shot, it's the post-production work that really brings it to life. After cropping the image square, and correcting the perspective in Photoshop, Andrew worked on the model's torso to optimize the detail and introduced a subtle split-tone to warm the highlights and cool the shadows. The most significant change, though, was to the color of the metal door in the background—changing the hue from a blue-gray to a shade of green that complements the detail of the shoes, helps integrate the subject and background so they work together as a whole.

⇨ GET THE LOOK

- Adopting or enhancing a universal color theme throughout an image is a great way of fusing the various elements in a picture so they work harmoniously with one another. While the initially-neutral backdrop made the green logo on the shoes stand out, it also created two distinct layers in the shot—the background and the subject—whereas changing the color of the door links the two together.

- In Photoshop CS4 or higher, a color shift like this is relatively easy to achieve using the Hue/Saturation tool. In the dialog window, simply click on the small hand icon and then on the part of the image that you want to change. This restricts subsequent Hue adjustments to the sampled color, in this case allowing the blue-gray of the steel shutter to be turned a suitable shade of green.

Original Image

■ PLAN VIEW

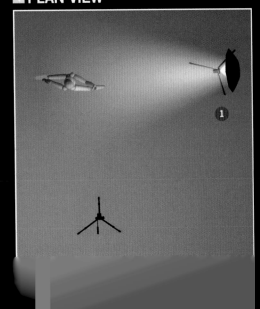

■ PERSPECTIVE VIEW

📷

PHOTOGRAPHER: Andrew Smith

CAMERA: Nikon D3

LENS: Nikon AF-S 24–70mm *f*/2.8G ED @ 35mm focal length

APERTURE: *f*/5.6

SHUTTER SPEED: 1/60 sec

ISO: 400

LIGHTING:

❶ Nikon SB-800 Speedlight with silver umbrella

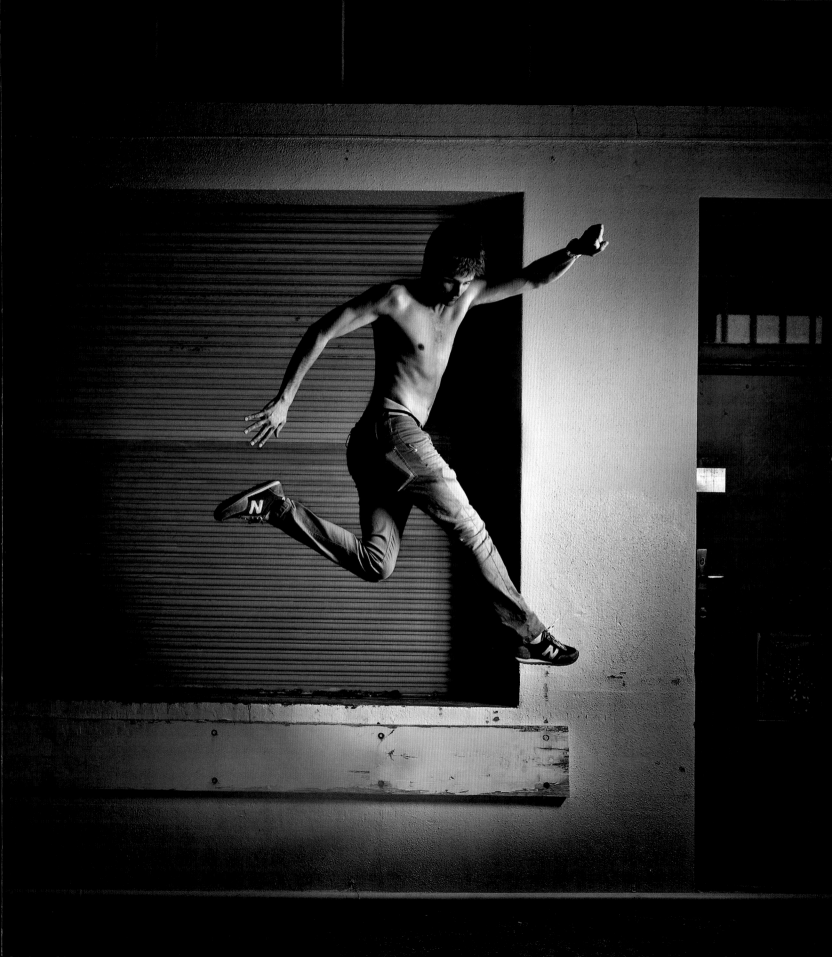

Sabra

A budding fashion photographer, Jaysen Turner has collaborated with a wide range of models and stylists to achieve his vision, building a solid portfolio of work to take him to the next level. For this shot, his co-conspirators were model Sabra, with Brittany taking care of the hair and makeup.

"SABRA HAD BEEN INSPIRED by a collection of images that she had seen elsewhere and called on myself and Brittany to execute them. We've shot several times together, and I love working with her because she'll come to me with a broad concept, then allow me to add my touch with the lighting— just like working for any other client.

"For this shot, we had total privacy in a park in the heart of Austin, Texas, and when we arrived the sun was streaming through the trees, throwing out these beautiful rays of light. This quickly faded as storm clouds rolled in, but I knew I wanted to emulate the look and take it a step further. With rain closing in fast I knew we didn't have long, so I set my strobe behind the model at full power and fired off as many frames as I could before the clouds burst."

Although time was against them, Jaysen and his team have created a shot that hints at a much larger story—one of the key elements for an editorial fashion series. Like a still from a David Lynch movie, the combination of a luxurious fur jacket, grungy military boots, and a teddy bear sends out conflicting messages that raise far more questions than are answered: Who is this girl? Where was she going? Is she asleep, or have we stumbled across something far more sinister…?

→ GET THE LOOK

Although it was the beauty of the sunlight streaming through the trees on a bright day that initially provided the inspiration for the lighting, by allowing the flash to overpower the ambient light Jaysen has taken it to a new, darker level. The warmth of the sun has been removed, and the look is deliberately nocturnal—sunlight has been replaced by cool moonlight. To do this successfully requires two things: a perfectly neutral color balance and preventing the ambient daylight from having too much of an effect on the scene. The former comes down to the choice of white balance and sensitive post-processing, while the latter depends on the exposure, typically achieved with a low ISO, small aperture, and a relatively fast shutter speed.

◼ PLAN VIEW

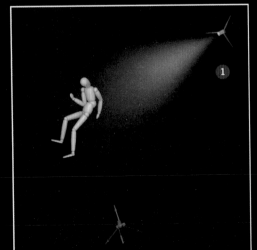

◼ PERSPECTIVE VIEW

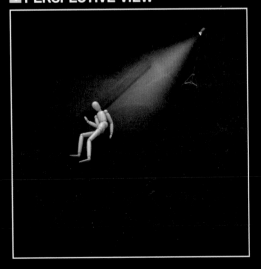

PHOTOGRAPHER: Jaysen Turner, Brooks Institute

CAMERA: Nikon D300

LENS: Nikon 24–120mm f/3.5–5.6G ED-IF AF-S VR @ 34mm focal length

APERTURE: f/10

SHUTTER SPEED: 1/60 sec

ISO: 100

LIGHTING:
① AlienBees AB800 with 7" reflector

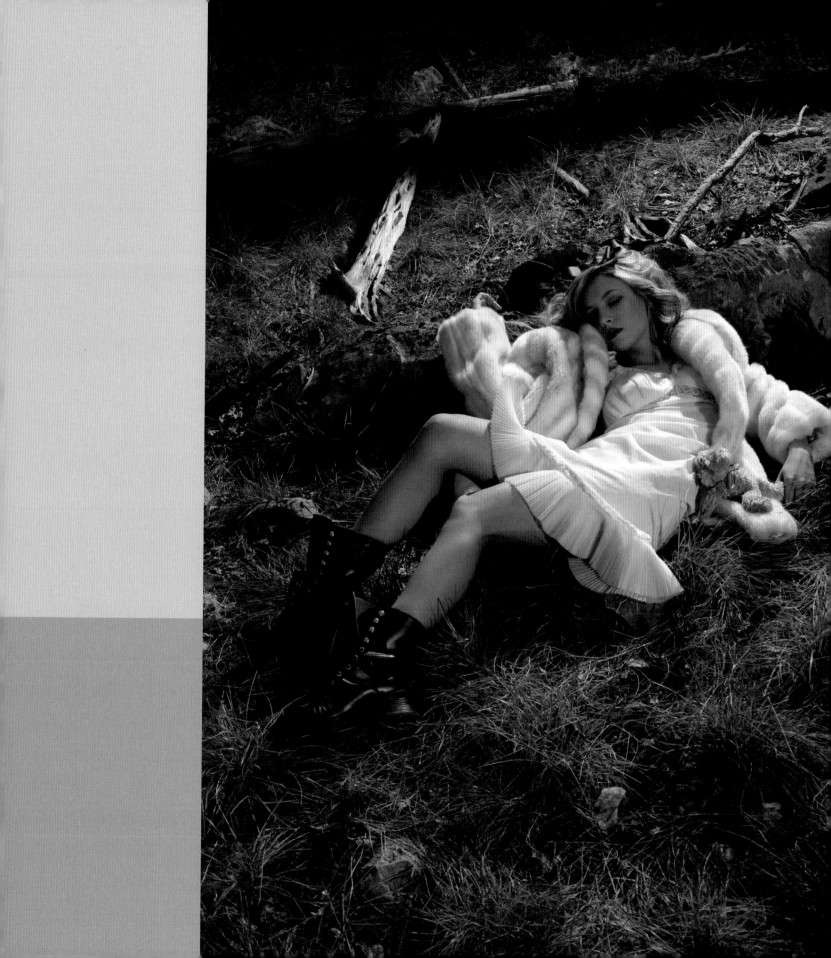

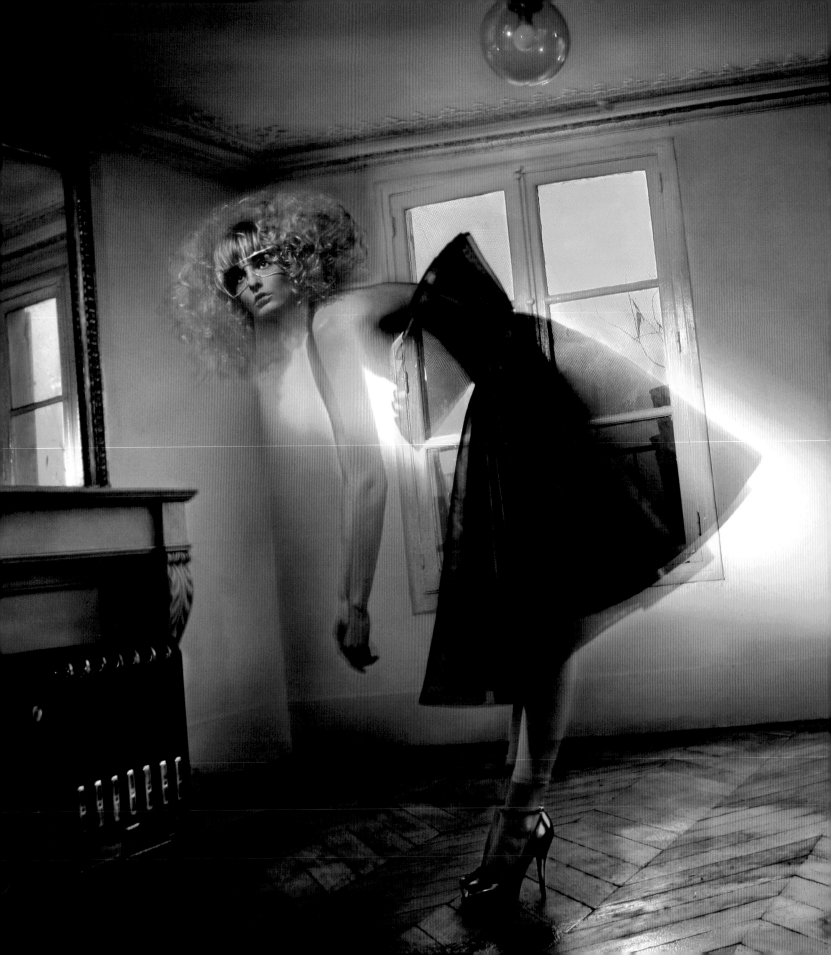

Three-Phase Time
By Raul Higuera (see overleaf)

Three-Phase Time

Raul Higuera shoots for personal pleasure as well as commissions, using the freedom a self-initiated project offers to experiment with new ideas and techniques. This image, for example, was initially conceived in Paris for a series of exhibition photographs, and was shown in New York, Miami, Mexico, Bogotá, and the Dominican Republic before being published in a number of fashion magazines.

WITHOUT A BRIEF, Raul was at liberty to approach the shot however he chose, and for this photograph that meant combining both continuous and flash lighting, with ambient daylight also thrown into the mix. His key light was a strobe fitted with a snoot, which created a small pool of light that was limited to the model. This was augmented with a daylight-balanced HMI lamp that he covered with a red gel and aimed at the wall behind his model, creating the distinct patch of color. To exaggerate the vibrant color in the shot, the windows were also covered with gels, this time blue, which intensified the ambient light spilling into the room and contrasted with the red of the HMI.

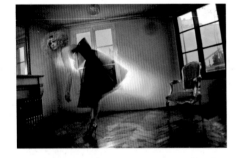

When it came to making the exposure, a daylight white balance setting ensured that the unfiltered strobe remained neutral, while a small aperture and low ISO combination produced the long exposure time necessary to create the "ghost-like" look: once the shutter was fired, the flash "froze" the model, with the extended exposure recording her subsequent movement as a blur.

⇒ GET THE LOOK

Combining continuous and flash lighting has enabled Raul to set a shutter speed for a perfect "flash and blur" effect, while the use of contrasting colored gels injects a rich vibrancy that immediately gives the image its "wow" factor. Yet while Raul has started with light sources that all match in terms of their color temperature, a similar look can be achieved on a smaller budget, without going to the expense of buying gel material for all the windows. Instead of lighting the interior with daylight-balanced lights, you could instead use tungsten-balanced light sources—an 800-watt redhead instead of an HMI, and a full CTO (color temperature orange) gel on the flash. Setting a tungsten white balance in-camera would provide a neutral color base that could then be further gelled, as Raul has done with the HMI. The cool daylight outside would naturally appear far bluer.

■ PLAN VIEW

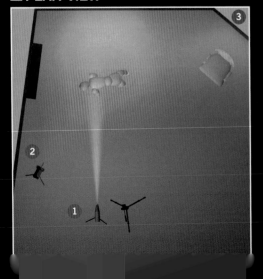

■ PERSPECTIVE VIEW

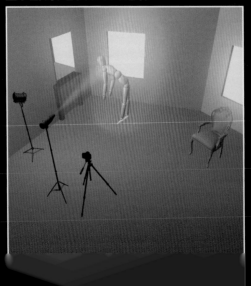

📷

PHOTOGRAPHER: Raul Higuera

CAMERA: Canon EOS 1Ds Mk II

LENS: Canon EF 24–70mm *f*/2.8L USM @ 28mm focal length

APERTURE: *f*/16

SHUTTER SPEED: 1.3 seconds

ISO: 125

LIGHTING:

1 Profoto 1200ws monolight with snoot

2 800-watt HMI with red gel

3 Daylight (blue gels over windows)

Rock 'n' Roll

Croatia-born Kristina Jelcic moved to London to develop her career as a fashion photographer, assisting a number of established professionals as she continued to build her portfolio. But she knows that fashion photography isn't just about the photographer and the model—it's also about "the other creatives who bring things to the table and help make a fashion photo what it is."

DESPITE APPRECIATING fully the role of stylists, hair, and makeup artists, Kristina is just as happy to take on these roles herself when appropriate, as she did here. "The idea behind the shoot was to recreate a slightly retro, summery, 1970s' Americana feel that was both soft and natural, yet strong as an image. I thought Jessica, with her long blonde hair, was the perfect model to invoke those feelings. With every shoot I do I pay attention to the styling—it can be really simple, but it's important to get it right as it can make or break the feel of the photo."

Shot in Epping Forest, on the outskirts of London, Kristina waited until late afternoon when the sun was low in the sky. With the sun behind and to the side of her model, the only other element needed was a small gold reflector, used to enhance the already-warm light as she bounced it back onto the model. Setting the camera's white balance to "cloudy" helped add a golden glow to the overall color, with a wide, $f/1.8$ aperture setting providing a shallow depth of field and the finishing touch to the soft, dreamy image.

⇢ GET THE LOOK

Even though the shot already had a hazy feel due to Kristina shooting toward the sun, she wanted to emphasize it in post production. "I cleaned up the skin and hair from the face (not too much as I wanted the overall feel to be quite natural) and created a curves adjustment layer with the blending mode set to normal. I grabbed the bottom of the master curve and moved it up slightly, which lightens the darkest tones and introduces an overall haze. Next, I switched to the red channel (still in the curves dialog) and brought the bottom of this curve up as well, adding an overall red glow. Switching to the blue channel, I grabbed the center of the curve, and pulled it down to get an overall yellow tone. Finally, I added a Hue/Saturation layer and reduced the saturation: Voila! A retro, seventies-style summer look!"

▪ PLAN VIEW

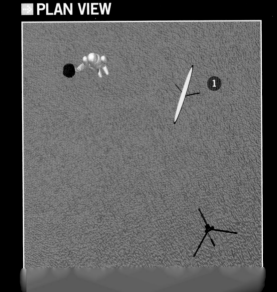

▪ PERSPECTIVE VIEW

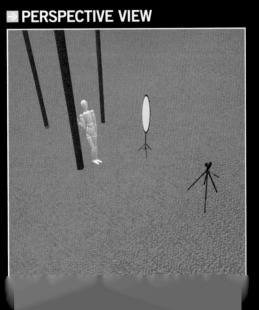

📷

PHOTOGRAPHER: Kristina Jelcic
CAMERA: Nikon D70
LENS: Nikon 50mm $f/1.8$D AF
APERTURE: $f/1.8$
SHUTTER SPEED: 1/1000 sec
ISO: 200
LIGHTING:
① Ambient plus gold reflector

Rock 'n' Roll
By Kristina Jelcic (see previous page)

Magical Winter Wish

For CT Pham—aka "Phamster"—creative strobe lighting is paramount for his fashion and portrait photography. This has meant a heap of research into the photographers and photographs that inspire him, analyzing other people's lighting setups and then determining how to recreate and develop them himself.

"THIS SHOT WAS the first I took for a series that was going to be based on the Four Seasons—something I'd been thinking of doing for a while. It was inspired by the photographer Oleg Igorin, who had done something similar, but I wasn't attempting to 'copy' his work outright; I simply saw it as the catalyst for my own images.

"The photograph was done in a parking garage, and one night I headed there with the model, two assistants, three Nikon Speedlights, and a single AlienBees AB1600 strobe with a Vagabond battery pack. I used the AB1600 for my key light, fitting it with a versatile 64-inch parabolic umbrella, and added two Speedlights—one each side of the model—to cross light the glitter. Both Speedlights were firing from small softboxes, with one gelled blue, and the other green to add some color. A third Speedlight was positioned behind the model and fired into a shoot-through umbrella to lighten the wall and provide partial side lighting. Because of the difference between my hotshoe flashes and the monolight, I had to set the AB1600 to 1/4 power, while the Speedlights were fired at full strength. It was then just a case of getting the model to blow the glitter from her hands while I shot. We got through a lot of glitter that night!"

→ GET THE LOOK

When you're shooting on location using batteries to power any strobes you use is a great solution if there isn't a main power supply—unless you take a generator with you. An increasing number of studio packs have a battery-powered equivalent that allows you to take them on location, and there are also battery packs for some monolights. However, don't write off using hotshoe-style flashes. Although they put out less power than a studio strobe, this isn't a problem when you're shooting in a dark interior, or outdoors at night—the flash will still overpower the ambient light. Also, more and more companies are producing accessories for small flashes, so you can shoot with softboxes and snoots, or stick them on a stand and use an umbrella to bounce the light. It's much easier and cheaper to carry spare batteries for them as well.

■ PLAN VIEW

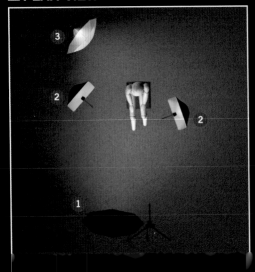

■ PERSPECTIVE VIEW

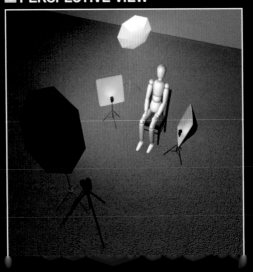

PHOTOGRAPHER: CT Pham
CAMERA: Canon EOS 5D Mk II
LENS: Canon 85mm L
APERTURE: f/9
SHUTTER SPEED: 1/160 sec
ISO: 500
LIGHTING:

1. AlienBees AB1600 monolight with 64-inch parabolic umbrella
2. Two Nikon Speedlights firing from small softboxes (one blue gel, one green gel)
3. Nikon Speedlight fired into shoot-through

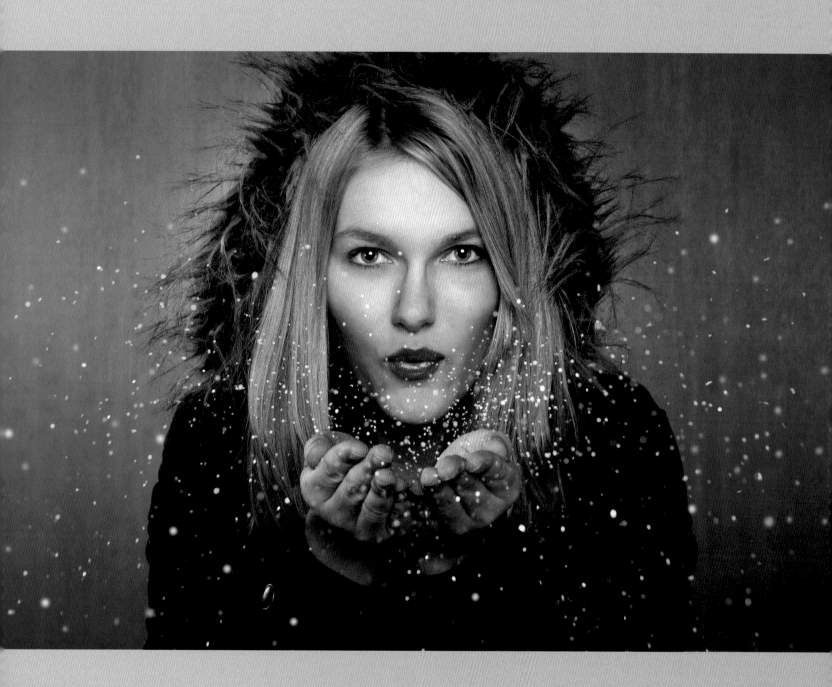

Love Miss Daisy

After a six-year stint working as a photographer in Miami, Brett Harkness returned to the UK to set up his own studio. Specializing in fashion, portraiture, and social photography, his work attracts a diverse number of clients and commissions, and is regularly featured in a wide range of photography magazines.

THIS IMAGE WAS SHOT for a clothing company called Love Miss Daisy, which focuses on 1950s' vintage clothing. Taken in the UK in July, Brett decided to end the day-long shoot with something a little different. "It was around 9pm, the light was fading fast, and we were about to wrap. But I wanted to finish with a bang. I had some smoke bombs with me that I'd been looking to use for a while, so I thought this was the time to give them a go!"

Wrapping the model in vintage petticoats, Brett set up his main strobe with a 135cm octabox, adding a second strobe behind the model to light the fallen tree at the left of the frame and create a rim-lighting effect as it passed through the smoke and across the subject. Although it was starting to get dark, there was still enough ambient light to get the shot if he'd wanted to, but Brett decided to let the flash dominate. By deliberately setting a short exposure with a fairly small aperture setting, the ambient light had little effect on the scene, allowing the flash to create the high-contrast look he was after. When a fallen branch was handed to the model to give her a more dramatic pose, the mystical scene was set.

⇢ **GET THE LOOK**

Smoke can add an extra dimension to a location shoot, whether it's adding a light, low-level fog around the model's feet in a gritty, urban environment, or using intense clouds to partially conceal the subject. For most photographers this means buying or renting a theatrical-style smoke machine, but as most of these need a power outlet this isn't always ideal when you're shooting on location, unless you want to take a generator with you. Brett's solution was simple: he headed to his local hardware store and picked up some smoke "bombs" that are more commonly used to check if chimneys and flues are clear. Although you don't have much control over the smoke, on a small-scale shoot like this they can work well. A word of warning, though—the smoke they produce is toxic, so don't use them too close to the model, and definitely don't think about using them in the confines of a studio!

▣ **PLAN VIEW**

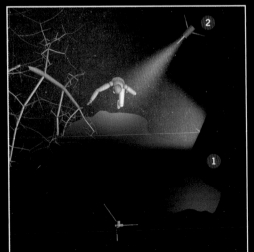

▣ **PERSPECTIVE VIEW**

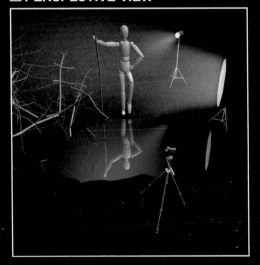

PHOTOGRAPHER: Brett Harkness

CAMERA: Canon EOS 1Ds Mk III

LENS: Canon EF 70–200mm f/2.8L IS USM II @ 90mm focal length

APERTURE: f/8

SHUTTER SPEED: 1/100 sec

ISO: 400

LIGHTING:

① Elinchrom Ranger with 135cm octabox

② Elinchrom Ranger with reflector

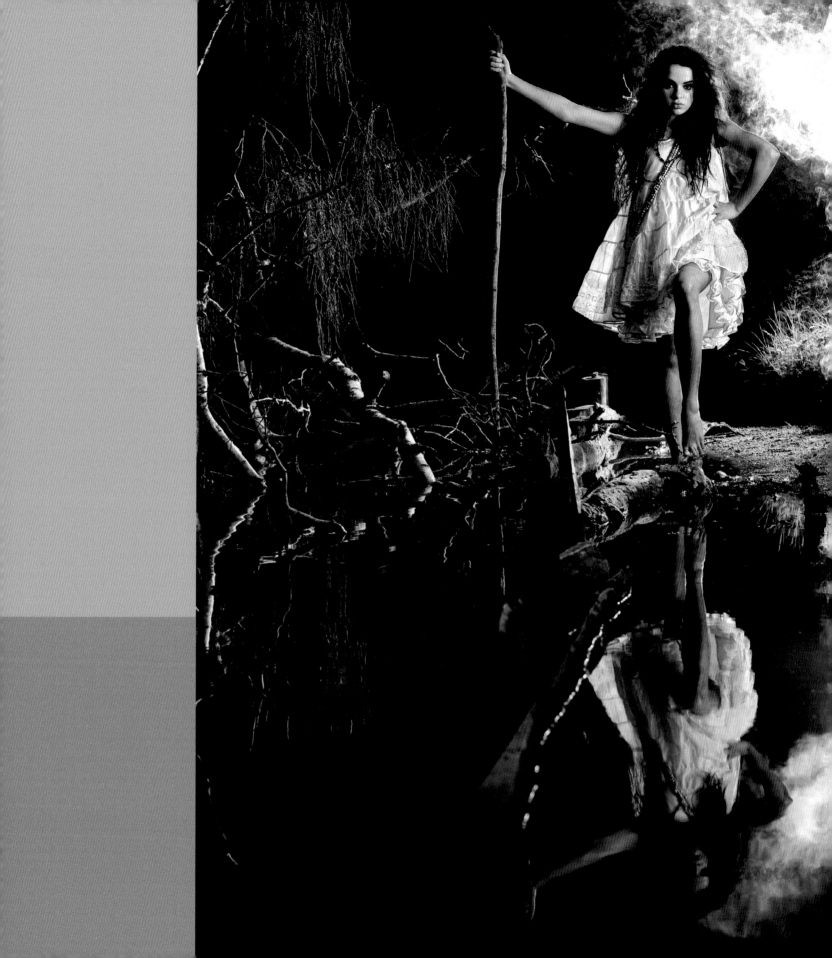

Bathroom

When Kerry Burrow isn't producing TV commercials or shooting promotional videos he can be found on location or in the studio, exploring a variety of creative techniques and experimenting with his fashion photography.

"SOMETHING I DO quite often when I'm shooting on location is to look for architectural features or interior designs that control the natural light. I'll look for colors and textures that complement and accommodate my end vision—that 'perfect' spot that works for the shot I've got in my head. In this image I was looking to push that concept further and step outside my comfort zone. While I normally look for colors that I know will work harmoniously together, this time round I wanted to experiment with 'unnaturally' grouped colors and see if I could work them into a result that would somehow look natural.

"I shot this in a pink-tiled bathroom, waiting until the end of the day when it was flooded with the light from a golden sunset. The light streaming through the window provided me with a strong backlight, but I needed to use a reflector to bounce some of it back onto my model. I went with a metallic blue reflector, just to see what would happen, and I actually surprised myself with the way it turned out. I only needed to play with the tones a small amount in post-production to get a good balance between the vibrant and inherently different blues, yellows, and pinks in the picture."

⟶ GET THE LOOK

■ When you're thinking of using a reflector in a fashion shot, the chances are you'll consider one of three options—a standard white reflector, silver for a bit more "power," or gold to warm the image. In this shot, Kerry ignored those established "rules" and opted for a metallic blue reflector. This not only reflected more light onto the subject, thanks to its metallic surface, but it also colored the light, countering the golden sunset and introducing its complementary color—blue—into the mix.

■ The best thing about this is you don't need to spend a stack of cash to create a similar effect, or simply experiment with alternative colors. Commercial pop-up reflectors from a photo store may be designed for a specific purpose, but a large sheet of card or board from your local art supplier will have a similar effect. It also has the added bonus of costing next to nothing.

▣ PLAN VIEW

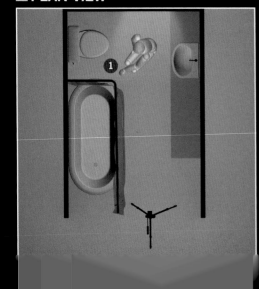

▣ PERSPECTIVE VIEW

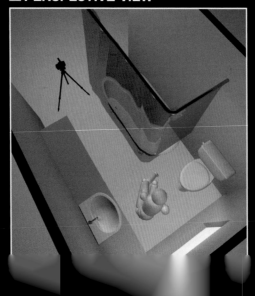

📷

PHOTOGRAPHER: Kerry Burrow
CAMERA: Canon EOS 5D Mk II
LENS: EF 50mm f/1.4 USM
APERTURE: f/1.4
SHUTTER SPEED: 1/80 sec
ISO: 1000
LIGHTING:
① Ambient daylight and metallic blue reflector

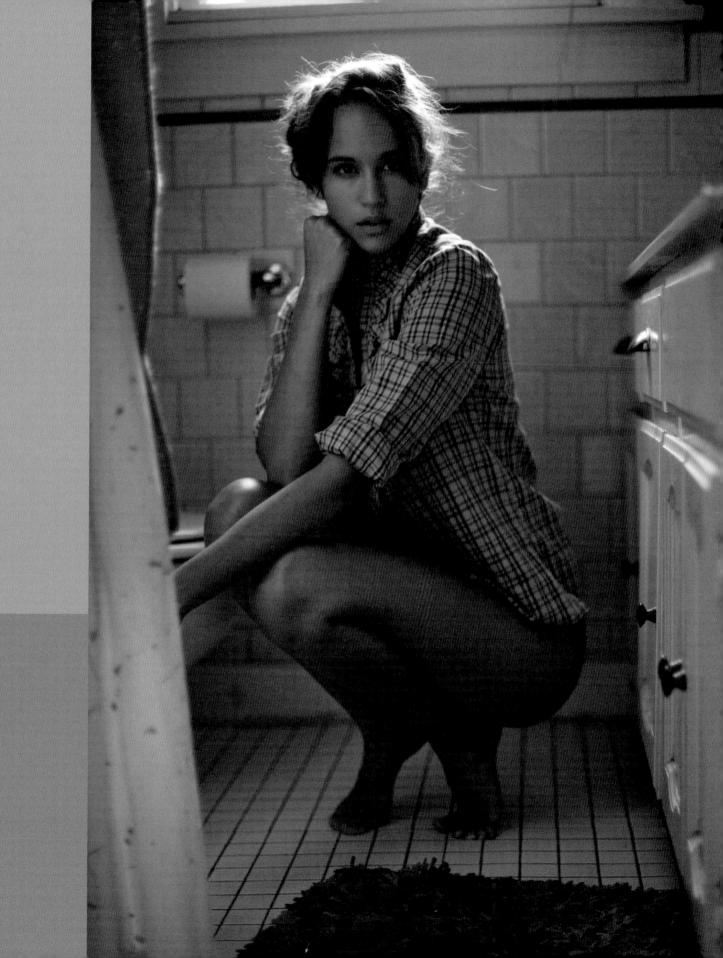

Marina

Having traveled for a while, living first in Shanghai, and then Bangkok, Jens Ingvarsson is currently based in New York where he splits his time between running his commercial modeling agency, Exodus Model Management, designing and producing his own range of handbags, and photography.

JENS HAD BEEN SHOOTING a handbag catalog in his studio when the sun began to set. "This shot wasn't planned at all, but when I saw the warm, almost magical light through the window I knew I wanted to use it. The model I was using for the catalog was wearing this stylish black feather hat—a hand-made improvisation that my fashion stylist put together right before the shoot—and I thought all those feathers would look great against the light. It was the right time for a coffee break, so we all took a break from the studio shoot and headed up to the roof with the camera.

"It was a very easy setup—I just positioned the model with the sun right behind her, and had my assistant hold a white reflector in front of her to bounce back some of the sunlight. I opened the aperture up to f/4 to get a relatively shallow depth of field and with the ISO at its lowest setting I handheld the camera at 1/60 second, allowing a fair amount of ambient light to flow in to overexpose the background slightly and enhance the flare. There was only a little bit of post-production work needed to finish up—other than some basic color correction I just added a purple tint to the shadows to emphasize the warmth of the highlights."

❖ GET THE LOOK

■ The sun is one of the most accessible (and cheapest) lightsources available, and it can be a great way of getting some really striking shots for your portfolio or a commission. Shooting against the light is a classic technique and, as Jens shows here, it really doesn't require much more than a striking subject and a reflector. Simply position your model with their back toward the sun, position a reflector in front of them to act as a fill light, and shoot. Using wider aperture settings will enhance any flare, which can add to the effect, and don't be afraid to overexpose your shots to blow out the background entirely. In the studio, you can create a similar effect just as easily with a large softbox set up directly behind your model—use warm gels or manipulate the white balance if you want to create a "sunset" vibe.

■ PLAN VIEW

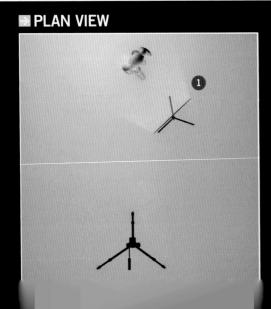

■ PERSPECTIVE VIEW

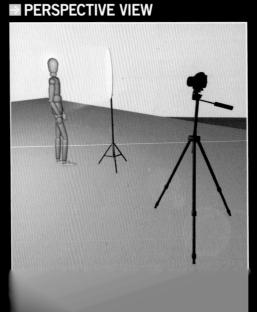

📷

PHOTOGRAPHER: Jens Ingvarsson

CAMERA: Canon EOS 5D Mk II

LENS: Canon EF 24–70mm f/2.8L USM @ 70mm focal length

APERTURE: f/4

SHUTTER SPEED: 1/60 sec

ISO: 50

LIGHTING:

① Ambient plus white reflector

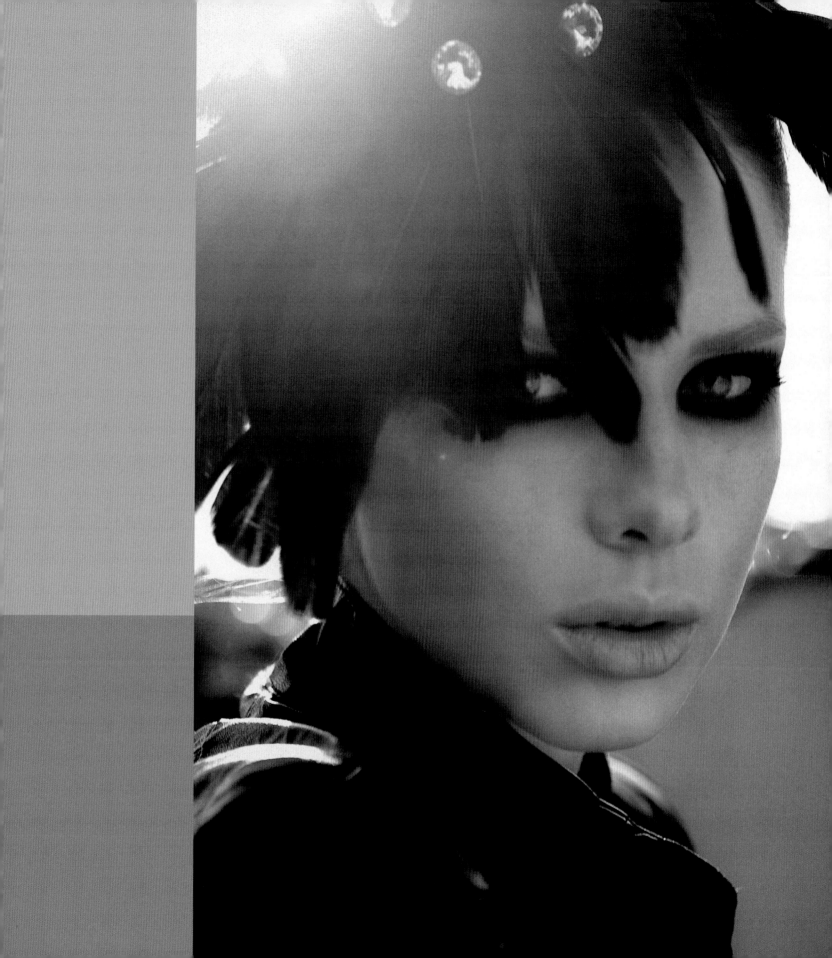

The Stairs

Currently based in Curitiba, Brazil, Paula Anddrade specializes in people photography, be it private commissions of couples, families, or children, or commercial fashion projects and model folios.

"IT IS REWARDING to photograph people who give me access to their world in order to capture them from my point of view; to discover their best angles and the right moment. There is grace to explore in everyone and I'm passionate about recording people, life, and the world at large through the camera's eye. I have a passion for pictures that are slightly unconventional, but communicate beauty through light, contrasting colors, and composition."

It's that exact combination of light, color, and composition that come together so successfully in this shot and, although incredibly simple, it's the naturalness of the lighting that plays a significant part in tying it all together. Taking advantage of the natural light streaming through the windows, Paula simply relied on the curved, light-colored walls to bounce the light around and act as a fill. Introducing artificial light into the location would almost certainly have destroyed the atmosphere here, by opening up the shadows and losing some of the sense of mystery.

Post-processing offered Paula the opportunity to heighten this mood, carefully adjusting the already-muted colors in her limited claret and gold palette, and deepening the shadows at the base of the image to balance the lighter tones at the top. However, the biggest change was the application of Photoshop's Motion Blur filter to the fabric—it's not the most refined filter available, but in this instance it works perfectly.

⇨ GET THE LOOK

The success of Paula's shot comes in no small part through the composition: the careful balance of both the visual elements in the frame *and* the tonal range. Almost monochromatic in appearance, the muted color palette of the location works in harmony with the subject, with the light walls balancing the swathe of fabric, and the deep red walls echoing the detail in the dress. More importantly, the viewer is drawn expertly into the image through the use of leading lines: the white rail to the left takes us up to the model, as does the motion-blurred fabric, while the curved wall to the right sweeps the eye toward the model and prevents our gaze from leaving the frame. This has all been emphasized through the choice of a wide-angle, 17mm focal length, which naturally exaggerates the perspective, especially when used from a low angle, looking upward.

◧ PLAN VIEW

◧ PERSPECTIVE VIEW

📷

PHOTOGRAPHER: Paula Anddrade
CAMERA: Canon EOS 5D Mk II
LENS: Canon EF 17–40mm *f*/4L USM @ 17mm focal length
APERTURE: *f*/4
SHUTTER SPEED: 1/40 sec
ISO: 200
LIGHTING:
❶ Daylight

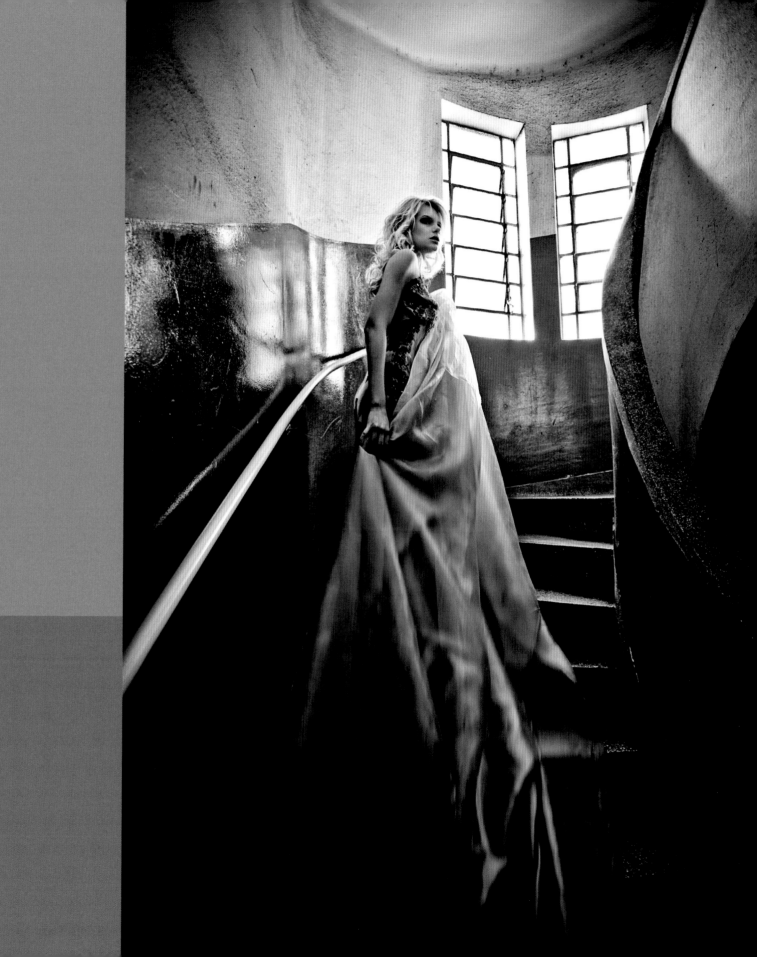

Mono

Black-and-white imagery is pervasive in all forms of photography, but combining fashion with monochrome seems somehow counterintuitive and perhaps even perverse when you consider the amount of time and effort that designers spend carefully choosing the color palette for their latest creations. Yet despite this, fashion stories and adverts that are strictly monochrome continue to be produced and published, and you don't need to look any further than the images in this chapter to see why this is.

Sure, monochrome may not be able to record color, but it more than makes up for this in other areas. Without the distraction of color, the shape, texture, and form of a designer's vision can come to the fore, while from a narrative perspective, black and white has the ability to create a specific mood in a highly enigmatic way. From stark, single-light setups that produce a harsh chiaroscuro effect harking back to the cinematic tradition of "film noir," through to far softer, more ethereal images that rely on a delicacy of touch from the photographer to create a limited tonal range, black and white is arguably more emotive than color, undoubtedly just as valid. And, of course, lighting plays a crucial part in this.

Tom

Like many photographers, Polish-born Anna Olszewska headed to art school to learn her craft, where the freedom to experiment with a multitude of creative techniques enabled her to build up a stunning portfolio of work with which to launch her professional career.

"I WAS WORKING with a professional stylist in the studio with the idea of creating a series of simple images with a quirky look. I was using a Canon EOS 40D with a 50mm 'standard' lens, and the lighting came from two strobes: the first to the right of the camera, fitted with a reflector and a grid to keep the light pool fairly tight, plus a spotlight aimed at the background to eliminate any strong shadows on the floor. A white reflector on the opposite side of the camera was added to bring out the detail in the left side of the model's face.

"It wasn't until I started working on the images in Photoshop that the 'ghostly' effect came to me. I combined two different images, copying one onto a layer above the other. By lowering the opacity of the second image I got the ghostly look, but I needed to work on the layer mask to conceal specific elements that I wanted to leave untouched—primarily the model's face. I then converted the color original into black and white using Silver Efex Pro, a Photoshop plug-in, increasing the contrast, the brightness, and emphasizing the textures, as well as adding a warm tone."

▣ GET THE LOOK

- Multiple exposures walk a fine line between looking overly contrived and unnatural, and enhancing a concept and (literally) adding another layer to an image. Anna's picture falls firmly into the latter category, with the ghost-like overlay creating a subtle sense of movement in an otherwise static studio shot.

- In the pre-digital age, multiple exposures were a hit-and-miss technique, requiring careful attention to the exposure and composition of both shots to make sure that both aligned correctly and exhibited the right balance in terms of their density. However, with an image-editing program it's very easy to experiment with this type of look—simply put each shot that you want to use on its own layer and move and manipulate them on screen until you get the result you are after. As well as reducing the opacity of one, or both, of the layers, you can also experiment with blending modes to create different effects, as well as combining both color and monochrome in a single image.

▣ PLAN VIEW

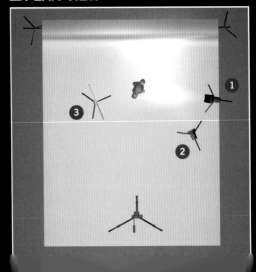

▣ PERSPECTIVE VIEW

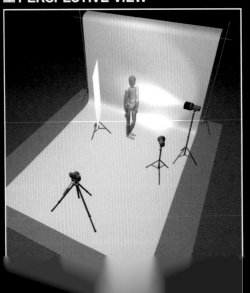

📷

PHOTOGRAPHER: Anna Olszewska
CAMERA: Canon EOS 40D
LENS: Canon EF 50mm ƒ/1.8 II
APERTURE: ƒ/8
SHUTTER SPEED: 1/125 sec
ISO: 100
LIGHTING:
1 Strobe with reflector
2 Grid spotlight
3 White reflector

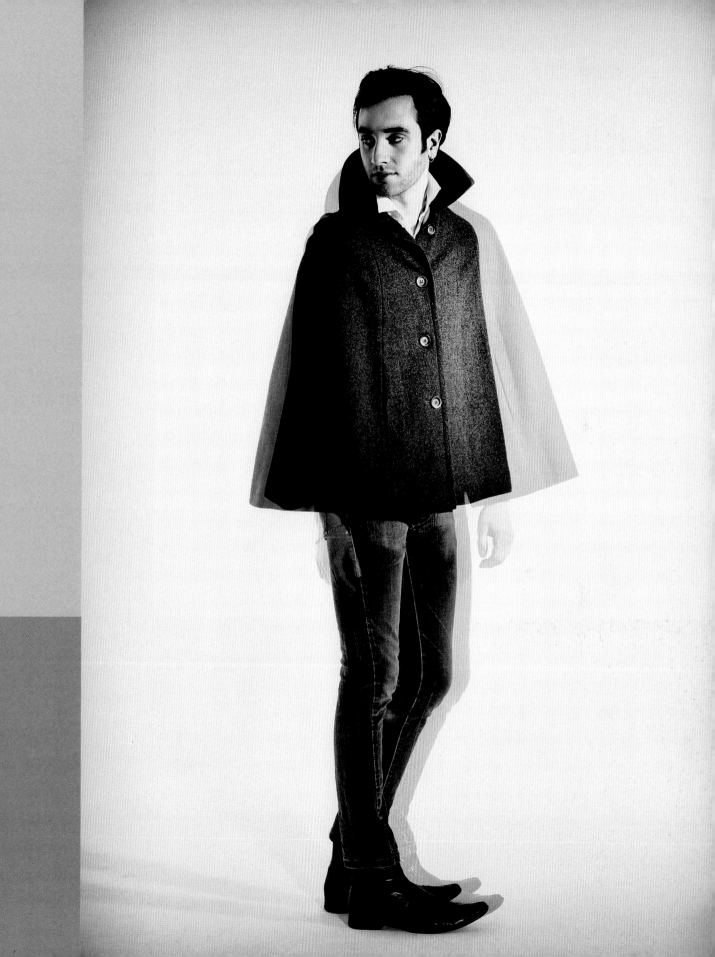

Isabella Araújo

As the sole photographer for Elder Depizzol, a Brazilian casting agency, fashion photographer Alexandre Godinho was responsible for producing a wide range of portfolio images for an assortment of models. Working to tight shooting schedules in makeshift studio environments often meant there was little time for elaborate lighting setups, yet the photographer still had to deliver results that would appeal to both the local and international modeling markets.

THIS STRIKING black-and-white image was taken in the mundane surroundings of a hotel meeting room. Measuring only 16' x 13' (5m x 4m), and with a low ceiling height, positioning multiple strobes in the confined space wasn't an option, so Alexandre used a simple one-light setup.

"When Isabella, the model, walked in wearing a gray dress I knew that my pictures were going to be black and white so I wanted contrast in the shot. The problem was that the room wasn't very big, and because the walls and ceiling were white they were all working like giant reflectors, creating an overall softness light. This was great as a general fill, but I wanted a high-contrast look. To achieve this I set up a small 200-watt monolight with a square softbox and positioned it about one foot (30cm) from the model's face, tilting it downward slightly to create the shadow under her chin. With the flash set at 1/4 power I could still use a relatively small aperture. When it came to post-processing I simply increased the contrast a bit more and added some noise to give it a 'grainy' look."

⇢ GET THE LOOK

■ Despite shooting in a space that most photographers would deem "unsuitable" for photography and using a strobe that many would assume isn't powerful enough, Alexandre has created a stunning black-and-white image that required surprisingly little Photoshop work. The single, low-powered flash—even at 1/4 power—easily becomes the dominant lightsource in the windowless room, rendering the white wall in the background a deep gray thanks to the combination of a fast shutter speed and low ISO. At the same time, the proximity of the flash to the subject has meant that her skintones remain bright while the shadows are dark: the closer the flash, the higher the contrast. This has also allowed Alexandre to overexpose the skintones slightly, and while this doesn't affect the impact of the image, it successfully conceals any blemishes without having to rely on image editing at a later date.

■ PLAN VIEW

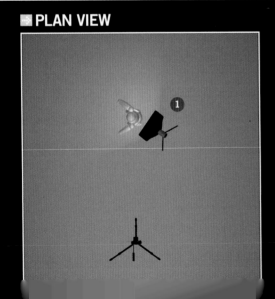

■ PERSPECTIVE VIEW

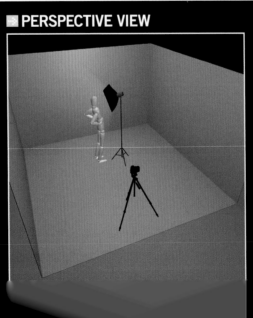

PHOTOGRAPHER: Alexandre Godinho

CAMERA: Canon EOS 5D

LENS: Canon EF 70–200mm *f*/2.8L IS USM @ 150mm focal length

APERTURE: *f*/9

SHUTTER SPEED: 1/200 sec

ISO: 200

LIGHTING:

❶ Atek 200 strobe with 70cm x 70cm softbox

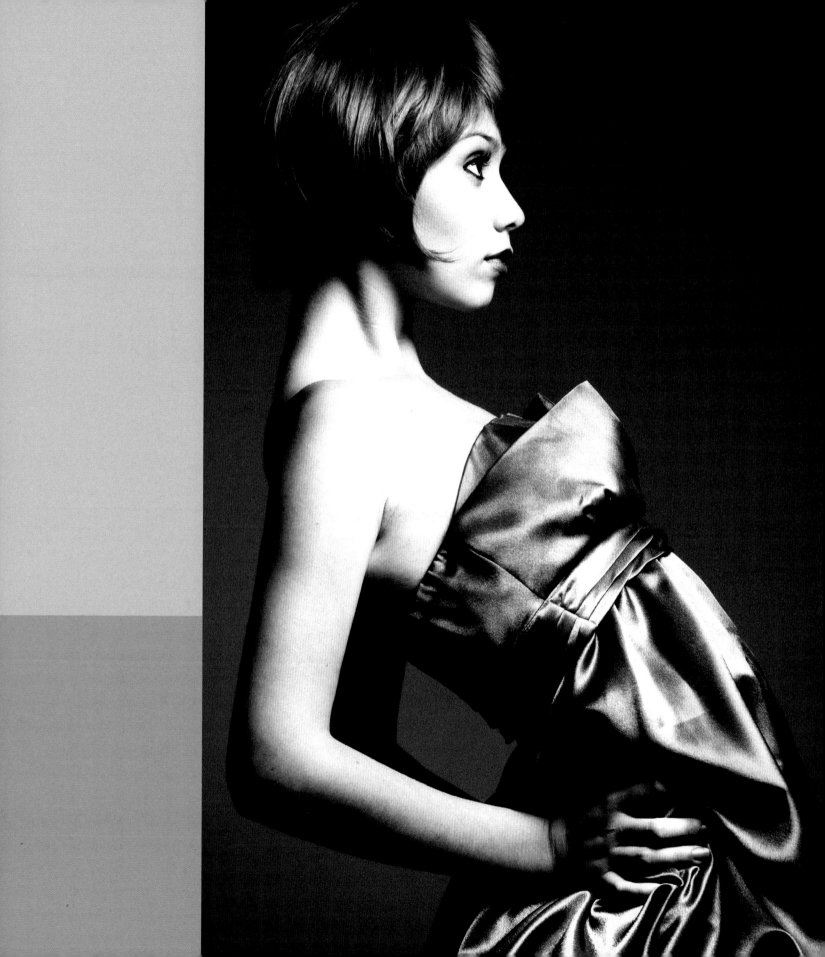

Santa Monica

Caitlin Bellah's exquisitely stylized fashion images have appeared in magazines around the globe, from *Cellardoor* in the UK to *Peppermint* in Australia, and *Teen Vogue* in her native USA. But perhaps what is more remarkable about this young photographer's success is that she's entirely self-taught, proving that a formal photographic education isn't as important as natural talent, vision, and persistence.

"AS FAR AS LIGHTING goes, all of my images are taken using natural light—sometimes with reflectors, other times without, as was the case with this picture. The shot was inspired by a collection of Victorian photographs of women at Ocean Beach, in San Francisco. I thought it was strange how these women would go to the beach in all of these heavy clothes and even though it should be a joyful day of 'fun in the sun' they almost always looked bored. I just wanted to take an image that reflected that mood; a shot that was slightly strange, where the mood contrasted with the location."

Styling plays a clear part in the success of Caitlin's slightly maudlin fashion shot, with the outfit and accessories giving it a timeless quality and the balloons adding a slightly surreal edge. This feeling of a photograph taken in "another time" is enhanced by the entirely nondescript beach location and quite intensive post-production work in Photoshop. Blurring the upper section of the frame digitally has transformed it into a featureless "fog" that adds to the somber mood, while a colored gradient and subtle vignette adds to the vintage tone.

→ GET THE LOOK

- Although Caitlin has used a colored gradient to add an aged look to her photograph, applying a uniform color, or "stain," is also a great way to add color interest to a black-and-white photograph. Staining is a process that goes back to the traditional black-and-white darkroom, but unlike toning, it would be done to the print without bleaching it first, so it only affected the lighter areas of the picture, keeping the shadows deep and relatively neutral.

- Recreating a stain is incredibly straightforward in most image-editing programs that feature layers and blending modes. In Photoshop, simply add a Solid Fill adjustment layer and choose the color you want to use for your stain from the color picker. It's then just a case of changing the blending mode to Darken or Multiply and reducing the opacity to add a vintage stain to your otherwise monochrome picture.

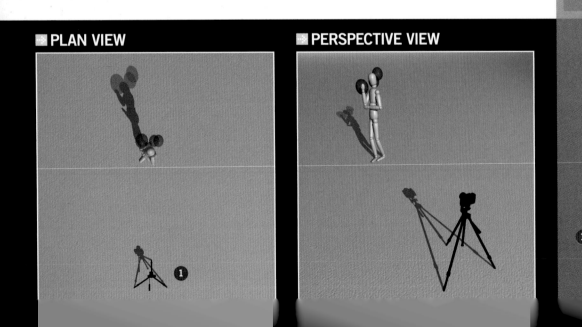

■ PLAN VIEW

■ PERSPECTIVE VIEW

PHOTOGRAPHER: Caitlin Bellah

CAMERA: Nikon D50

LENS: 18–55mm *f*/3.5–5.6G AF-S DX @ 50mm focal length

APERTURE: *f*/9

SHUTTER SPEED: 1/320 sec

ISO: 200

LIGHTING:
1 Daylight

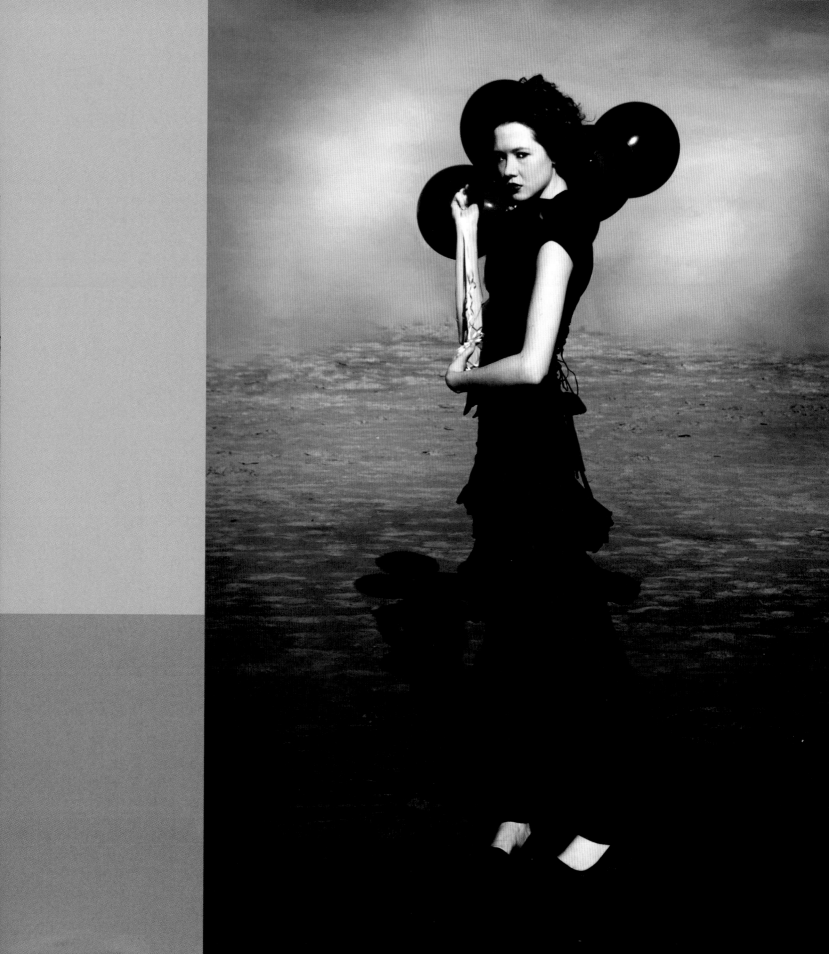

Molly

Whether you're a full-time professional, or an aspiring fashion photographer, a portfolio of images that shows the depth and breadth of your work is essential. This means constant testing, not only with your kit and your techniques to explore new creative options, but also with the people who are vital to the final shot: your models and stylists.

JAYSEN TURNER'S AIM was simple with this test shot—he wanted to produce a series of black-and-white images with hard shadows that emulated the work of his favorite photographers. Working in the studio with a simple one-light setup, Jaysen set his strobe high and to the left of the camera, positioning his model close to a plain white seamless backdrop. Aiming the flash directly at her from a high angle created the hard shadows he was looking for, while the pose prevented the shot from looking static and ensured an even tonality on the face.

"This shoot was strictly for portfolio development for all three of us and I was really happy that we came up with something that we all ended up using. It's good when the photographer gets the result they're after, but even better when the model and stylist get something out of it as well, especially when we hadn't worked together before and everyone was giving up their time without being paid. Because we were a small team I think it facilitated much more of a collaborative effort than when you're working for someone with a very specific look in mind—you can work more freely, and that helps make a shoot more relaxed."

⇨ GET THE LOOK

■ Lighting fashion shots doesn't necessarily mean a complicated setup or multiple lights and, as Jaysen proves, a single strobe and a well-defined goal is more than enough to produce a striking picture. The key to this image is its simplicity: the single, direct flash and the naturally heightened contrast of a black outfit against a white background. However, when you're dealing with such extremes of tone, getting the exposure right is critical. For this shot, Jaysen took an incident light reading with a handheld flashmeter, which reads the light falling onto the subject, rather than the light being reflected off it. As a result, there's no chance of the exposure being affected by extremely light or dark areas, making it far easier to gauge the optimum exposure, even with a high contrast shot.

▣ PLAN VIEW

▣ PERSPECTIVE VIEW

📷

PHOTOGRAPHER: Jaysen Turner, Brooks Institute

CAMERA: Nikon D300

LENS: Nikon 50mm *f*/1.8D

APERTURE: *f*/11

SHUTTER SPEED: 1/60 sec

ISO: 100

LIGHTING:
❶ AlienBees AB800 monolight with 7" reflector

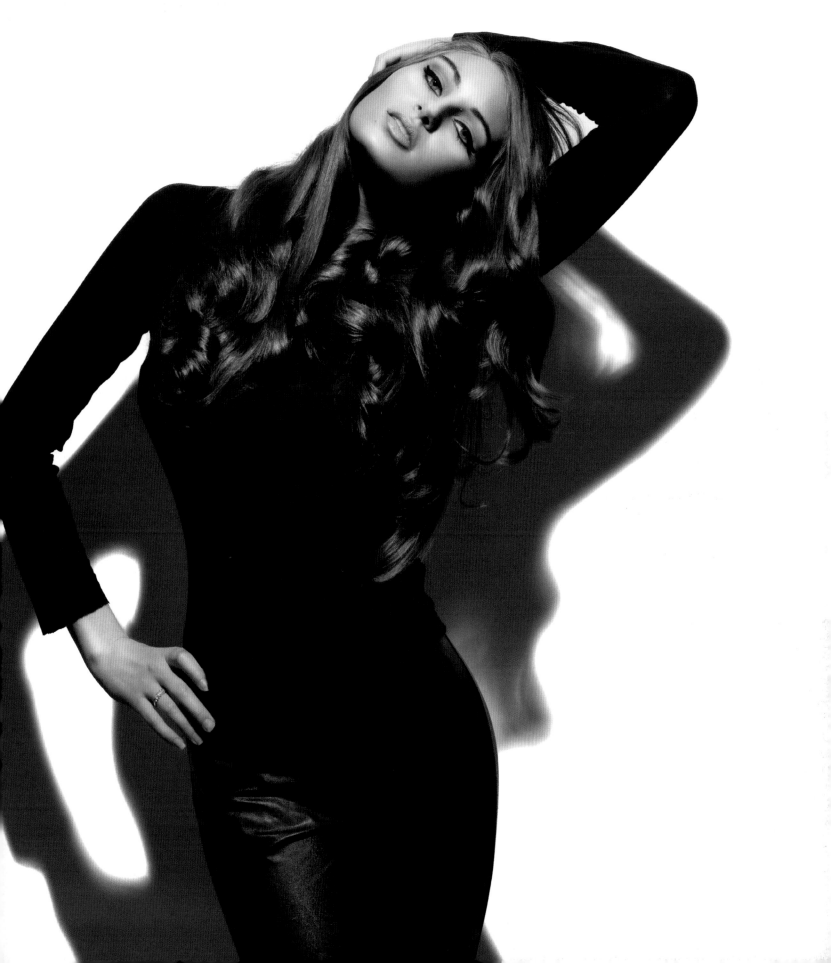

Test Session

By day, German-born Malte Pietschmann studies Media and Entertainment Management at Stenden University in The Netherlands, but his evenings and weekends are spent behind the camera as he expands his impressive fashion and beauty portfolio.

"I WORK WITH amateur models on a regular basis and I usually do a short test session before the actual shoot. This gives my models the opportunity to get used to being in front of the camera, I show them how I work, and create a relaxed atmosphere for when we work together again. When I'm doing a test session I tend not to use extensive lighting equipment because all the flashes and cables can easily overwhelm someone who hasn't been in that environment before—my main aim is to get the best from the model from the very start, and that means creating a comfortable working atmosphere."

Although he usually relies on natural light for his test shots, when the light isn't working for him, Malte will introduce unobtrusive artificial lightsources, usually starting with a single incandescent lamp. For this shot, he positioned a tungsten lamp to the left of the camera at the model's eye level, augmenting this with a hotshoe-mounted Nikon SB-900 that he bounced off the white ceiling to provide an overall soft light. Shooting in black and white meant there was no issue with the different color temperatures of the lights, which limited his post-production work to a small amount of retouching and "cleaning," followed by contrast adjustments to optimize the tonal range.

⇨ GET THE LOOK

⬛ Almost all digital SLR manufacturers have a fast 50mm lens in their line-up, and these can be incredibly useful for fashion photographers. Although you're restricted to a single focal length, the wide aperture settings on these lenses—typically *f*/1.8 or *f*/1.4—allow the depth of field to be restricted far more than it can be with a zoom lens, which enables you to concentrate the focus on the subject. For his tight head-and-shoulders beauty shot, Malte used a Nikon D90, which has a 23.6 x 15.8mm sensor. Because it isn't a "full-frame" sensor the focal length of his prime lens was increased by a factor of 1.5, giving it an effective focal length of 75mm, which is perfect for portrait-style images. Shooting at the lens' maximum aperture of *f*/1.4 has allowed Malte to focus precisely on the model's eyes, with the defocused hair creating a soft vignette that frames the face.

⬛ PLAN VIEW

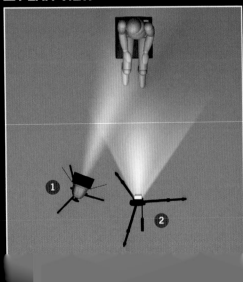

⬛ PERSPECTIVE VIEW

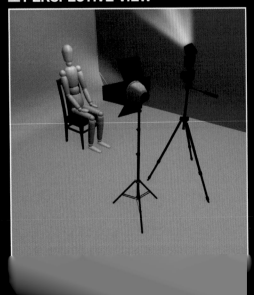

📷

PHOTOGRAPHER: Malte Pietschmann
CAMERA: Nikon D90
LENS: Nikon 50mm *f*/1.4D
APERTURE: *f*/1.4
SHUTTER SPEED: 1/80 sec
ISO: 250
LIGHTING:
❶ Incandescent lamp
❷ Nikon SB-900 Speedlight

Celluloid Closet

For anyone with even a passing interest in fashion photography, Rankin's name is instantly recognizable. His rise to stardom arguably began two decades ago when, in 1991, he co-launched the iconic style magazine, *Dazed & Confused*. Almost immediately, the magazine gained universal popularity, becoming one of the main outlets for Rankin's creative fashion and portrait work. Stars such as Eminem, Hilary Swank, and Jake Gyllenhall have all appeared on the cover, while Rankin's credits as a photographer include iconic figures such as The Rolling Stones, former British Prime Minister Tony Blair, and even Her Majesty the Queen.

THIS IMAGE WAS SHOT for a *Dazed & Confused* fashion story published in 2003, and later appeared in Rankin's book, *Fashion Stories*. Yet despite its age it is incontrovertibly timeless. Its execution in black and white—and on film—immediately sets it outside any of the quickly dated trends associated with color photography, such as cross-processing, over- or under-saturation, or the heavy manipulation that heralded the arrival and excitement of digital imaging. The styling is also impossible to place—the vintage look of the outfit is at once historical and totally in keeping with the contemporary fascination for "retro" fashion. This is all brought together by the classic "*film noir*" style, created by a single HMI light (itself a crossover from the world of movie-making) and set within a studio that reveals and revels in the tools of the photographer's, and cinematographer's for that matter, trade.

⇨ **GET THE LOOK**

■ Black-and-white photography and the cinematographic *film noir* style are made for each other when it comes to fashion images. Deep, impenetrable shadows punctuated by brilliant white highlights work naturally in monochrome—more so than color—and it's one area where continuous lighting, rather than flash, excels. It's also a great place to start when you want to learn about light and lighting: Whether you're working with a low-cost incandescent lamp or using an ultra-expensive HMI there are no concerns about the white balance when you're shooting for a black-and-white result, and seeing precisely where your shadows are falling provides immediate feedback. With just a single lamp it's possible to create a wide range of looks through careful attention to the angle and height of the lamp, the light-to-subject distance, and the position of the model in relation to the camera, and all of this will provide a solid foundation when you want to start exploring more extravagant setups.

⊞ PLAN VIEW

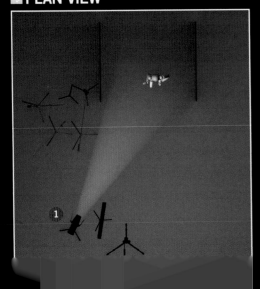

⊞ PERSPECTIVE VIEW

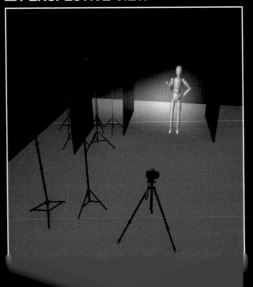

📷

PHOTOGRAPHER: Rankin (Courtesy of Rankin/trunkarchive.com)
CAMERA: Mamiya RZ67 Pro II
LENS: Mamiya 65mm *f*/4
APERTURE: *f*/11
SHUTTER SPEED: 1/60 sec
FILM: Kodak T-Max 100
ISO: 200
LIGHTING:
① 1200w HMI

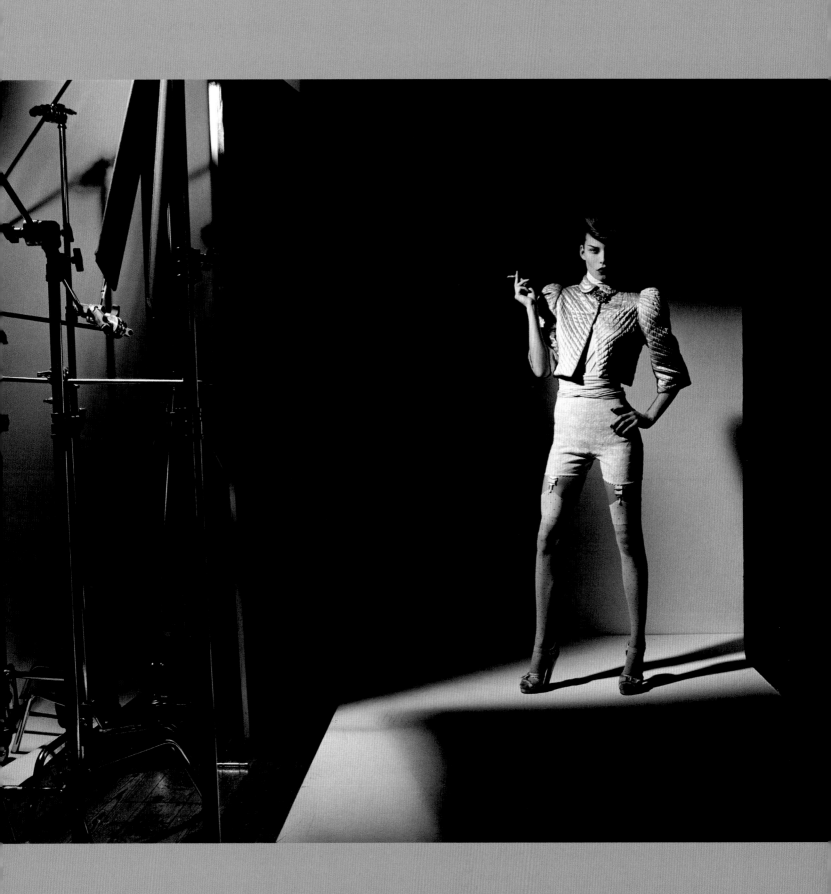

Eve

Specializing in fashion, hair, and beauty, Polish photographer Piotr Zgodziński's work can be found in many international publications, as well as gracing the covers of magazines such as *Marie Claire*, *Métamorphose*, *Coiffure Professionnelle*, *Estetica*, *HAIR*, and *Coiffure*.

THE MAJORITY OF PIOTR'S commercial work is—like most photographers'—shot digitally, but when the day job is over he will often recharge his batteries by shooting film. "After the work is finished I feel exhausted, and at moments like this I want to take things at a slower pace, quietly, with just available light and a model. With film, you have to value each frame and expose carefully, so the art of previsualizing the end result becomes the most important skill. I find this also helps with my digital photography, allowing me to 'see' the right result with less trial and error."

For this shot, there were two main lightsources—a large window to the right of the camera, and a household lamp placed to the left (partly visible) that provides the rim light to the hair. Piotr added a small silver reflector to reduce the shadows on the model's face, which was helped by the white walls and ceiling, which also bounced the ambient light back onto the subject. Then, using nothing more sophisticated than a Kiev 60 medium-format camera, Piotr loaded up with Kodak Tri-X black-and-white film, attaching a yellow filter to the lens to lighten the model's skin and hair, and rating it at ISO 1600 so he could shoot handheld. He finished up by push-processing it himself through Rodinal developer for a distinctly filmic look.

GET THE LOOK

Although film is nowhere near as popular as it once was, Piotr shows how it can be beneficial, even to pro photographers. Because there are only a few exposures on a roll, this encourages you to think more carefully about what it is you are shooting and how you are going about it—the composition, exposure, and lighting, for example. Film also has a very unique characteristic: grain. While you can try and recreate this digitally (some methods are more convincing than others), nothing produces the same effect as "the real deal." With this image, Piotr uprated his Kodak Tri-X so he was effectively treating it as if it were an ISO 1600 film, instead of rating it at its actual ISO 400 speed. The development of the film was then extended to compensate, a process that typically increases both contrast and grain in a way that is unique to the film/developer combination.

PLAN VIEW

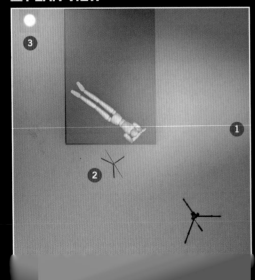

PERSPECTIVE VIEW

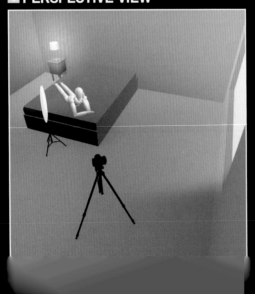

PHOTOGRAPHER: Piotr Zgodziński

CAMERA: Kiev 60 6x6

LENS: Carl Zeiss Jena MC 120mm *f*/2.8 Biometar

APERTURE: *f*/2.8

SHUTTER SPEED: 1/30 sec

FILM: Kodak Tri-X Professional

ISO: 1600

LIGHTING:

1 Natural daylight from window

2 Silver reflector

3 Incandescent lamp

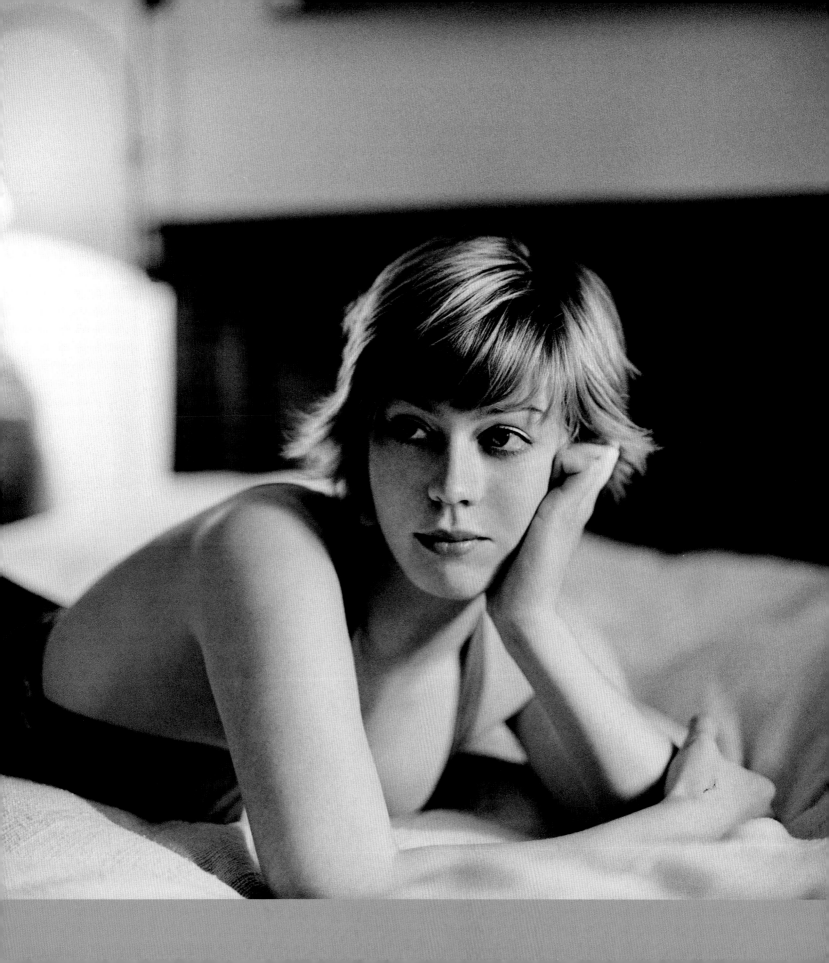

 MONO

Museu Histórico

Based in Santa Catarina, south Brazil, Estudio Nagô was formed in 2005 when photographer Marcos Moreira and illustrator Marcelo Fausto decided to fuse their respective disciplines and love for fashion.

REINVENTING THEIR APPROACH to the fast-paced fashion industry on a regular basis, the duo draw on a wide range of influences for their ever-changing portfolio, with this image inspired in part by Thomas Dworzak, a photographer and Magnum member known for his intense documentary work and coverage of global conflict. "We had been invited to shoot some images for a new fashion magazine, and were given an open brief. As we rarely get the chance to do any commercial work in black and white, that was where we decided to start. I was looking at the work of Thomas Dworzak, and in one particular image a lady sits in a bus near a window, with the light coming from behind her. As soon as I saw that shot, I knew that was the look that I wanted.

"The location we arranged was the beautiful Museu Histórico (History Museum) in Itajaí. Because of the art they've got on display we weren't allowed to use flash, so we had to use a continuous, cool-running 1200w HMI light instead. Although we were shooting just after midday, we had to reduce the power of the lamp to 50% to get the look we were after because it was cloudy outside and there were protective screens over the windows, which both reduced the ambient light levels. This meant using a relatively long exposure and ISO 1600—not only because of the low light, but also because we wanted a gritty look."

⇢ GET THE LOOK

- Black-and-white images often respond far better to high contrast than color shots and this image is characterized by deep shadows and bright highlights that give it a classic "*film noir*" feel. This is undoubtedly helped with the styling (the vintage hat, feather boa, ornate chair, and art deco surroundings all allude to the past), but it also owes a lot to the lighting. With windows on three sides of the model it would have been easy to choose an exposure that revealed her in her entirety, filling in the shadows and creating a much softer image. However, the addition of the bright, direct light from above has changed the main lightsource and therefore the exposure. Now, instead of seeing everything, the model sits in a sharp pool of light that creates a far more exciting chiaroscuro image.

 PLAN VIEW

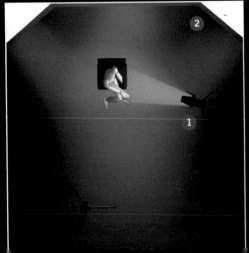

PERSPECTIVE VIEW

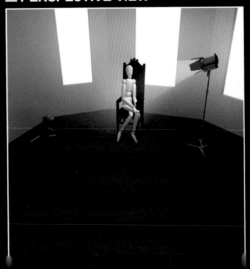

📷

PHOTOGRAPHER: Estudio Nagô
CAMERA: Canon EOS 5D Mk II
LENS: Canon EF 17–55mm *f*/2.8 IS USM @ 38mm focal length
APERTURE: *f*/4
SHUTTER SPEED: 1/20 sec
ISO: 1600
LIGHTING:
1 1200w HMI
2 Ambient window light

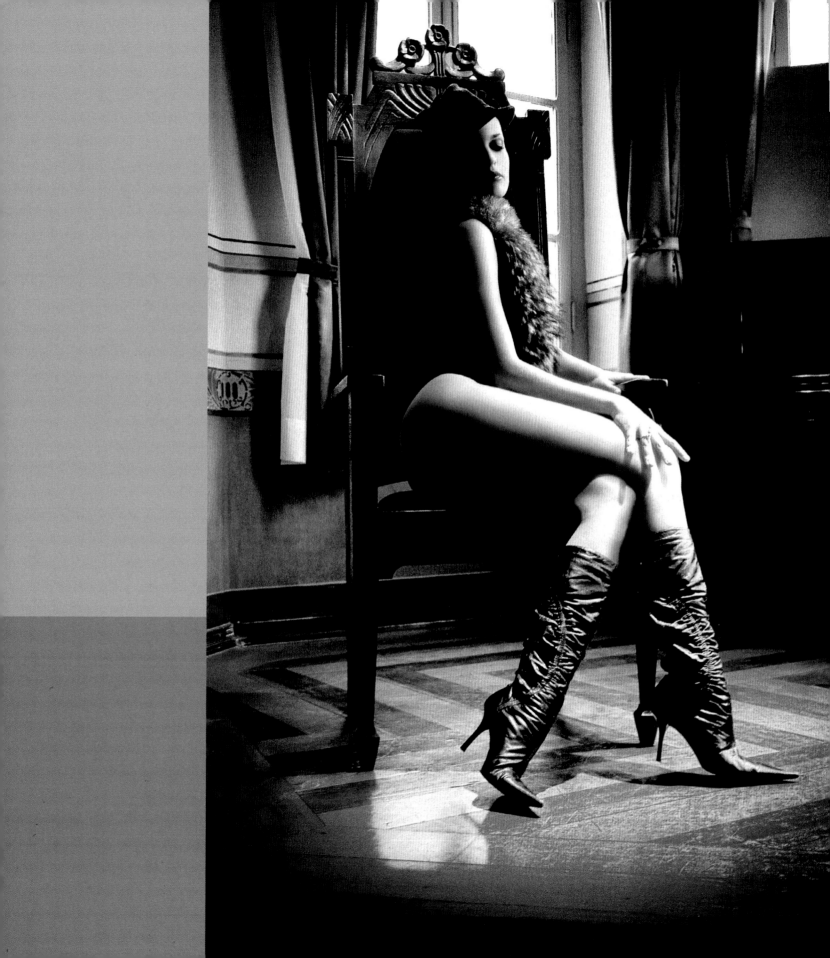

Mook

Inspired by Mario Testino, Rankin, Corinne Day, and Patrick Demarchelier, Amy Pledger may just have left college, but she's already shooting fashion images for an ever-expanding range of magazines and retailers. Amongst her clients is Mook, a UK-based fashion store specializing in vintage clothing. The company was looking to promote its unique range of retro evening dresses for the prom season, and asked Amy to take the photographs.

"THE BRIEF FOR THIS SHOOT was 'classically simple.' The client wanted a set of pictures that showed their vintage outfits without the model dominating the shot, or the dresses getting lost against a distracting backdrop. For reference I looked at classic adverts for designers such as Calvin Klein—shots that were taken a few years ago, but were simple and to the point. Although most of the photographs for this shoot were used in color (the dress was a vibrant pink), the source material I was looking at was predominantly black and white so I converted some of my shots into monochrome. The color images worked well, but I like the romantic yet minimal black-and-white look."

To light her model, Amy used two monolights fitted with softboxes, positioning them either side of the model and aiming them slightly downward. This provided the even illumination that preserves the soft, diaphanous feel of the fabric, while the slight downward angle of the lights meant the model's face was subtly darker. In Photoshop, the image was converted from color into black and white, manipulating the tones to create the gentle "gray-on-gray" result.

⟶ GET THE LOOK

■ Although the majority of digital SLR cameras let you shoot in black and white, shooting in color—even if you're certain you want a monochrome image—offers much greater versatility. If you're shooting Raw images (which is recommended for quality), then the obvious option is to convert to mono when you process your shots. However, not all Raw converters offer as much scope as a dedicated editing program such as Photoshop, which offers a powerful set of black-and-white tools. The most useful of these is the Black and White option found under Image > Adjustments in the top menu. A range of sliders enables you to specifically control the mix of red, yellow, green, cyan, blue, and magenta in your monochrome conversion, effectively providing a complex system of filters that allow you to lighten and darken specific hues for a precise black-and-white conversion.

■ PLAN VIEW

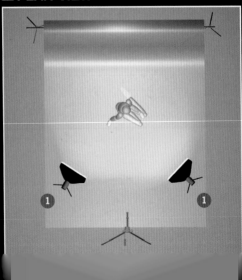

■ PERSPECTIVE VIEW

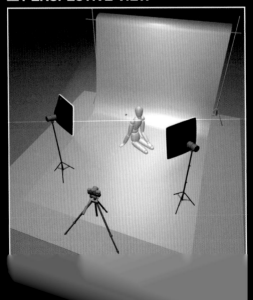

📷

PHOTOGRAPHER: Amy Pledger

CAMERA: Nikon D60

LENS: Nikon 18–55mm ƒ/3.5–4.5D ED @ 20mm focal length

APERTURE: ƒ/4.2

SHUTTER SPEED: 1/50 sec

ISO: 200

LIGHTING:

① Two 600ws monolights with softboxes

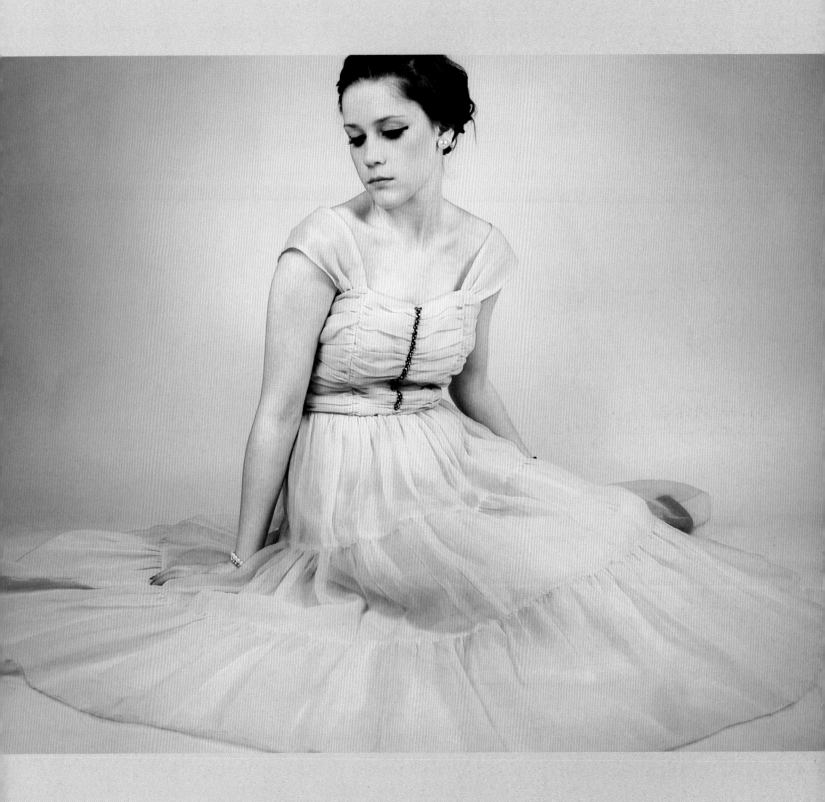

Francisca

Having dropped out of college to pursue a photographic career, teenager Harry Crowder has got off to a solid start, shooting both private and commercial commissions, with a client list that includes Lebanese couture designer Ziad Ghanem.

UNAFRAID TO EXPERIMENT with the kit he's using, Harry turned in part to an innovative, non-photographic lighting solution for this shot—a high-power, daylight-balanced lamp designed for treating Seasonal Affective Disorder, the medical condition more commonly referred to as "the Winter Blues."

"I used the S.A.D. lamp as my main light, shining it through the car's windshield. In addition I set up two low-powered flashes—one aimed through the side window and the other through the rear windshield, both pointing toward the camera. Although I was using a softbox on one flash and an umbrella on the other, I wanted to diffuse the light even more so I hung white cotton sheets over the car's windows to add another level of diffusion and clean up the background."

The result is a beautifully soft lighting setup that envelops the model on three sides, effectively converting the interior of the car into a giant light-tent. To further enhance the overall softness of the shot, Harry took it with the aperture on his 50mm f/1.8 prime lens wide open, focusing manually, but *not* on the subject. Instead, he knocked the focus back very slightly to introduce a subtle, yet effective soft-focus effect that's reminiscent of the treatment given to Hollywood screen sirens of the 1930s, '40s, and '50s.

⟶ GET THE LOOK

Although much of this image's soft look was created in-camera, post-processing offered the opportunity to take it a step further. Harry intensified the flare from the backlighting and adjusted the output levels to reduce the overall contrast. By increasing the value of the black output in Photoshop's levels dialog, shadow areas can be lightened, turning black into dark gray, which immediately decreases the contrast and adds a low-level visual "haze." This works especially well when you want to create a high-key look to an image or, as Harry has done here, go on to introduce a subtle warm tone and give an image a faded, vintage look.

◼ PLAN VIEW

◼ PERSPECTIVE VIEW

PHOTOGRAPHER: Harry Crowder
CAMERA: Canon EOS 500D
LENS: Canon EF 50mm f/1.8 II
APERTURE: f/1.8
SHUTTER SPEED: 1/40 sec
ISO: 400
LIGHTING:
1 Daylight-balanced S.A.D. lamp
2 150ws monolight with softbox
3 150ws monolight with umbrella

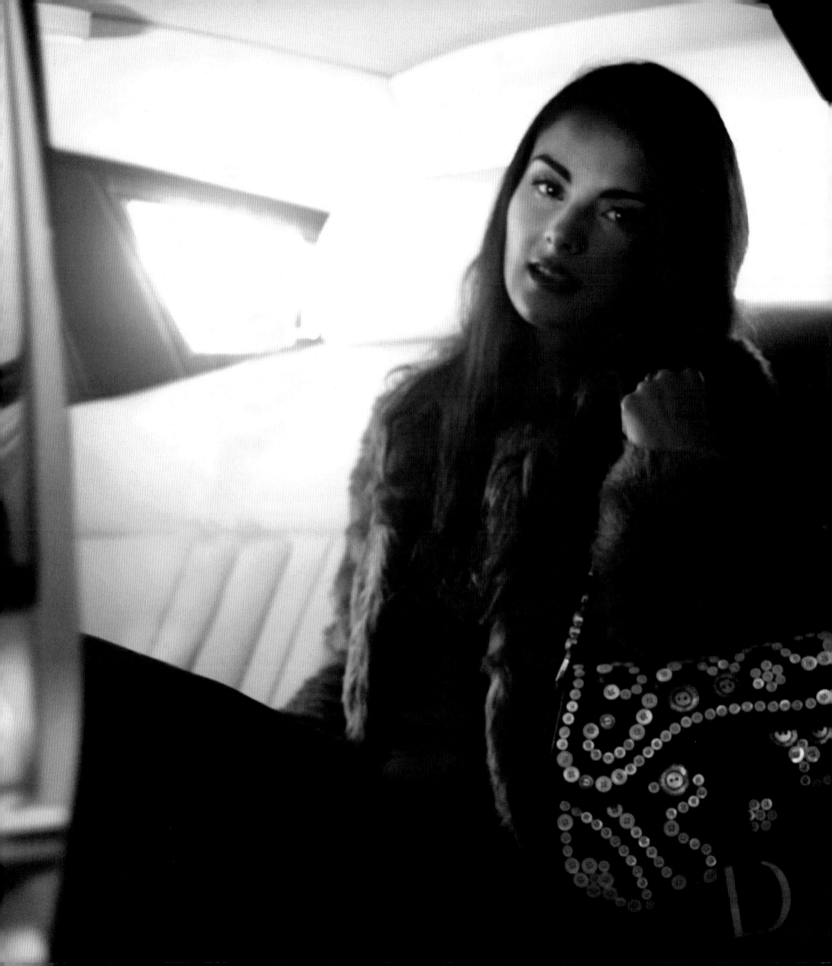

Reference

Contributors

Websites
Note that website addresses may often change, and sites appear and disappear
with alarming regularity. Use a search engine to help find new arrivals.

Pages: 70–71

Photographer: Miles ALDRIDGE
www.milesaldridge.com
Courtesy of Miles Aldridge/Trunk Archive
(www.trunkarchive.com)

Pages: 11, 22–25

Photographer & creative director: Ethan T. ALLEN
www.ethan-t-allen.com
Art direction, fashion & styling: Stefan Daniel Bell
Model: Piper Attebery
Hair & makeup: Xochitl Angelica

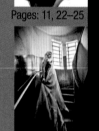

Pages: 66–67, 114–115

Photographer: Paula ANDDRADE
www.paulaanddrade.com
www.flickr.com/paulapcda
Model: Barbara Schneider
Hair & makeup: JoJo

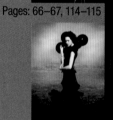

Pages: 122–123

Photographer: Caitlin BELLAH
www.caitlinbellah.com
www.flickr.com/caitlinbellah

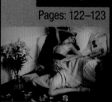

Pages: 84–84

Photographer: Rossina BOSSIO
www.rossinabossio.com
www.flickr.com/photos/rossinabossio
Model: Belladonna Friis

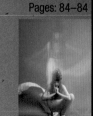

Pages: 58–59

Photographer: Trevor BRADY
www.trevorbrady.com
Model: Dasha **Stylist:** Deanna Palkowski
Hair & makeup: Marianna Scarola

Pages: 110–111

Photographer: Kerry BURROW
www.flickr.com/kerryburrow

Pages: 64–65

Photographer: Kerry BURROW
www.flickr.com/kerryburrow

Pages: 54–55

Photographer: Mark CANT
www.markcant.com

Pages: 136–137

Photographer: Harry CROWDER
www.harrycrowderphotography.com
www.flickr.com/harrycrowderphotography
Model: Francisca Posada-Brown

Pages: 44–45

Photographer: Yanick DÉRY
www.yanickdery.com

Pages: 74–76

Photographer: Amy DUNN
www.amydunn.com
www.flickr.com/amydunn
Model: Jaime **Assistant:** Jon Slevec
Hair & makeup: Tenya Du
Clothing designer: Clare Renee
Location scout: Sandra B.

PICTURE CREDITS

Contributors

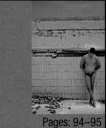

Photographer: Efrén Hernández LUIS
www.flickr.com/ef2009
Model: Primi Escobar García
Makeup: Jonathan Flores

Pages: 94–95

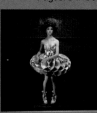

Photographer: Kevin MASON
www.kevinmason.garage-studios.co.uk
Model: Belladonna Friis **Dress/Shoes:** Emma Sandham-King **Makeup:** Janeen Witherspoon-Cove **Hair:** Emma Hedges **Lighting:** Natasha Alipour-Faridani & Kevin Mason **Set:** Matt Halls & Kevin Mason

Pages: 38–39

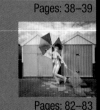

Photographer: Kevin MASON
www.kevinmason.garage-studios.co.uk
Model: Elin **Stylist:** Emma Sandham-King
Makeup: Janeen Witherspoon-Cove **Hair:** Emma Hedges **Assistant:** Natasha Alipour-Faridani

Pages: 82–83

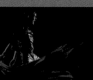

Photographer: Mikhail MIKHAYLOV
www.mikhaylovphoto.com
Model: Vitaly

Pages: 56–57

Photographer: Marcelo NUNES
www.bandits.com.br
www.flickr.com/marcnunes

Pages: 62–63

Photographer: Marcelo NUNES
www.bandits.com.br
www.flickr.com/marcnunes

Pages: 28–29

Pages: 2, 52–53

Pages: 118–119

Pages: 1, 60–61

Pages: 40–41

Pages: 91–93

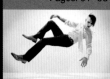

Pages: 35–37

Pages: 106–107

Photographer: OLLIE & CAPALDI
www.ollieandcapaldi.com

Photographer: Anna OLSZEWSKA
www.annaolszewska.com
www.flickr.com/koolanka
Model: Tom Adam **Assistant:** Trish Ward
Stylist: Karolina Szczechura

Photographer: Anna OLSZEWSKA
www.annaolszewska.com
www.flickr.com/koolanka
Model: Bogusia Kawczynska **Assistant:** Trish Ward
Stylist: Claire Roberts **Makeup:** Kamila Tokarska
Hair: Paige Morse

Photographer: Simon PAIS
www.simonpais.com
Model: Axel **Stylist:** Gabriela Cordero
Hair & makeup: Maria Paz Urra

Photographer: Simon PAIS
www.simonpais.com
Model: Eliana **Stylist:** Antonio Karmona
Hair & makeup: Paz Urra
Background painting: Roberto Matta

Photographer: PEROU
www.perou.co.uk
Model: Marilyn Manson **Stylist:** Robert Morrison

Photographer: CT PHAM
www.phamster.shuttrr.com
www.flickr.com/-phamster-
Model: Katie

Photographer: Malte PIETSCHMANN
www.maltepietschmann.com

Pages: 126–127

Photographer: Amy PLEDGER
www.flickr.com/30616213@N04
Model: Annie Bryant

Pages: 116–117, 134–135

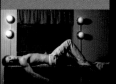

Photographer: RANKIN
www.rankin.co.uk
Model: Louise Pederson
Courtesy of Rankin/Trunk Archive
(www.trunkarchive.com)

Pages: 128–129

Photographer: Diana SANDOVAL
www.dianasandoval.com
Model: Edwin

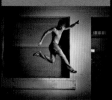

Pages: 77–79

Photographer: Andrew SMITH
www.cubagallery.co.nz
www.flickr.com/cubagallery

Pages: 16, 96–97

Photographer: ESTUDIO NAGÔ
www.estudionago.com

Pages: 14, 132–133

Photographer: Danny TUCKER
www.dtphoto.net
Model: Sheridan Manion

Pages: 72–73

Photographer: Danny TUCKER
www.dtphoto.net
Model: Katy Tucker
Wall art: RUN Collective

Pages: 4–5, 88–90

Photographer: Jaysen TURNER
www.jaysenturner.com
Model: Molly
Hair & makeup: Zoraima

Pages: 124–125

Photographer: Jaysen TURNER
www.jaysenturner.com
Model: Sabra
Hair & makeup: Brittany

Pages: 17, 98–99

Photographer: Trish WARD
www.trishwardphotography.co.uk
Model: Clare Martin **Assistant:** Anna Olszewska
Stylist: Esther Cain **Makeup:** Siobhan Walsh
Hair: Carrie Li

Pages: 32–34

Photographer: Richard WARREN
www.richardwarrenphotos.com
Models: Clara Veiga & Jorge V.
Fashion editor: David Widjaja **Hair:** Noah Hatton
Makeup: Renato Almelda **Manicurist:** Tatyana Molot
Movement consultant: Layzah Claudia

Pages: 46–48

Photographer: Piotr ZGODZIŃSKI
www.zgodzinski.com
www.flickr.com/zgodzinski
Model: Eve

Pages: 130–131

The publishers would also like to thank the following agencies for their kind permission in using the following images:

Product images courtesy of Paul C. Buff, Inc./ AlienBees (www.alienbees.com): pages 10; 12; 13; 15; 16.

Product images courtesy of Profoto (www.profoto. com) (with the exception of boom arm, light stand and flashmeter images): pages 18–20.

Product images courtesy of iStock (www. istockphoto.com): pages 8–9 (iStock/Avesun); 11 (iStock/Alexey Ivanov) top left; 11 (iStock/Jacques Kloppers) bottom right; 13 (iStock/Rollover); 15 (iStock/Soundsnaps) center; 15 (iStock/DSGpro) right; 16 (iStock/Isaac Koval) top; 18 (iStock/ Valerie Loiseleux) second from right.

Acknowledgments

This book wouldn't have been possible without the tremendous response and involvement from all the photographers listed on the previous pages, so a big thank you for your time, your stunning imagery, and for providing me with a behind-the-scenes glimpse into your working practices: without your "secrets" this book just wouldn't have happened.

Thanks also to Gayle Taliaferro at Trunk Archive, Cara and Stacey at Focal Press for their words of encouragement, and the team at Ilex—Adam, Natalia, Roly, James and Tara—for giving me this opportunity to start with and for pulling the project together. Thanks also to Rolo for the 3D lighting diagrams.

In true Oscars fashion, I also need to thank my parents for their unwavering support: For buying me my first camera when it became clear I wasn't interested in a career as a brain surgeon, rocket scientist, or accountant all those years ago, and for backing me 100% in everything that's followed. It's appreciated more than you know.

And finally, special thanks have to go to Nat and Tat for distracting me with reruns of "Spy Kids 2" when I really should have been working: not entirely conducive to meeting deadlines, but definitely more fun! Love you both!